Keepers of Tradition

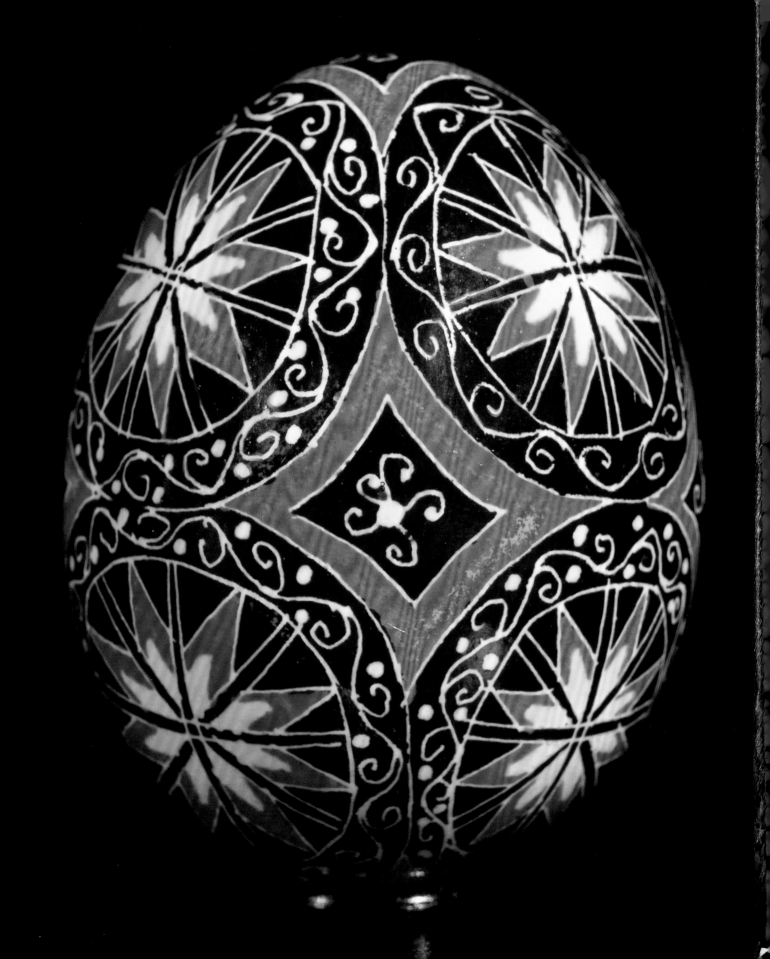

Keepers of Tradition

ART AND FOLK HERITAGE IN MASSACHUSETTS

MAGGIE HOLTZBERG PHOTOGRAPHY BY JASON DOWDLE

A collaboration of the
Massachusetts Cultural Council
and the
National Heritage Museum,
Lexington, Massachusetts

Distributed by the
University of Massachusetts Press

Published in conjunction with the exhibition *Keepers of Tradition: Art and Folk Heritage in Massachusetts*, a collaboration of the Massachusetts Cultural Council and the National Heritage Museum, Lexington, Massachusetts

Exhibition Dates
May 17, 2008–February 8, 2009
online exhibition available at
www.massfolkarts.org

Bank of America and a generous gift from an anonymous foundation provided major funding for this exhibition. Additional support was provided by the National Endowment for the Arts, the Massachusetts Cultural Council, and the National Heritage Museum.

Produced by the
Massachusetts Cultural Council and the National Heritage Museum, Lexington, Massachusetts
www.massculturalcouncil.org
www.monh.org
Designer: Rich Hendel
Editor: Ulrike Mills

Studio photography by Jason Dowdle
Portrait photography by
Billy Howard Photography

"To Be of Use," from *Circles on the Water* by Marge Piercy, copyright © 1982 by Marge Piercy. Used by permission of Alfred A. Knopf, a division of Random House, Inc.

This book was typeset in The Serif types. Printed in England by Butler & Tanner Dimensions are given in inches; height precedes width.

Library of Congress Control Number 2008920539

ISBN 978-1-55849-640-8
10 9 8 7 6 5 4 3 2 1

Cover
Front: Puerto Rican large *vejigante* mask by Angel Sánchez Ortiz, Holyoke, Massachusetts
Back, from top: Tamara Shillingford in Boston Carribean Carnival, photograph by Maggie Holtzberg; Paul Cooper, bladesmith, photograph Billy Howard Photography; The *Thomas E. Lannon* being built, photograph Lew Joslyn; Joe Derrane with his button box, photograph Tom Rich Photography; Karol Lindquist making a lightship basket, photograph Jeffrey Allen
Frontispiece: *Pysanki* by Carol Kostecki, Montague Center, Massachusetts
Page v: Cow weather vane by Marian Ives (cat. 4.51)
Page x: Tobacco pouch by Dave Holland (cat. 4.12)
Page xii: Detail of Armenian needle lace by Almas Boghosian (cat. 4.19)

Contents

THE COMMONWEALTH OF MASSACHUSETTS
EXECUTIVE DEPARTMENT
STATE HOUSE • BOSTON, MA 02133
(617) 725-4000

DEVAL L. PATRICK
GOVERNOR

TIMOTHY P. MURRAY
LIEUTENANT GOVERNOR

May 2008

Dear Friends:

On behalf of the Commonwealth of Massachusetts, welcome to the *Keepers of Tradition: Folk Arts in Massachusetts* exhibition at the National Heritage Museum in Lexington.

Featuring music and dance, and myriad crafts and sacred arts, *Keepers of Tradition* reflects the quality and diversity of folk and traditional arts and artists in our state. Since colonial times, folk art has played a role in the telling of America's story. I congratulate the local artisans featured in this exhibition and catalog. I commend your dedication to the continuation of cultural traditions.

As you explore the museum, I hope you will find a little bit of your own Massachusetts and that you will be surprised and delighted by the wealth and diversity of art that this exhibition, and the Commonwealth, has to offer.

Best regards,

In his introduction to the 1992 Festival of American Folklife, Smithsonian Institution Secretary Robert McAdams wrote, "An important challenge before museums today is to find ways to address themselves to the increasing diversity, and at the same time the growing interdependence and vulnerability, of social life everywhere. Museums need to be publicly recognized as important institutional means by which groups in our very pluralistic society can define themselves and find places within the changing dynamics of contemporary life." Fifteen years later, the role of museums has not changed. This, in a nutshell, is the reason for our involvement in any particular project.

The National Heritage Museum and its partners, sponsors, and donors—the Massachusetts Cultural Council, the Scottish Rite of Freemasons, the National Endowment for the Arts, Bank of America, and others—understand the importance of telling this story. By highlighting the living artisans featured here and their folk crafts, music, and dance, we hope our visitors will become aware of how deeply rooted the shared elements of our ethnicity, religion, occupations, and regional identity are. This exhibition offers a window onto the traditions of the past and reveals Massachusetts as a microcosm of the cultural diversity in American life today.

John H. Ott
Executive Director
National Heritage Museum

We work hard to support and promote the arts and culture in Massachusetts, in part because they help us understand who we are. They build bridges across diverse cultures. They help us interpret our past and shape our future. This publication will show you an astonishing range of artistic traditions that go to the heart of Massachusetts and why it has always held such a central place in the story of America.

Whether a hand-pieced quilt depicting a textile mill in Lowell, a Puerto Rican carnival mask crafted in Holyoke, or a dry fieldstone wall built alongside a farmhouse in the Berkshires, the work showcased here broadens our sense of the way art is woven into everyday life. It also opens our eyes to the unique cultural makeup of our state.

I wish to thank all the artists whose work is represented in this exhibition, and the curator and staff who conceptualized and organized it. Thanks also go to the governor, the state legislature, and the citizens of Massachusetts for supporting this celebration of our collective heritage.

Anita Walker
Executive Director
Massachusetts Cultural Council

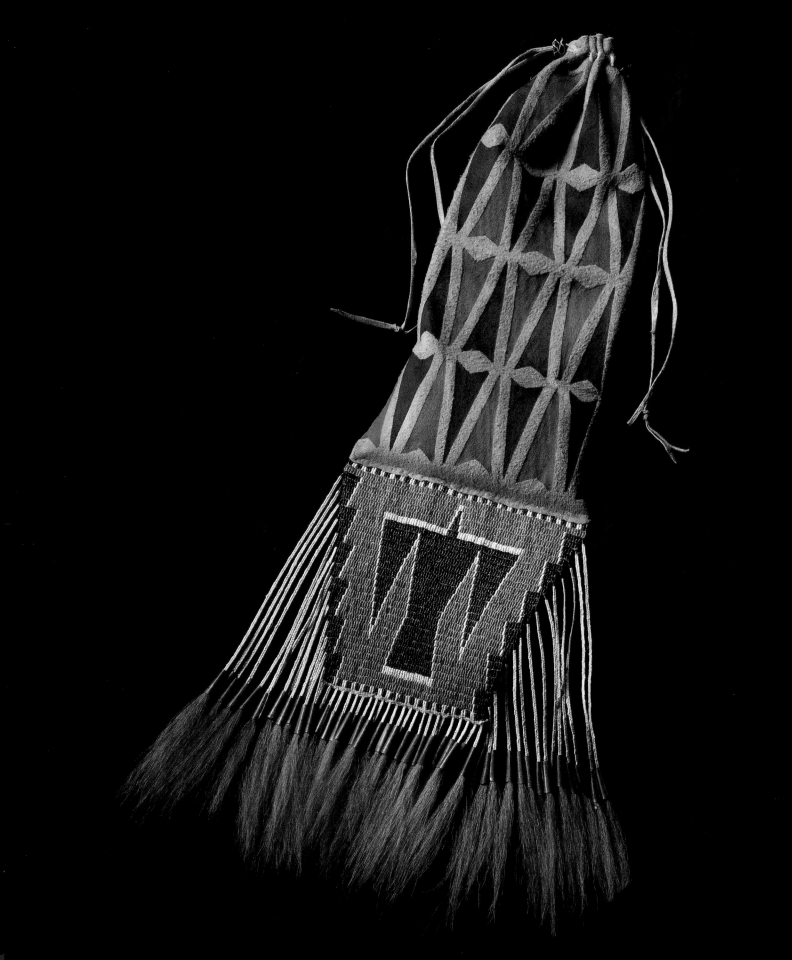

Serving as the state folklorist in Massachusetts since 1999 has meant getting to know the Commonwealth's folk arts and heritage from the ground up. With camera and sound recorder in hand, we have interviewed scrimshanders on Nantucket, feast-day organizers in Boston's North End, contra-dance fiddlers in Greenfield, and Native American regalia makers on Cape Cod. Vital folk art traditions are being carried on all across the state within both long-settled ethnic and new immigrant communities. Yet many of these traditions are hidden to the general public and remain largely unknown beyond the local community in which they flourish.

Folk traditions of music making, dance, and craft, as well as annual celebrations, deserve to be acknowledged and honored. They are important because they represent cultural expressions that are actively practiced and treasured by groups of people across this state. Whether documenting an eleventh-generation wooden-boat builder in Essex or an Armenian lace maker in Whitinsville, one finds artists and craftspeople who are as passionate about striving for artistic excellence as they are about adhering to cultural tradition.

This catalogue will introduce the reader to Yankee pounded-ash baskets and pieced quilts, Ukrainian decorated eggs, Jewish illuminated calligraphy, duck decoys, Chinese carved seals, Russian iconography, Irish step-dancing costumes, Puerto Rican *santos*, Caribbean *mas* making, and much more. All these diverse objects and traditions are tied together by personal passion that is grounded in tradition, in a sense of place, and in the need to be useful. These are traditions that communities and individuals care enough about to sustain, to enshrine, and to pass on.

In honoring traditional artists, we hope that *Keepers of Tradition* will educate and delight the public. Folk art takes many expressive forms. Visitors should recognize a bit of themselves in this presentation—whether it is a reminder of how a grandmother pieced quilts, a neighbor sang, or an oil deliveryman, with fingers stained and callused, fiddled Cape Breton tunes each Saturday night.

Maggie Holtzberg, PhD
State Folklorist
Massachusetts Cultural Council

Acknowledgments

I am profoundly grateful, above all others, to the artists of Massachusetts who shared their traditions, tunes, stories, and handmade objects. Considering that many of the objects shown here are actively used in homes (hand-sewn textiles, musical instruments, home altars), it is remarkable that so many lenders were willing to part with precious objects for such a long time. Regrettably, some objects, such as Native regalia and rare musical instruments, could not be included. We thank all lenders for generously sharing their treasures. This exhibition and catalogue would not have been possible without ongoing support from the National Endowment for the Arts (NEA), and we are particularly indebted to Barry Bergey, director of the NEA Folk and Traditional Arts Program. We also extend our gratitude to Bank of America and to an anonymous local foundation for their generous financial contributions.

Planning and preparing this exhibition, over the course of three years, was a true collaboration between the Massachusetts Cultural Council and the National Heritage Museum. The museum staff guided us in the early stages and brought their special expertise to the work of designing, interpreting, and presenting this rich material.

We could not have covered so much geographic territory without the help of dozens of fieldworkers. Their field notes, tape-recorded interviews, and photographic images provided documentation and laid the groundwork for a continuing relationship with the artists.

Friends and colleagues read various versions of this manuscript, offering insights and suggestions. They include Dan Blask, Charles Coe, Elaine Eff, Jane King, Kate Kruckemeyer, James Martin, Charlie McDermott, Millie Rahn, and Mina Wright. Penny Pimentel's graphic arts skills helped tell the story of the exhibition as it was being developed. Kelly Bennett offered her artistic eye, and her calm presence was sustaining during rough times. My gratitude goes to intern Suhyung Kim for her diligent research and interpretation of U.S. Census data on immigration, and her rendering of complex demographic data into visual form. I am especially grateful to exhibition coordinator Bronwyn Low, who has been invaluable throughout all stages of this project, from conceptualizing the show and setting interpretive goals to the myriad details of producing an exhibition, catalogue, public programs, and audio guide.

I feel fortunate to have worked with photographer Jason Dowdle, who over the course of seven long days photographed more than one hundred exhibition objects. Employing the tools of the film industry—C-stands, nets, and hot lights—he brought each object to life. His use of shadows, back lighting, and highlights dramatically presents the objects to their best effect.

It was a treat to work again with portrait photographer Billy Howard and a big disappointment that we did not have the opportunity to photograph more of the artists whose work is included in this book. The words and images that follow were greatly enhanced by Ulrike Mills' editorial care and Rich Hendel's exquisite design.

I could not ask for better colleagues than the dedicated and engaged staff at the Massachusetts Cultural Council—they are like a second family to me. My parents' love, support, and genuine interest in my work continue to delight me. They were my first role models as people who found work they were passionate about.

Finally, I wish to thank my wonderful son Russell who, since he was a little boy, has been carted around to more than his fair share of ethnic festivals, fiddle conventions, and folklore field interviews. He was probably the only nine-year-old in his class who could answer, "What's a folklorist?" Nine years later, I wish him well as he finishes up his senior year.

Maggie Holtzberg

Keepers of Tradition

1.1

*Soca & Associates
band members,
Boston Caribbean
Carnival, 2007.
Photograph by
Maggie Holzberg*

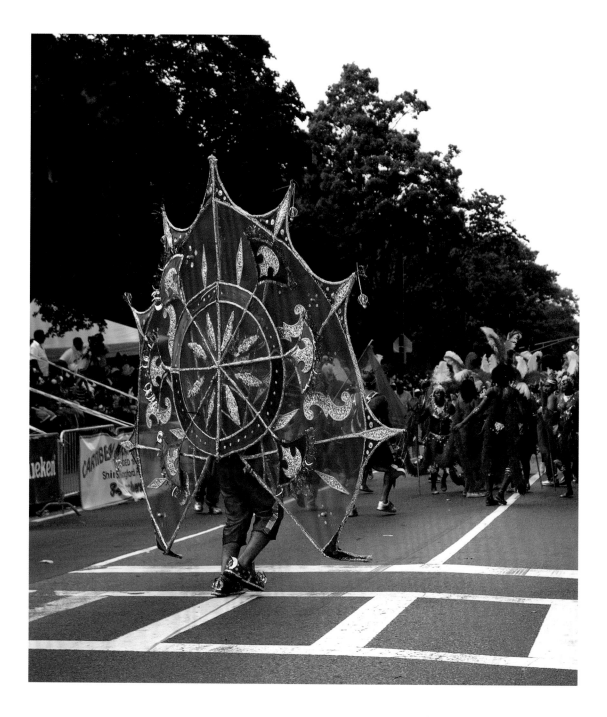

Introduction

I attended the annual Boston Caribbean Carnival for the first time in 2003.[1] Four years later, enormous crowds gather along Blue Hill Avenue in Roxbury, braving the hot and humid August weather in anticipation of a spectacle. Multiple sound systems on flatbed trucks blast calypso music, and the smell of jerk chicken is in the air. Vendors sell flags and trinkets from Trinidad, Tobago, Jamaica, Barbados, and a number of other West Indies islands. No one seems to care that the parade rolls out two to three hours past the time advertised.

What the gathering crowd awaits is a succession of *mas* (masquerading) bands from competing clubs that dance their way down the twenty-one-block parade route. A king and queen lead each band, adorned in dazzling handmade costumes of bent wire, steel frames, fabric, feathers, sequins, and glitter. Junior king, junior queen, individuals, and sections of dancing masqueraders complete each club's entourage (cat. 1.1). The final stop on the parade route is a street stage, where Trinidadian judges observe the celebrants from a viewing station.

Many in the Caribbean cultural community live for carnival. "This is something that people do out of their hearts. It is a cultural thing from where we came from," says Henry Antoine, executive director of the Caribbean Cultural Festivities Association. More than 600,000 attended Boston's 2007 carnival. Yet outside the participating community, most Bostonians are completely unaware that a festival of this magnitude in pageantry, beauty, and spirit takes place in their own city.

Bandleaders tell me it takes considerable time and substantial resources to participate in carnival. Preparations begin in late May and lead right up to the week of carnival. Lacking roomier facilities, most local clubs do the work of conceptualizing, designing, and constructing costumes in basements and backyards. This activity is known as *mas* camp and usually takes place at night, from 5:00 p.m. to midnight. The Trinidad and Tobago Social Club (T&T) is one of nine Boston-area *mas* bands that consistently win top prizes in carnival competitions; it took Best Band for ten consecutive years, from 1997 to 2006. T&T is headed by bandleader Errol A. Phillip, a man deeply dedicated to the Caribbean carnival tradition. The club has a meeting space in the basement of Phillip's triple-decker home in Jamaica Plain. Step inside during *mas* camp and you enter a world of specialized cultural knowledge, artistry, and serious costume production. A corner is filled with trophies and framed photographs of winning costumes hang on the walls. Yet, from the street it would be difficult to know that inside the basement of this house fabulous carnival costumes are constructed every year.

Similarly hidden is the Canadian-American Club in Watertown. Known by insiders as the "Can-Am," the club is housed in a nondescript brick and glass-tiled building on Arlington Street. Each month the club hosts dances, *seisiúns* (music jam sessions), and concerts where an older crowd goes to socialize, listen to music, and dance. Smoking is still allowed downstairs. There is a cash bar but one can also find "tea" (really more a meal of sandwiches and cake) for sale in a room adjacent to the dance hall. You never know who might drop in from "down home."[2]

Aside from a small sign outside the Canadian-American Club building, there is nothing to let you know what goes on inside. But if you happen by on a Saturday night and the door is open, you will hear the driving sounds of Cape Breton strathspeys and reels played on fiddle, guitar, accordion, and piano. "You hear the feet. The building practically pulses," says Marcia Palmater, host of Boston radio station WUMB. Finding such a place means suddenly entering a different world. Once inside, you could easily be in Cape Breton, Nova Scotia.

A wealth of various fiddle styles flourishes in Massachusetts, Cape Breton being one of them, and what better place to find Cape Breton music than Watertown, known as a destination community for generations of emigrants from the Canadian Maritime Provinces.

Massachusetts has an abundance of these "little worlds" of closely held (living) traditions (fig. 1). Knowing a tradition exists and finding someone who embodies that tradition with artistry and excellence is a folklorist's dream. While folk traditions are seldom part of history books and the daily news, they are fundamental to who we are. Through family or from community elders, we learn much more than just skills; we absorb the values, aesthetics, cultural history, rules, and behaviors that make us insiders in that community. This kind of folk knowledge is ephemeral. Wonderful bodies of lore, song, dance, and ways of doing work can be lost unless they are documented. Yet documentation is only the first step in preserving cultural heritage; it is the work we do to bring recognition and support to individual tradition bearers that can make the difference in retaining a tradition. A tradition that has been vibrant for many generations may disappear in one generation.

Folk art tradition is the glue of human community—the way it forms, what keeps it together or what threatens it, how it is transmitted, and how it is preserved. Our lifestyles have changed; we tend not to stay in the same community in which we grew up, and with both parents often working, children are less immersed in customs and traditions. We no longer have access to the extended families and lifelong neighbors that once were common. If we are going to keep community a living part of our culture, we need to understand how it works. That is what folklorists do.

In April 1999, with funding support from the National Endowment for the Arts, the Massachusetts Cultural Council (MCC) reestablished a folk arts program that would support, preserve, and promote appreciation of the state's diverse cultural traditions. At the time, eight years had passed since folklorist Dillon Bustin held the position of folklife and ethnic arts coordinator at the MCC. In the late 1980s, a corps of folklorists had been hired

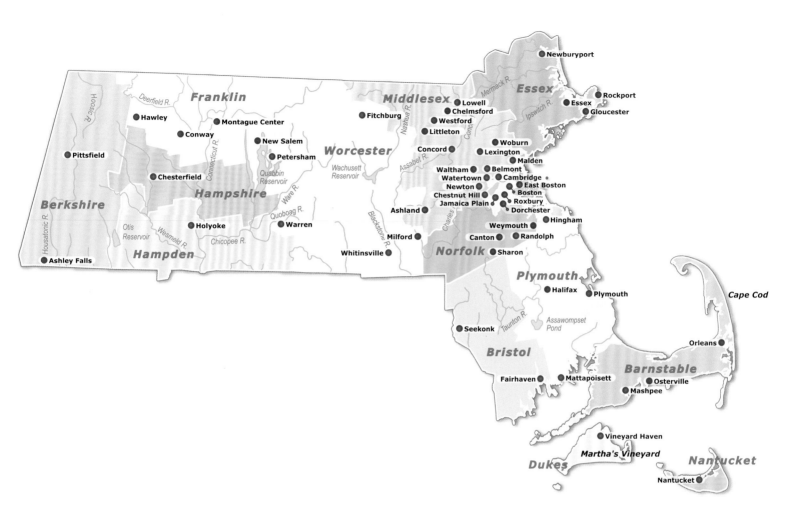

Figure 1

Map of Massachusetts
*Red dots indicate the location
of featured artists. Created by
Suhyung Kim*

to survey the state folk arts traditions. Original field notes, audio recordings, and images gathered by this corps were archived at the Smithsonian Institution, but copies were also deposited at the Massachusetts State Archives in Boston. The following year, Massachusetts was featured on the National Mall in Washington, D.C., as part of the Smithsonian Institution's Festival of American Folklife. Visitors met firsthand with Massachusetts boat builders, clambake cooks, and dance fiddlers.

Despite Bustin's good work of establishing an infrastructure for folk arts in the state during the late 1980s and early 1990s, the program was suspended during one of the state's funding crises.[3] By 1999, unfortunately, little or nothing survived from the work that had been done by the Folklife and Ethnic Arts Program. No contact information existed for the state's traditional artists, no searchable data base, no archive of slides and tapes. We were able to obtain duplicates of the Smithsonian fieldwork, but locating additional and more up-to-date information meant basically starting over.

One of the first orders of business was to begin identifying and documenting the Commonwealth's folk art traditions by launching a statewide survey. Over the past eight years, nearly two dozen folklorists have been hired on a contract basis to help conduct fieldwork documenting traditions found in ethnic, regional, occupational, and religious communities throughout Massachusetts. The fieldwork focuses on living traditions that have a link with the past. We are interested in how people come to a tradition, how they learn it, and how their traditional art reflects the values of the community in which it exists. We have sought out individuals who practice expressive traditions that have been handed down to them—music, craft, dance, and verbal lore. We are especially drawn to traditions that are held within families, within work cultures, or within geographical regions that make a place unique. We have documented traditions of long-settled populations (Wampanoag leatherwork and Yankee wooden-boat building), as well as traditions of more recently arrived immigrant groups (Cambodian folk dance and Caribbean carnival).

When folklorists look carefully at folk traditions, they pay as much attention to an object or a performance's use as they do to its formalistic and aesthetic qualities. The craft object (or dance step or fiddle tune) represents human creativity and skill in its social context.[4] This means approaching folk art with an ethnographic perspective by systematically observing, describing, and interpreting forms of expressive culture in situ. Wherever we go, we look for cultural expressions of local importance. Folk art, be it fiddle tune or carnival mask, draws its strength from communally understood forms and symbolic elements—the details that speak to an insider. Traditional art can be a shorthand for belonging, ethnic affiliation, and religious belief, or a marker of place. Because conforming to communally defined aesthetics usually trumps a craftsman's or musician's need to break new ground, traditional art can also be a window into what is considered "artful" locally.

Getting out into the field is (cat. 1.2) the heart of the folklorist's job. Fieldwork entails going into local communities to find, talk with, photograph, and record people practicing folk art traditions, with the goal of understanding these from an insider's point of view. The "field" of our research has been the homes, kitchens, workshops, dance halls, boat yards, places of worship, parade routes, festival sites, and other gathering places of people living in communities around the state. These are places where traditional art is produced and used, displayed and valued. We go about our work with the hope of understanding folk art and music in the context of those who make it, use it, or move to its sounds. What value does a certain object hold for the person who made it or the people who use it? What is the significance of a certain decorative motif? Why this type of dance tune? Why this way of building a stone wall?

A folklorist's search can be like detective work, and pursuing leads can sometimes be a challenge. Locating a lead—a singing auctioneer, Portuguese accordion player, or Puerto Rican mask maker—may take months, sometimes years. But persistence usually pays off. One July afternoon, while attending an annual Italian festival outside of Boston, someone

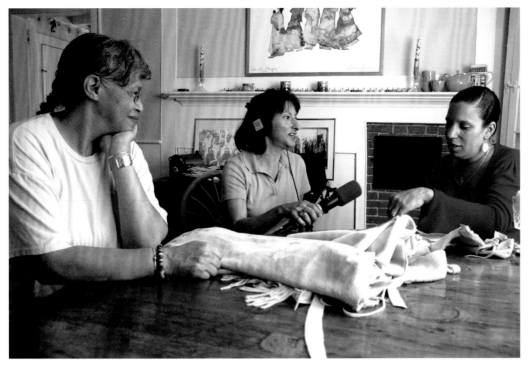

1.2

Anita Peters Little "Mother Bear" (left) and Michelle Fernandez (right) being interviewed about Wampanoag regalia making by the author. Photograph by Russell A. Call

mentioned that a local man, Charles Cerone, had carved a miniature statue of Saint Mary and that it was displayed in his front yard on a nearby side street. I left the festival grounds in Hawthorne Park, walked a few blocks, and found the wooden carving in the front yard of a two-family house. I photographed the small statue but did not find Mr. Cerone at home. In writing up field notes, I noted the wrong street name. Five years later, I tried to locate Cerone. His telephone number was unlisted. I could just make out the house number in the photograph I had taken. But because I had written down the street incorrectly, local tax assessment records did not identify Cerone as the owner. I then drove through the neighborhood looking for the two-family house in the picture, to no avail. Fortunately, the local newspaper ran a story thanking the Saint Mary of Carmen Society for donating money from festival proceeds to help maintain Hawthorne Park. The caption below the photograph identified members of the society and representatives from the city parks and recreation department. One individual, Arthur Magni, was both a city employee *and* a member of the society. I reached Magni through city hall. Bingo! Not only did he offer to pass on my message to Charles Cerone, but he also told me that Cerone would be pleased "to share a symbol of a tradition he holds very dear and in which he takes great pride."

Once a source is located and a connection established, the field interview can require hauling a camera and audio recorder to unusual places: up inside the bell tower of Old North Church to photograph and record the English tradition of change ringing; in a steamy Russian bathhouse to learn about the tradition of *palza* (hand-held broom made of oak leaves);

1.3

Nairi Havan (left) learning marash *embroidery from Anahid Kazazian. Photograph by Maggie Holtzberg*

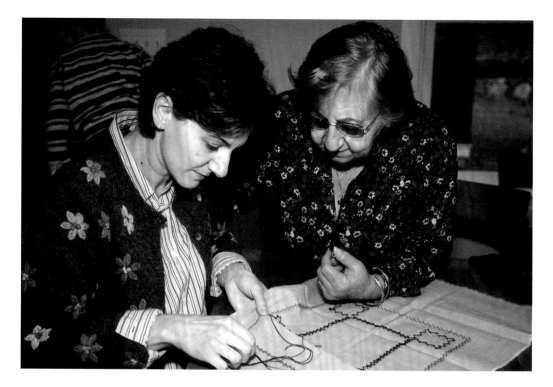

or 150 feet up on a rickety platform to see a steeplejack at work. The hours can be taxing. To understand decoy carving, it helps to go hunting for water fowl. One frigid February morning at dawn, I donned enough layers to look like the Michelin man and ventured out with veteran hunter Jon Detwiler to go goose hunting. Other tradition bearers are night owls. Watching legendary rhythm tap dancer Jimmy Slyde mentor his apprentice Rocky Mendes meant attending one of their nightly sessions, which habitually started after 11 p.m. The sessions typically continued into the wee hours, two to three times a week.

Our fieldwork has brought to light many artists and traditions worthy of attention. An archive holds audio recordings, field notes, and images of an increasing number of exemplary artists and traditions. MCC's Traditional Arts Apprenticeship Program supports a master artist to pass on his or her skills, artistry, and cultural heritage to a promising apprentice. Anahid Kazazian, for example, taught her daughter Nairi Havan the complex art of Armenian *marash* embroidery with the help of an MCC apprenticeship in 2002 (cat. 1.3). When asked how she felt the program helped sustain her traditional art, she responded, "In ways I was not aware of, such as passing on a tradition which will inevitably disappear because people have no time to sit and sew or stitch and repair. They can get items new from the market. The need to respect ancient tradition because we must; it's who we are today, where we came from, and where we will go."[5]

Seamus Connolly, a renowned Irish fiddle player, had served as a master artist to ap-

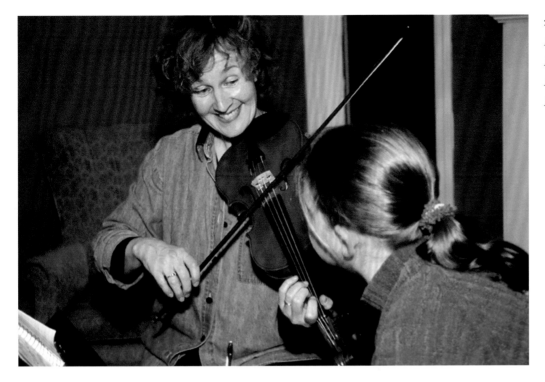

1.4
*Laurel Martin showing
Betsy Sullivan Irish bowing.
Photograph by Maggie
Holtzberg*

prentice Laurel Martin (cat. 1.4). When he heard that Laurel would be taking on her own apprentice, he responded this way: "This apprenticeship is important for Laurel because what she's doing is preserving the old styles that I learned from the old masters in Ireland. People like Paddy Canny. The technique is getting lost. Betsy Sullivan, the apprentice, is young and very unusual. What stands out about her is that she has no interest in the flashy Irish music one hears today. She wanted to learn the older style of playing."[6] Some artists have applied for and received MCC Artist Grants and Traditional Arts Apprenticeships. Others have been booked at major folk festivals or featured in radio broadcasts. Bringing greater visibility to the state's traditional arts practitioners is an ongoing goal.

"FOLK ART" CONNOTATIONS

To say that there has been a lack of agreement on the meaning of the term folk art is an understatement.[7] What folk art means depends on who is using the term—gallery owner, art museum curator, artist, collector, or folklorist. For the purposes of this catalogue, folk art is defined as artistic expression that is deeply rooted in shared ethnicity, religious belief, occupational tradition, or sense of place. Our approach to folk art originates with *people* rather than objects, hence the title, *Keepers of Tradition*. For us, folk art is the shaping of

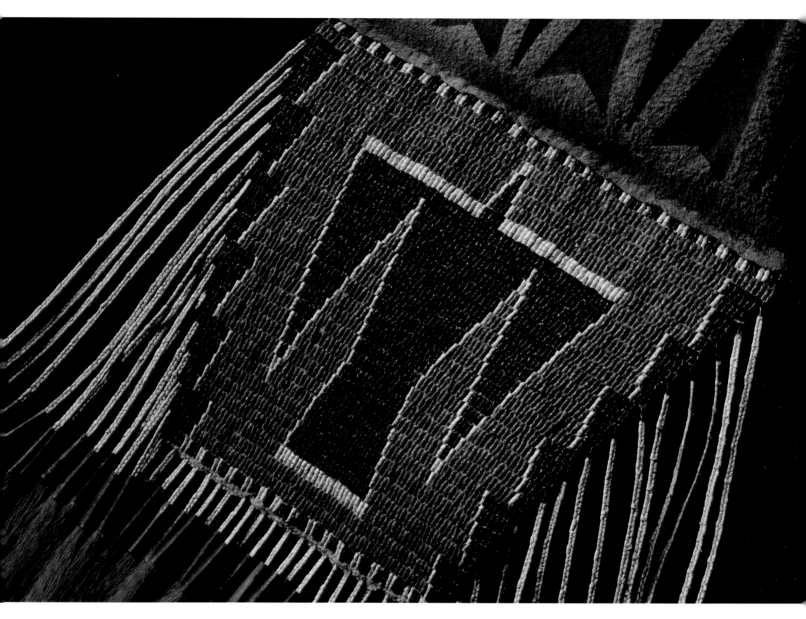

1.5

Detail of netted quill work on tobacco pouch, Native American regalia inspired by eighteenth-century Anishinaabe design, by Dave Holland, 2007, deerskin, porcupine quills. Collection of the artist

deeply held values into meaningful forms—whether those forms are dance tunes, wooden ships, saints' processions, or cross-stitch samplers.

When we speak of folk or traditional art, we are talking about recognizing a high level of artistic mastery in unexpected media, for example the uniformity and utility of a Nantucket lightship basket, the Native porcupine quill work on a tobacco pouch, the stunning ornamentation and rhythmic variation of an Irish button accordion player (cat. 1.5). These are things of beauty that not only hold meaning for specific groups of people but that have also stood the test of time.

Yet, the makers of many folk art objects and creators of expressive forms do not refer to their work as "art." (This is not to say that aesthetic considerations are not at play; they are.) Folk things are thought of in association with the function they serve in daily life: a carved decoy to dupe ducks, hooked rugs to bring color and warmth into a New England home in winter, a gospel song to testify one's faith, a horned carnival mask to provide playful fright, square-dance calls sung to direct dancers, or a gold-leafed icon to make visible the border between heaven and earth. These are useful things made beautiful.

When we asked a range of people what they would expect to see in an exhibition of folk arts in Massachusetts, they spoke of quilts, baskets, naive paintings, scrimshaw, and Native American crafts. When asked what adjectives came to mind when they heard the phrase "folk art," the response was, "rustic," "primitive," "decorative," "noncommercial," "useful," "poor people's art," or "simple." The general public seems to have unconsciously absorbed the academic art world's conception of folk art, which is one defined by deficiency—art that is unsophisticated, plain, and, for the most part, created anonymously. In other words, folk art is quietly perceived as a poor imitation of fine art.

Fine-art museums and collectors have unintentionally reinforced these notions.[8] Maxim and Martha Codman Karolik were among some of the first collectors to recognize that American folk art deserved serious aesthetic consideration. Their collection and subsequent gifts of eighteenth- and nineteenth-century American art to the Museum of Fine Arts, Boston, formed the basis of the museum's 2001 show, *American Folk*. The exhibition showcased beautiful objects: Yankee samplers, plain paintings, hooked rugs, whirligigs, decoys, furniture, and weather vanes. Reflecting the collectors' interests, *American Folk* focused attention on the formal beauty of the objects, the majority of which were labeled as the work of an "unidentified artist." Visitors to the museum could easily leave the exhibition with the impression that the making of folk art essentially stopped at the end of the nineteenth century. But of course it did not. Our goal is to counter this impression by introducing the wealth of folk art traditions actively practiced today by members of ethnic, regional, occupational, and religious communities, right here in Massachusetts.

We have organized the catalogue around the functional roles of traditional art—celebratory, decorative, sacred, domestic, communicative, and occupational—and the context in which traditional art is created and used. We close with a look at apprenticeships, as that is how these artistic traditions are characteristically passed down from one generation to the next. In an apprenticeship, learning takes place directly through observation and imitation of someone steeped in the tradition, rather than through formal classes, books, or other means of institutional instruction. It is the unique relationship that forms between master artist and apprentice that safeguards so many traditional arts.

1.6

Gravemarker, Old Burying Ground, Boston Common. Photograph by Maggie Holtzberg

ART REFLECTS POPULACE

What type of traditional art does one expect to find in Massachusetts and where? The answer lies in who lives here and how long their ancestors have been here. Successive waves of immigration have increasingly diversified Massachusetts. Areas with high concentrations of specific ethnic groups suggest rich centers of traditional arts activity. Various groups of people living in specific locations develop cultural traditions (craft, customs, music, song, stories, dance, pageantry, vernacular architecture, and more) that, over time,

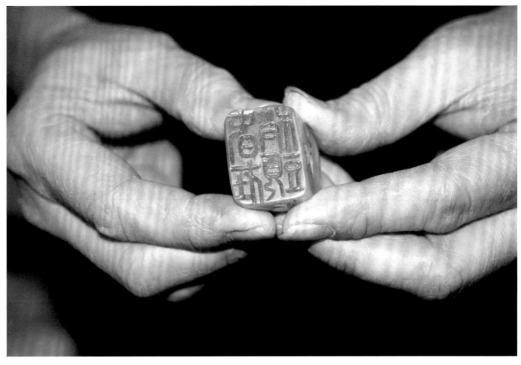

1.7

Chent Chow holding
Chinese seal. Photograph
by Maggie Holtzberg

become associated with a place. Early English immigrants carved gravestones with angels and winged death's heads, and built saltbox houses that looked like those they had left behind in East Anglia, England (cat. 1.6). Italian immigrants terraced the land to raise grapes and peppers in rural areas, and their descendants continue to cultivate urban gardens, make wine, and build temporary altars for display on saints' days. Finns settled near lakes and continued practicing their traditions by building saunas.

Where does one begin looking for traditional art? Imagine narrowing field research to a specific community—the Armenian community of Watertown, for example, or the maritime communities found along the coastal towns of eastern Massachusetts. What to focus on? Folk art scholar Henry Glassie, who has spent a lifetime studying what art is to people in "other" cultures, has observed that in shaping their own styles, all cultures come to emphasize certain media. Spend enough time with people and they will lead you to the "robust centers of culture" where certain material forms or performances are imbued with beauty and power.[9] Fieldwork in the Polish and Ukrainian communities of the Connecticut River Valley undoubtedly leads to individuals who have mastered the art of *pysanki* (egg decorating) and *wycinanki* (cut paper). Frequent Boston's Irish American neighborhoods and you will discover that creative genius thrives in the rhythmic drive and melodic variation of reels and jigs played at local pubs and dance halls. Within the Chinese community of Greater Boston, you quickly discern a deep appreciation for antiquity, which takes phys-

1.8

Hmong needlework on skirt by Seua Moua. Photograph by Kate Kruckemeyer

ical form in the graceful practice of calligraphy and the miniaturist art of seal carving (cat. 1.7). In parts of Springfield and Boston, one discovers that communities originally from the West Indies islands of Haiti, Trinidad, and Tobago spend months each year making *mas*, perfecting oversized sequined and feathered costumes for the annual Caribbean carnival. Polish *pysanki*, Irish reels, Chinese seals, and Caribbean carnival costumes are "robust centers of culture" that attract some of each culture's most gifted individuals.

Our selection has been guided by who the people of Massachusetts are and what artistic expressions they value, not by what is "distinctly Massachusetts" about their art. The distinction reminds me of a conversation I had with a friend. When I mentioned that we had just interviewed two Hmong embroiderers, he responded, "Every time I hear you say something like that my first thought is, what does that have to do with Massachusetts folk art? Just because they live here now—it takes time for something to become part of 'our culture.' A few Hmong, the Russian iconographer—their work hasn't had time to be influenced enough to become something distinctly Massachusetts." In historical and geographic terms, a Massachusetts folk art would be something like stonewall building, which is English or Yankee. But what happens when traditions are transplanted (cat. 1.8)? When Seua Moua makes a traditional blue Hmong embroidered skirt in Springfield, she is still perpetuating a Hmong tradition, but it is being preserved (or endangered) in a foreign place. It is not a "Massachusetts tradition" per se but rather a traditional art with deep roots that has been transplanted and is now practiced in Massachusetts. Three generations later, perhaps it will be recognized as a Massachusetts tradition. It depends on how many Hmong settle here and how many of those settlers hold on to this particular tradition. Something becomes traditionalized by being used and associated with a particular place or cultural group; it endures over time.

Many find it surprising that the state folklorist would focus attention on traditions that originate elsewhere. Yet all traditions come from somewhere else, and change has always been a vital part of any tradition. Change in locale influences the availability of raw materials. Change in technology influences methods of production. Change in your neighbors influences who will understand your choice of color and symbolism. Change in the availability of less expensive alternatives (for example, plastic pitchers and imported mass-

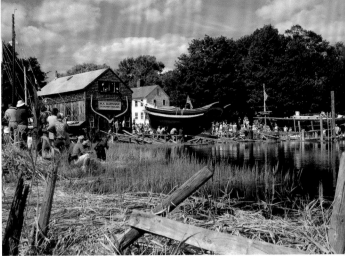

1.9 (left)
Trunnel-fastened frames and planking on schooner Isabella.
Photograph by Maggie Holtzberg

1.10 (right)
Launch of the schooner Isabella, *2006. Photograph by Maggie Holtzberg*

produced baskets) influences the use of the handmade objects (redware pottery and woven baskets). What was once made and used primarily for practical purposes (a Nantucket lightship basket to collect potatoes) is now produced for collectors and tourist markets—and because the creation of it continues to please its maker.

In a world with increasing standardization, where the makers of things (objects, music, and food) are increasingly distanced from the users of things, the appeal of direct connection is powerful. An imported bed comforter from a discount department store is useful, but it does not quicken the pulse like a hand-pieced quilt depicting Lowell textile mills, made with scraps of fabric by a woman who gathered remnants from those very same mills. A fiberglass yacht is sleek, seaworthy, and efficient but it does not satisfy the soul the way a timber-framed, trunnel-fastened, wooden schooner does (cat. 1.9). We delight in the hand-wrought object, built using techniques that date back to biblical times. Why else would a crowd of nearly 3,000 turn out for the side-launch of a vessel built on the banks of the Essex River where, for eleven generations, members of the same family have built and launched wooden ships (cat. 1.10)?

In his introduction to *The Encyclopedia of New England*, poet Donald Hall makes the point that in any New England town, family names recall migrations. French Canadians came to chop wood and work in textile mills, Cape Verdeans to hunt whales and later work cranberry bogs, Irish to escape the famine, Poles to farm the Connecticut River Valley, Italians and Finns to quarry granite, Portuguese to fish. Indeed, the nineteenth century saw successive waves of immigration that made New England the most multi-ethnic region

Figure 2

Timeline
*Highlights of
Massachusetts
Immigration History.
Created by Suhyung
Kim with Stephen
Matchak*

TIMELINE: HIGHLIGHTS OF MASSACHUSETTS IMMIGRATION HISTORY

Pre-1600s

Native Americans: The Nauset in Cape Cod; the Wampanoag in the southeast; the Massachusetts in the northeast; the Nipmuc in the central hills; and the Pocumtuc in the west

History records John Cabot as the first European who wrote about the 1497 voyage to New England

Fishermen from England, France, Portugal, and Spain

1600s

1620 – English Pilgrims land at Plymouth Rock near an abandoned Wampanoag village

1630s to 1640s – "Great Migration" of Puritans to Massachusetts Bay

Mid-1640s to 1790 – African population increases because of slavery trade

1700s

Population begins to soar mainly because of Scotch-Irish immigration into English-dominant New England after a failed Irish uprising in the 1790s

1790 – First federal census taken

1800s

1815 – Great wave of immigration, notably from England

1810s to 1850s – Settlements of immigrants in major cities because of American industrialization: Waltham in the 1810s, Lowell in the 1820s, and Lawrence in the 1830s (textiles); Springfield and Watertown (metal working); Lynn in the 1840s (shoes and leather goods); New Bedford in the 1840s (whale products and shipbuilding)

1847 – Irish immigration influx because of the Great Famine

1850 – Federal census taken, ethnic origin of population counted; the Irish make up 43 percent of the 16.5 percent foreign-born in Massachusetts

1860 – Foreign-born population occupies 21.1 percent statewide and 35.9 percent in Boston; 1860 to 1870 – French-Canadians arrive through the early 1870s; 1880 to 1890s – Mass migration of eastern and southern Europeans begins in the late 1880s; Jewish immigration begins because of anti-Semitism in Russia and Poland

1900s

Immigrant population diversifies to include Greeks, Portuguese, Lithuanians, Poles, Belgians, Armenians, Turks, and Syrians, as well as Finns, Azoreans, Cape Verdeans, and Scandinavians

1900 to 1910 – More than 8 million immigrants enter the United States

1915 – Armenian immigration to Watertown (shoe factories) skyrockets because of Armenian genocide in 1915

1920s–1930s – Foreign-born population makes up almost one quarter of state population and one third of Boston population, then begins to decrease because of the exclusionary laws of 1926 and the Great Depression that begins in the late 1920s

1970 – Vietnamese refugees arrive because of the Vietnam War in 1975. Vietnamese now occupy 1 percent of the population of Springfield

1975 – Cambodian immigration to Lowell begins to rise in 1975. Lowell now boasts the second-largest Cambodian population in the United States

1979 – Iranian immigration begins after the 1979 revolution in Iran

1989 – Immigrants from Eastern Europe arrive because of the collapse of communism

South Asian migration increases because of educational opportunities in New England

1990 – Changes in immigration laws encourage some migration. Immigration population rises to 9.5 percent, from 8.7 percent in 1980

2000–2005

Immigration population rises to 15.4 percent. Influx of Brazilians and other immigrants from Latin America. Marked increase of immigrants from Africa, Asia, and the Caribbean; Europeans are the only immigrant group that decreases in population

in the United States at the time. The Commonwealth has long been an important port of call for immigrants. In addition to providing jobs, the state has a long history of providing refuge for those seeking religious and political freedom. Our communities reflect the diversity that resulted from nearly four hundred years of immigration history (fig. 2). Yet, most continue to view New England as homogeneously white with Yankee sensibilities. The extent of diversity remained largely invisible until the 1980s and 1990s, when immigration to Massachusetts changed to become primarily non-white and non-European.[10]

The figure on the following page is a snapshot of the top twenty ethnicities living in the state's twenty most populated cities in the year 2000 (fig. 3).

One of the realities of folklore fieldwork at a public agency is the constraint of small budgets and limited time. Unlike field research in academe, our fieldwork is done in the service of tangible programs and services (for example, Artist Grants, Traditional Arts Apprenticeships, and increasing the recognition of and work opportunities for traditional artists). With a mandate to cover the entire state, we can often do little more than identify tradition bearers and try to support them in significant ways. We document a lightship basket maker on Nantucket, aware that half a dozen other basket makers on the island merit investigation. Yet, finding the time and resources for comparative research is impractical. We are, by necessity, generalists. We sample the field and, by serving a few, raise visibility for many. If you find yourself wondering why a certain ethnic, musical, craft, or dance tradition is not included here, remember that folklore fieldwork is an ongoing process of discovery and that the work continues. Tell us what we are missing. Join us in the quest. After all, documenting folk art tradition is gratifying work and has the potential to enrich the lives of all involved.

NOTES

1. Boston's Caribbean Carnival, which celebrates its thirty-fifth year in 2008, is similar to carnival festivals in other cities of the West Indian diaspora, such the one held on Labor Day in Brooklyn and on Columbus Day in Miami, and the *Carifiesta* held in early July in Montreal.

2. The Canadian Maritime Provinces include Nova Scotia, New Brunswick, and Prince Edward Island.

3. Political and economic difficulties in the early 1990s prompted a reduction in the MCC's budget from $27 million to $3.5 million within four years; as a result, many discipline-specific programs were eliminated, including the Folklife and Ethnic Arts Program.

4. In the 1960s the field of folklore scholarship underwent a major shift. Prior to the 1960s it was customary to collect, categorize, and analyze items without their cultural context or use. Having previously recorded ballad texts (without tunes), we now document the ballad singer in his or her community.

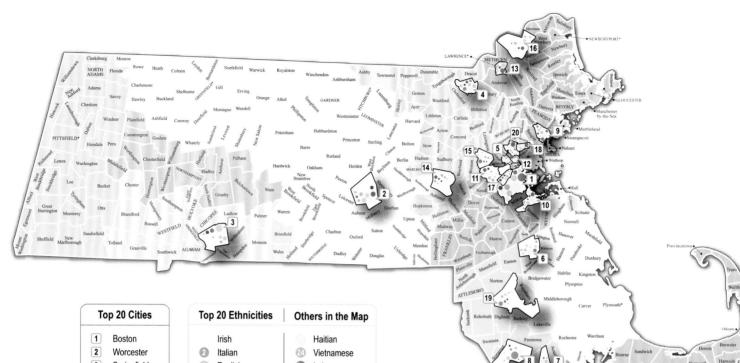

Top 20 Cities

1	Boston
2	Worcester
3	Springfield
4	Lowell
5	Cambridge
6	Brockton
7	New Bedford
8	Fall River
9	Lynn
10	Quincy
11	Newton
12	Somerville
13	Lawrence
14	Framingham
15	Waltham
16	Haverhill
17	Brookline
18	Malden
19	Taunton
20	Medford

Top 20 Ethnicities

	Irish
2	Italian
3	English
4	French
5	German
6	Polish
	French-Canadian
8	Portuguese
9	Puerto Rican
10	Scottish
11	Swedish
12	Russian
13	Scotch-Irish
	Chinese
15	Greek
16	Canadian
17	Lithuanian
18	Dominican
	Cape Verdean
20	Asian Indian

Others in the Map

	Haitian
24	Vietnamese
25	Lebanese
26	Brazilian
33	Cambodian
34	Jamaican
42	Japanese

Figure 3

Map of Massachusetts

Settlement Pattern of Top Twenty Ethnicities
in 2000. Created by Suhyung Kim

5. Excerpted from Traditional Arts Apprenticeship Final Report, January 2, 2003.

6. Personal communication with the author, January 2002.

7. For an understanding of the definitional wars surrounding the term "folk art," see Kenneth L. Ames, *Beyond Necessity: Art in the Folk Tradition* (Winterthur, Del., 1977); Ian M. T. Quimby and Scott T. Swank, eds., *Perspectives on American Folk Art* (New York, 1980); and Henry Glassie, *The Spirit of Folk Art: The Girard Collection at the Museum of International Folk Art* [exh. cat., Museum of New Mexico, Santa Fe] (New York, 1989).

8. A notable exception is the work of Bertram K. and Nina Fletcher Little, who spent more than sixty years collecting and writing about New England folk art and decorative crafts. What made them unusual was that they paid equal attention to the aesthetic qualities of an object and to its use in everyday life, researching who made it, when, and where, as well as how it was used and by whom. Their collection can be seen at the couple's one-time summer retreat called Cogswell-Grant, in Essex, Massachusetts.

9. Glassie 1989, 36.

10. Marilyn Halter, "Ethnic and Racial Identity," in *Encyclopedia of New England* (New Haven, 2005). Halter poses the idea that in New England "ethnic" is perceived as related to European immigrants. Other populations, for example Chinese, Native Americans, and Africans, are perceived in racial terms. "The peculiar idea persists in both the region and the nation as a whole that if your race is white, you are defined by an ethnicity—whether Irish, French, Canadian, or Italian—but if you are black or mixed, you are defined by skin color alone" (326).

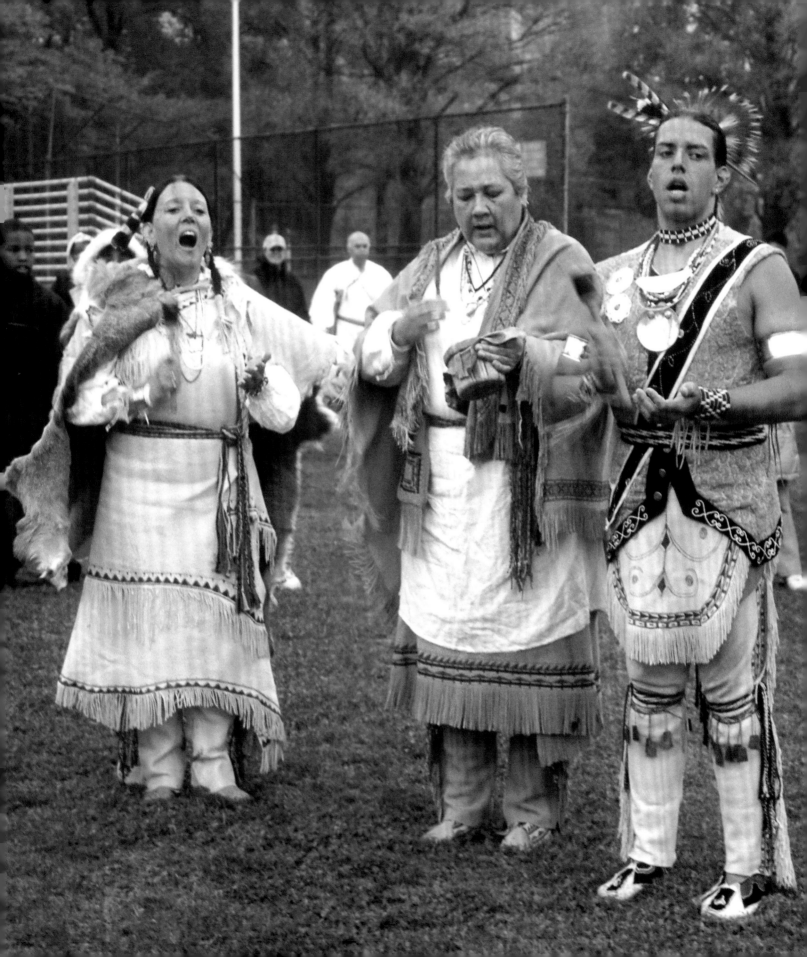

Celebrations

CULTURAL PRIDE ON DISPLAY

Native Americans on Cape Cod and Martha's Vineyard don deerskin leggings for seasonal pow wows (cat. 2.1). Members of Boston's Caribbean community strut in oversized sequined armatures of brilliant colors, playing *mas* at carnival each summer. Step dancers regularly compete at Irish dance competitions and festivals known as *feis* wearing costumes elaborately sewn with Celtic motifs. Annual Portuguese and Italian feast-day processionals wind their way through urban streets in veneration of saints. Circle dances, parades, competitions, and processionals are all gatherings of people in a public ritual, performing ethnicity, so to speak. Cultural pride is on display. Some annual celebrations are spiritual in nature, such as a saint's day procession through the streets or carnival heralding the beginning of Lent. These gatherings allow religious devotion to be expressed communally. Others gatherings are secular. They celebrate the agricultural harvest, for example the Cranberry Festival in southeastern Massachusetts, or a calendar event, such as the Southeast Asian Water Festival in Lowell. Chinese New Year, which is based on the lunar calendar, is celebrated each year in Boston's Chinatown. Parades are punctuated by dragon dances, lion dancers, and firecrackers. The festivities mark a time of personal reflection and spiritual cleansing, and they serve as a mass invocation of good luck for the coming year (cat. 2.2).

Some celebrations are equally expressive of ethnic pride *and* religious devotion. In the close-knit Italian neighborhood of Nonantum, known as "the Lake," fire hydrants and lane dividers on public streets get special attention each July. Faded stripes of green, white, and red are revived with fresh coats of paint in anticipation of the Saint Mary of Carmen Fiesta. This annual festival is run by the Society of Maria S.S. del Carmine, an all-male organization that was established by Italian Americans in 1935 as a means to support recent Italian immigrants. Continuing to celebrate Saint Mary's feast day, a tradition of their native homeland, was very important to this community, and money was raised to import a large statue of the Virgin Mary. The festival, which is now in its seventy-third year, culminates with a procession in which the saint is paraded through the local streets. Charles "Buddy" Cerone, a member of the Society and a cabinetmaker and carpenter, describes the event, "It's a five-day festival. Sunday, after Mass, we take the statue out of the church and we put it on a carriage. We don't carry it; it's too heavy, although it has been done. We put it on a carriage and we start from the church and go through the entire neighborhood of Nonantum, through all the streets. It takes about three hours. We present [the statue]

2.1 (opposite)
Aquinnah Wampanoags in regalia at celebration of ancient fish weir on Boston Common, 2005. Photograph by Maggie Holtzberg

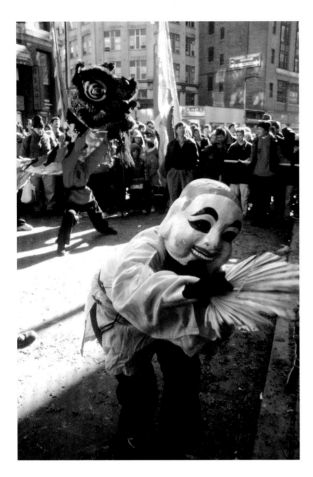

2.2

Clown and lion dancer,
Chinese New Year's
Celebration, Boston, 2001.
Photograph by Lian Jue

pretty much like they do in the North End and other festivals" (cat. 2.3).[1]

As the procession moves through the streets, the rolling carriage is stopped to allow participants to pin money on the calendars [ribbons] that stream from the statue. This public act of devotion honoring the Madonna is preceded by five days of secular festivities in Pelligrini Park (Hawthorne Park)—with amusement rides, carnival games and prizes, musical acts, and deep-fried foods. The festival has drawn young and old, Italians and non-Italians for generations. DePasquale's sausage shop, a local family business, is a perennial food vendor. In the midst of this carnival atmosphere is a religious site—a tall, narrow, temporary chapel sits adjacent to the bandstand. As Cerone described, the large statue of the Madonna is placed inside after her procession through the streets (cat. 2.4). Before her arrival on Sunday, as if holding her place, a three-foot-tall, hand-carved replica is on display: the miniature that Cerone was inspired to make in 1999. Her role in the festival has become a tradition in its own right (cat. 2.5).

"After Mass on Sunday morning, I'll send my sons down to pick up the statue and bring it home. Then we set it up at the front of my house, so it's there when we come down the street with the procession. When we finish the procession, which normally takes us around three and a half hours (a one-mile route), we wind up going down to Hawthorne Park. We back [the large statue] into the chapel. At 10:00 o'clock at night we take it out of the chapel and proceed back to the church, down Adams Street, with a candlelight procession and fireworks. Then we bring the statue back into the church and we have a benediction."

The benediction marks the end of the festival. The Madonna is put back in storage in the basement of Our Lady's.[2] Cerone stores his "little statue" in the attic of his home on Chapel Street. One of a kind, the carving is a material expression of his religious devotion and pride in his Italian heritage (cat. 2.6). Look closely and you can see the grooved channels carved by Cerone's chisel. And those small faces? "They're the angels. This is baby Jesus with the crown and these are the angels. Three, five, six, seven, eight, nine."

As Cerone mentioned, the streets of Boston's North End Italian neighborhood come alive each summer on successive weekends. Processions honoring various saints wind their way through the tight, narrow streets. Saint Anthony's Feast is celebrated at the end of the summer (cat. 2.7). This photograph was taken just as confetti was thrown and fireworks and noisemakers filled the air at the Eightieth Anniversary Saint Anthony's Feast. The

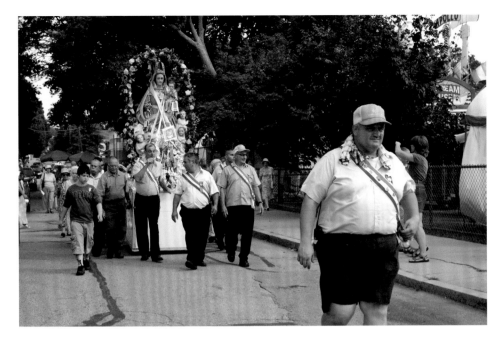

2.3

Procession of Saint Mary of Carmen, Newton, 2007. Photograph by Maggie Holtzberg

2.4 (bottom left)
Large statue being backed into temporary chapel. Photograph by Maggie Holtzberg

2.5 (bottom right)
Charles Cerone (right) shaking hands with Daniel "Echo" Visco inside temporary chapel. Photograph by Maggie Holtzberg

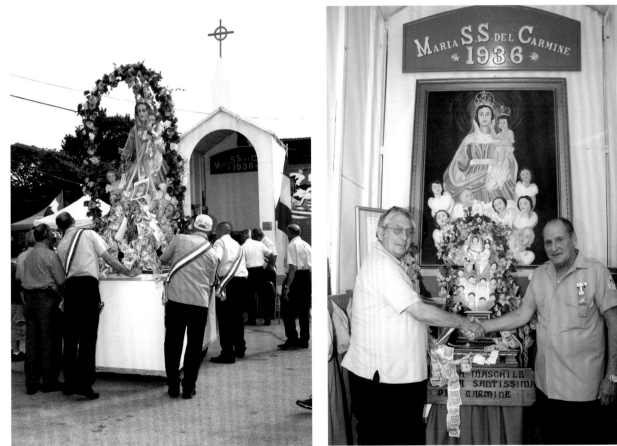

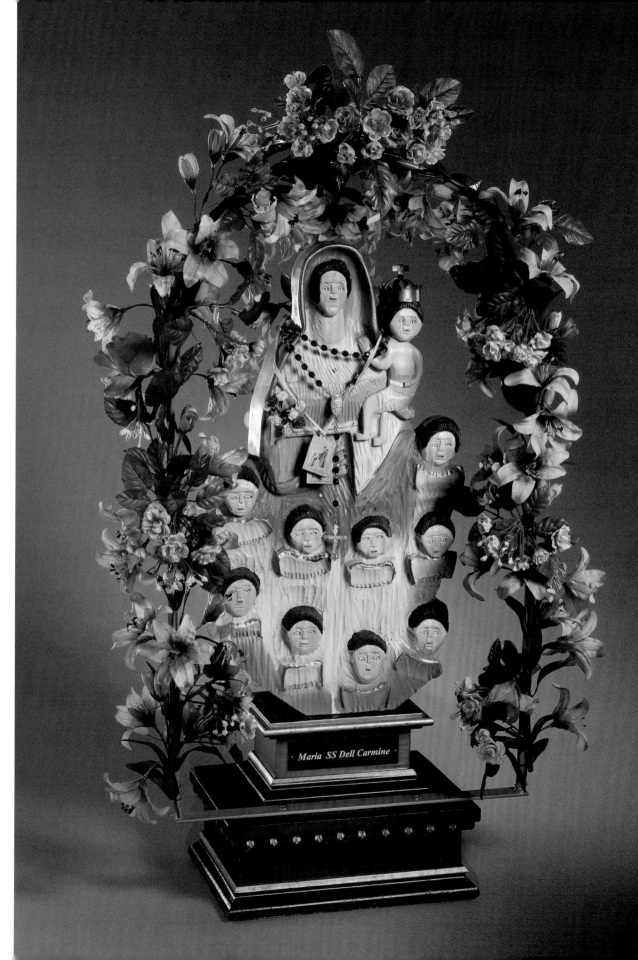

2.6

*Little Statue,
Italian American
wood carving by
Charles Cerone,
1999, basswood,
paint, iron,
artificial flowers,
wood carving,
36 x 22 x 13 1/2
(statue); 37 x
22 x 22 (base).
Collection of the
artist*

Maria SS Dell Carmine

streets were packed with local residents, those who returned to the neighborhood, having moved to the suburbs, and tourists. The statue of Saint Anthony, one of the most revered and holy saints in Catholicism, was being blessed before being carried to a temporary chapel by about twenty men. The Roma Band led the procession, playing a slow waltz as the procession moved down Endicott Street.

The annual Fishing Procession of Our Lady of Good Voyage (cat. 2.8) takes place in late September in the seaport town of New Bedford. The feast praises Our Lady as the patroness of fishermen and all mariners. Historically, the feast commemorates the apparition of Our Lady to three fishermen, all named "John," off the coast of Cuba in the year 1600. In danger of shipwreck during a sudden violent storm, they called upon Our Lady to save them. A replica of this miraculously appearing image is venerated here in New Bedford at Our Lady's Chapel and is the focal point of the annual feast.

In 2003 the organizers of the Fishing Procession were willing to alter their schedule slightly to accommodate New Bedford's Working Waterfront Festival.[3] Starting at Our Lady's Chapel in downtown New Bedford and accompanied by a Portuguese Brass band, the procession made its way to the waterfront for an afternoon service where blessings were asked for all who make their living on the sea, and for the repose of the souls of all deceased mariners.

Angel Sánchez Ortiz (cat. 2.9) is a master artist in the Puerto Rican tradition of *vejigante* mask-making—the colorful spiky papier-mâché *mascara* worn during carnival.[4] His striking, fantastical masks of boldly painted papier-mâché depict animals, legendary people, and sometimes spirits and monsters that are imbued with cultural meaning. Forms and imagery come from the blend of African, Spanish, and native Táino cultures that is expressed in Puerto Rican carnival celebrations. Ortiz grew up experiencing the traditional carnival festivities held every February. During this time, family and friends were immersed in the celebration that heralds the beginning of Lent.

Born and raised in the Calle Cuatro neighborhood of Ponce, Puerto Rico, Ortiz excelled

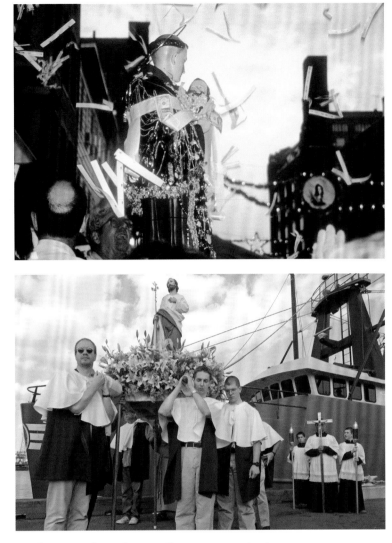

2.7 (top)

Saint Anthony's Feast, Boston's North End, 1999. Photograph by Maggie Holtzberg

2.8 (bottom)

Our Lady of Good Voyage Procession, New Bedford, 2005. Photograph by John Robson

25

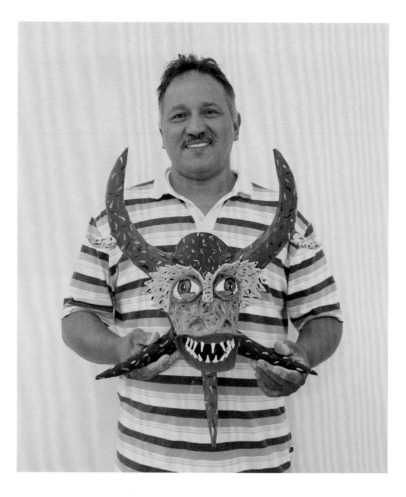

at artistic pursuits as a child but was particularly drawn to the tradition of making papier-mâché masks for carnival (cat. 2.10). He learned the craft "in the streets" of Ponce, watching elder artisans and older boys prepare for the carnival season. While many youth in Ponce demonstrated keen interest in making *una mascara* (a mask) during the excitement that even today takes hold of the city each year, Ortiz's interest persisted long after the annual celebrations ended. As a young man, he became well known for his artistry, and each year he played the role of *vejigante* at the carnivals in Ponce and neighboring towns, wearing his intricately designed and boldly colored *mascaras* (cat. 2.11). The name *vejigante* comes from the Spanish word for bladder, *vejiga*. The *vejigante* inflates a dried cow's bladder and paints it to resemble a balloon. As you can see from Ortiz's figure, the *vejigante*'s costume is a cape with bat wings under the arms. During the carnival celebrations in Loíza Aldea and Ponce, the *vejigantes* roam the streets in groups and chase children with their *vejigas*.

The masks and the process of their construction have multiple layers of meaning for their makers. The joy that the *vejigante* provided to the people, a joy that included both the thrill of watching the playful tricksters teasing the crowd and cultural pride in the artistic

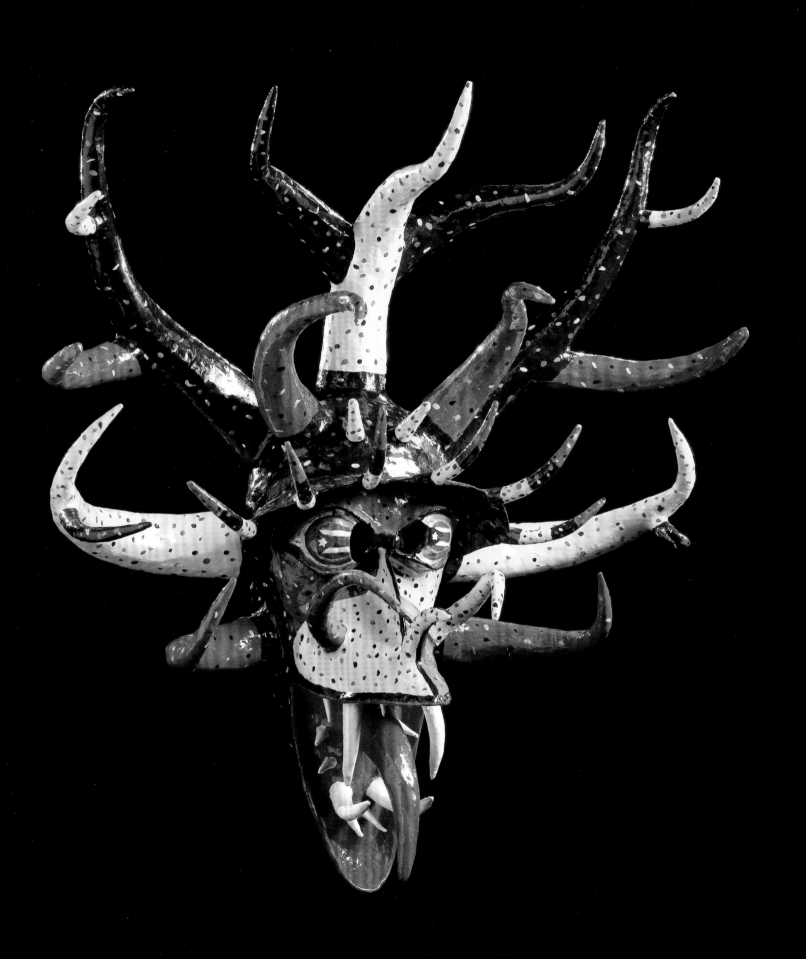

2.11

Vejigante en Estile de Ponce *(vejigante in the style of Ponce), Puerto Rican carnival mask by Angel Sánchez Ortiz, 2005, papier-mâché, rock, 13 1/8 x 8 1/4 x 8 (assembled). Lent by the Massachusetts Cultural Council*

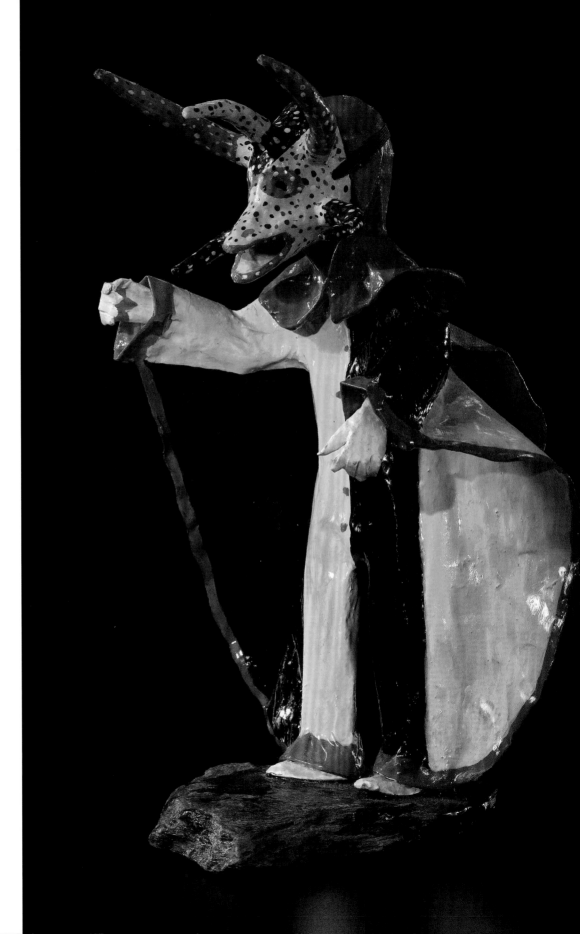

representation of beloved mythical figures, spoke to Ortiz. Over time, he also found that the construction of the masks, and in particular the use of paper as a material, came to hold deep meaning; the masks and his other paper crafts became symbolic to him of his connection to Puerto Rico in general and Ponce specifically.

Ortiz makes *vejigante* masks in the three major Puerto Rican styles, including the coconut shell mask of *Loiza* and the wire-frame mask of *Hatillo*, but it is of course the papier-mâché mask of his native Ponce that is his specialty. He builds the body of the mask on a form, often a balloon, a basketball, or a plaster form he shapes for this purpose. Decorative elements such as horns, protruding eyes, and articulated jaws, also made from paper, are added to the base form to create the mask's character. It might represent a traditional figure, for example the king of carnival, *El Rey Momo*, or a popular legend such as the *Chupacabras*, or it could spring directly from the artist's imagination. Careful painting in bright acrylic colors further defines the spirit of each mask. In addition to masks, Ortiz makes many other large and small figurines representing the *vejigante* and paints pictures reflecting this and other aspects of Puerto Rican culture.

2.12

Tin men from Local 17, Sheet Metal Workers' International Association, Saint Patrick's Day Parade, Dorchester, 2007. Photograph by Dave McCormack

Ortiz moved permanently to Holyoke in 1988. In his first years in Massachusetts, he worked with a number of youth and community groups to share his knowledge of the *vejigante* tradition. "What I want is to bring the culture *here*, to the United States, so that the kids can ... continue here, so they can talk about it and say here, too, in the United States, [the culture] is the same as in Puerto Rico. Realistically, the *vejigante* was born in Ponce, but in different little towns they keep on celebrating. Here in the United States a lot of children don't know the culture, and [it's] one of my goals that they learn the culture."

Ortiz had great success forming a troupe of young *vejigantes* in late 1995, but he then withdrew from the public eye and continued his work in private. However, community memory of his beautiful masks remained strong, and eventually cultural leaders such as educator Angel Nieto prevailed upon him to resume his work in the community. The support of Ortiz's wife, Zulma Cabral, a maker of traditional dolls and a practiced *vejigante* dancer, was also instrumental in his reemergence as a leading artisan in the Puerto Rican community in western Massachusetts. In the past few years, Ortiz has exhibited his work at Caribbean Nights in Holyoke, the Worcester Art Museum, the Augusta Savage Gallery at the University of Massachusetts, Holyoke Community College, and the Lowell Folk Festival. He has taught young people and educators the skill of mask-making through local agencies and schools, and once again he is also playing the role of *vejigante* at Puerto Rican festivals and parades in western Massachusetts.

The day after the 2006 Saint Patrick's Day Parade in Dorchester, a photograph in the *Boston Globe* showed two men dressed up as tin men (cat. 2.12) handing out lollipops. The

2.13

*Tin Men,
occupational
tradition,
fabricated by
retired sheet-metal
workers from Local
17, William Walsh,
Glenn Walker,
Dan Hardy, and
Richard "Dick"
Clarke, 2007,
copper, galvanized
iron, stainless
steel, 63 3/4 x
28 3/4 x 17 each.
Lent by the Sheet
Metal Workers'
International
Association, Local
Union 17*

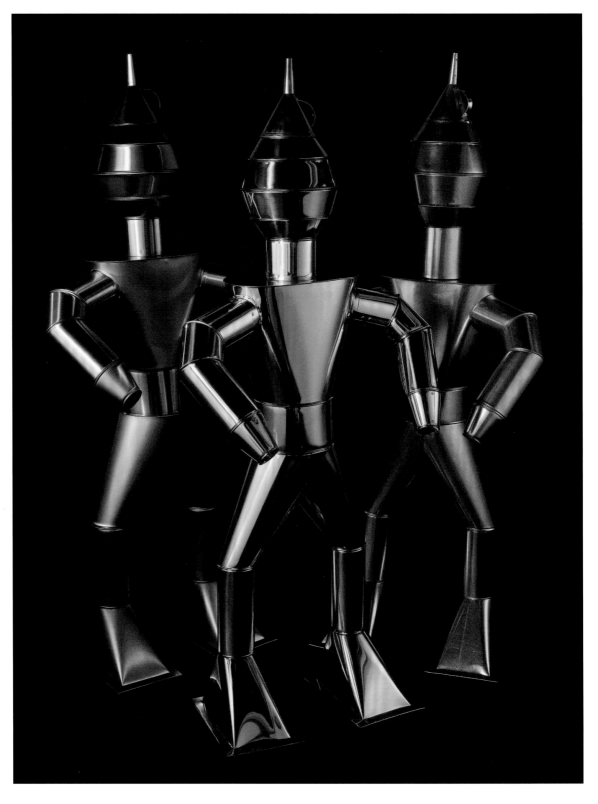

caption identified them as members of Local 17 of the Sheet Metal Workers International Association, located in Dorchester. Figurative sculptures known as tin men were made by sheet metal workers long before the tin woodman in the *Wizard of Oz* appeared on screen. Metalsmithing is an ancient trade. For centuries, tin men have been used as trade signs advertising a metal-smith's shop or wares.[5] Including tin men in the annual Saint Patrick's Day parade is not only a way for Local 17 of helping out the community and celebrating union pride, it is also a powerful recruitment tool for apprentices. The making of tin men is a skill traditionally taught in apprenticeship classes. The skills required in making a tin man include all those necessary to become a journeyman: layout, scribing, cutting, folding, rolling, bending, riveting, soldering, and filing. A tin man is emblematic of trade skill, calling attention to the craftsmanship required in fabricating metal products (cat. 2.13).

As retired sheet-metal worker Billy Walsh put it, "I think the role of the tin men is to show that we can fabricate a flat metal sheet into something that looks like the human body." Pointing to a tin man he has been working on, Walsh notes, "That was just flat metal. By laying it out and fabricating it, shaping it, we made it into something. We are the only trade that takes a flat metal stock from the mill and rolls it, forms it, and fabricates it. Every other trade buys . . . from a warehouse."[6]

Four retired sheet-metal workers spent more than fifty hours each fabricating the tin men seen here. We had only asked for one figure, but they chose to make three, eager to demonstrate their ability in working with three different types of metal: 16 ounce copper, galvanized steel, and stainless steel.

Clearly, creating objects with aesthetic appeal is something that sheet-metal workers enjoy. Labor lore scholar Archie Green points out that much of sheet-metal work is hidden above ceilings. He suggests that making tin men and decorative objects may be a compensatory effort to achieve visibility. The objects serve as an outlet for creativity and affirmation of membership in a highly skilled trade (cat. 2.14).[7] Apprentice and Training Program instructor Ronnie McGann fabricated this larger lighthouse, working hard to replicate stone work. The smaller lighthouse was made by Richard "Dick" Clarke, who also has made woven baskets of brass and copper strips. "My wife said I better stop making these because the house is getting too full."

When apprentices are shown projects like these, their eyes light up. But you won't see apprentices actually making these decorative pieces. Clarke comments, "I don't think they get into this here. More so the ventilation duct work, maybe some cornice work, but nothing fancy like this. This all comes after quite a while." McGann laments the changes, "Unfortunately, there is just not enough opportunity to [learn] these skills that were done in the past because of automation and technology. I do sense that the trade is dying, as far as this end of the business. [Many] skills will go by the wayside." Clarke conferred, "There's not too many skilled layout men anymore that could lay out a lot of this stuff. [It takes] a lot of skill. . . . The machines all do it now."

2.14

*Lighthouse (left),
occupational
craft by Richard
"Dick" Clarke,
2006, 10 1/2 x 7 1/4
x 6 1/4. Collection
of the artist;
Lighthouse (right),
occupational
craft by Ronnie
McGann, 2007,
copper, brass,
plastic, 19 1/2 x 8 x
9 1/4. Collection of
the artist*

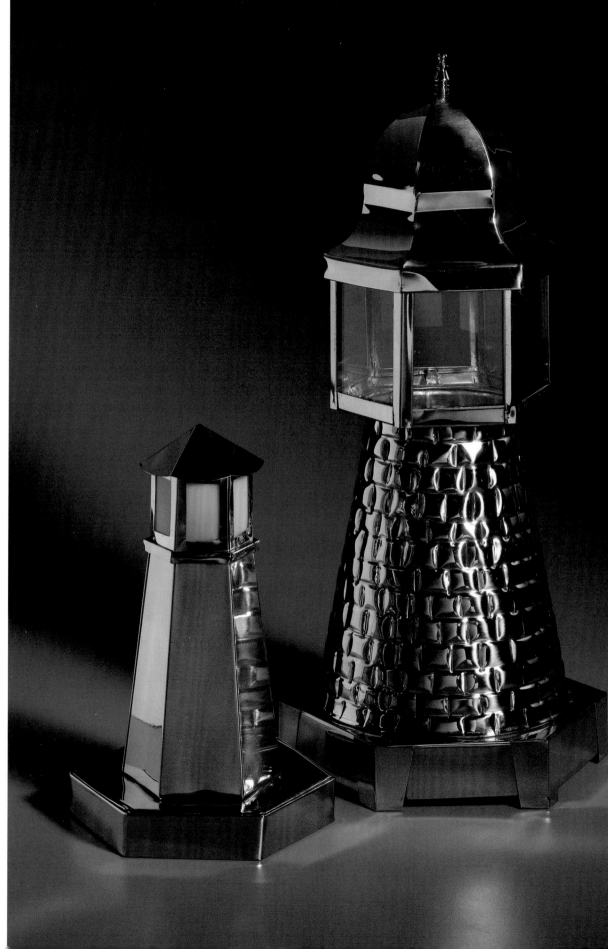

Just a few miles from the Saint Patrick's Day Parade is Boston's Caribbean carnival. Unlike the pre-Lenten carnivals in more temperate climes, Boston's carnival is held at the end of August. Local band leader Errol A. Phillip points out, "There's no way you can have carnival in North America during Mardi Gras. The way we would like to be out there for carnival, the month of February isn't going to cut it in Boston."[8] He goes on to explain the connection to the original Mardi Gras, "Carnival came in when slavery was abolished. You're giving praise for freedom." Though the local event has lost its explicit connection to emancipation, it has not lost its celebratory power.

The organization behind this spectacular event is the Caribbean American Carnival Association of Boston (CACAB). *Mas* bands compete for top prizes (cat. 2.15). The king and queen costumes are the most elaborate, but most striking about all the masquerading revelers' attire are the vibrant color combinations: gold, tangerine, and magenta; silver, lilac, and turquoise; emerald, lime, and white.

A tradition called *J'Ouvert*, roughly translated as the dawning of the day, begins the morning of carnival. People dress up as a way of making political commentary, ridiculing recent scandals or local events. During the 2007 *J'Ouvert*, revelers came dressed as George W. Bush, as devils, and as members of a prison gang. *J'Ouvert* runs from 5:00 until 9:00 a.m. and signals the beginning of carnival, which rolls out midday.

Errol Phillip came to Boston from Trinidad in the late 1970s and has participated in the Boston carnival since shortly thereafter. Like other social clubs in the Caribbean community, the Trinidad and Tobago Social Club provides many cultural opportunities for members, including cricket matches, social events, and competitions in favorite Caribbean games such as dominoes and the card game All-Fours. In 1994 the club expanded from "playing T-shirts" (wearing club T-shirts) to "playing *mas*" (full costume) and quickly gained recognition for its skills. But it is a challenge to stay unbeaten. T&T's theme for 2007 was Caribbean Cocktail. Here you see Tamara Shillingford wearing a queen costume called "Blood Mary" (cat. 2.16).

The first step in putting a carnival band together is to come up with a theme or overall concept for the band and to develop costume illustrations for each section of dancers. Costumes are then sewn, decorated, and fitted to each individual dancer. This entails weeks of welding, sewing, and gluing, applying feathers, sequins, foil papers, and glitters, and investing lots of creativity, energy, and patience. The larger costumes, for the king and queen, are more difficult to design and build. They can weigh more than two hundred pounds and reach over eighteen feet in height. Huge frames are created by bending wire

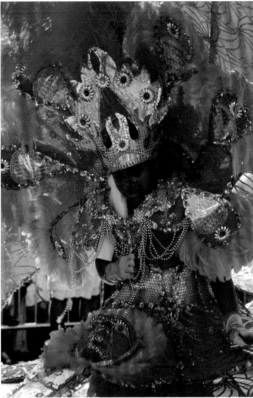

2.15

Deborah Joseph, Individual, Trinidad & Tobago Social Club, Boston Caribbean Carnival, 2003. Photograph by Maggie Holtzberg

33

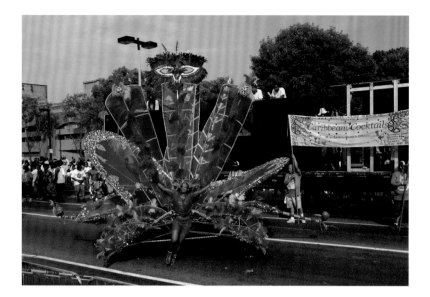

2.16

Tamara Shillingford, Queen wearing "Blood Mary," Trinidad & Tobago Social Club, Boston Caribbean Carnival, 2007. Photograph by Maggie Holtzberg

into the desired shapes. Sometimes wheels are added to ease movement. Physics plays an important role, as the individuals must be able to move and dance across stages and streets without having their costumes fall apart. In the last few weeks before carnival, the largest costumes are made outdoors under a tent—they do not fit through the doors of a building. In Trinidad, children traditionally make *mas* in school as part of their study of history and culture. In Boston, this happens in *mas* camps. The camp includes both children and adults who spend a few hours each day working, all on a voluntary basis. For bandleaders like Phillip, the labor of love that is *mas* camp occupies every spare moment; Phillip notes that he, like many in the Caribbean community, schedules vacation time from his profession as an anesthesiologist technician for the critical weeks of carnival preparations. Errol and his wife Ann Marie both work in the allied health field. "I have a hard time with my wife every year. She met me in this field. But as far as she is concerned, I don't work; I play *mas.*"[9]

New themes and costumes are created every year, and most participants discard their costumes after carnival. Errol was pleased to save one for use in the exhibition. Considering the cost of constructing costumes ($4,000 to $5,000 for king and queen), a place to store costumes and separate them into parts that could be creatively reassembled for future themes would greatly benefit bandleaders.

The northern Pioneer Valley is home to a substantial population of descendants of Polish and Ukrainian immigrants. Community attachment to that heritage is strong, as evidenced by the continuing vibrancy of Polish and Ukrainian Catholic parishes and the crowds that flock to church fairs and cultural celebrations. Among the most cherished cultural expressions in this community is the tradition of decorated eggs, known in Polish and Russian as *pisanki* and in Ukrainian as *pysanki.*[10] In pre-Christian Eastern Europe, the egg symbolized the source of life; decorated eggs heralded a good harvest and were used as tal-

ismans to ward off evil spirits. Catholicism incorporated the cultural reverence for *pysanki* by associating the decorated egg with the rebirth of Christ and the season of Easter. While many of Eastern European heritage (and Americans generally) continue to decorate eggs at Easter time, Carol Kostecki of Montague Center works year-round creating spectacularly detailed designs on spheres, which range from quail and miniature chicken eggs gathered for her by a local farmer to huge, imported ostrich eggs (cat. 2.17).

Kostecki, who was born and raised in nearby Greenfield, is of French-Canadian, German, and Abenaki descent. Her husband William's heritage is Polish, and with him she became a communicant at the Polish parish of Our Lady of Czestochowa in nearby Turners Falls. When the couple took a class together on *pysanki*-writing (drawing) from the former priest at the Ukrainian parish in the vicinity in the early 1990s, Carol became "hooked." She began to make *pysanki* at Easter and to sell them at her church's tag sales; the excitement of those who bought her pieces added to her own enjoyment of the process, and she soon started to work year-round in the evenings and between clients at her beauty shop. The priest who was her initial teacher soon left the area, so Kostecki continued her study of *pysanki* on her own by reading books and through trial and error. Over the next decade and a half, during which time she retired, she became known throughout the Pioneer Valley for her lovely eggs, and she has been sought out to teach courses in a number of venues, including the Descent of the Holy Spirit Ukrainian Church where she first watched *psyanki* being made. When we interviewed her in 2001 for the Folk Arts and Heritage Program, she told us she wished she knew of other *pysanki*-writers in the region, particularly expert artists who could help her hone her craft. In 2005 we were able to connect her to a master artist in Connecticut known to that state's folklorist, Lynne Williamson. Over the next two years, Kostecki undertook an apprenticeship with this master artist, Father Paul Luniw of Saint Michael's Ukrainian Catholic Church in Terryville, Connecticut, through the regional Southern New England Folk and Traditional Arts Apprenticeship Program. For Kostecki, the opportunity to study with Father Luniw was invaluable; she points out that the priest, a student of the form since he was five years old, was able to teach her "things you don't read in books," such as advanced techniques for controlling color variation and creating the most intricate designs (cat. 2.18).

While there are many styles of egg decoration in Eastern Europe, *pysanki* are typically made through a wax resist process. A simple egg might take an hour to decorate, and the most ornate ostrich egg represents months of work. Designs are drawn—or, as the artists would describe it, *written*—on an egg with wax, and then the egg is dyed. Kostecki uses a stylus called a *kistka* to create the wax outlines on her eggs; additional coats of wax and dye are applied until the art is complete. The designs on her *pysanki* include imagery and color symbolism reflecting Catholic belief as well as pre-Christian Ukrainian and Polish culture. Kostecki has also created *pysanki* patterns of her own, among them some that feature such symbols as deer and fish from her own Abenaki tradition.

2.17
Pysanki
(Ukrainian),
decorated egg by
Carol Kostecki,
2006, chicken
egg in resist-dye
technique,
2 1/4 x 1 1/2 diam.
Collection of the
artist

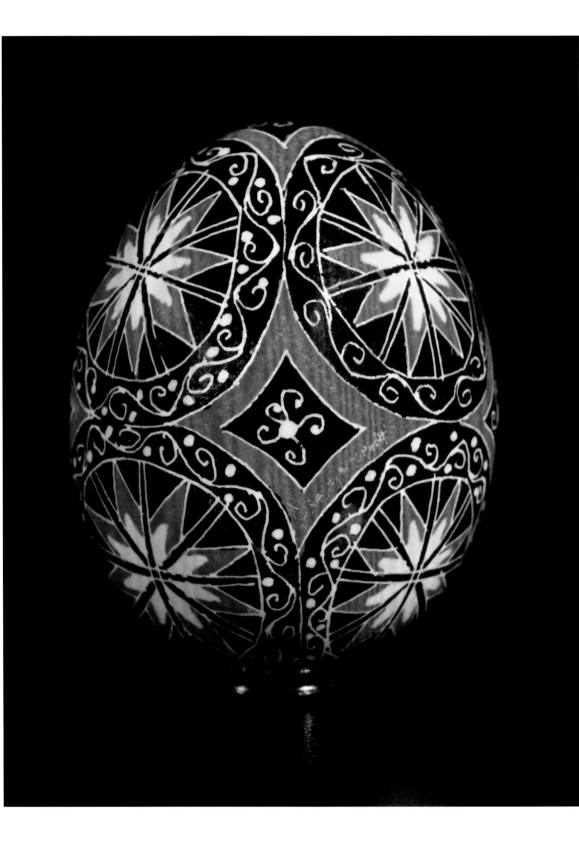

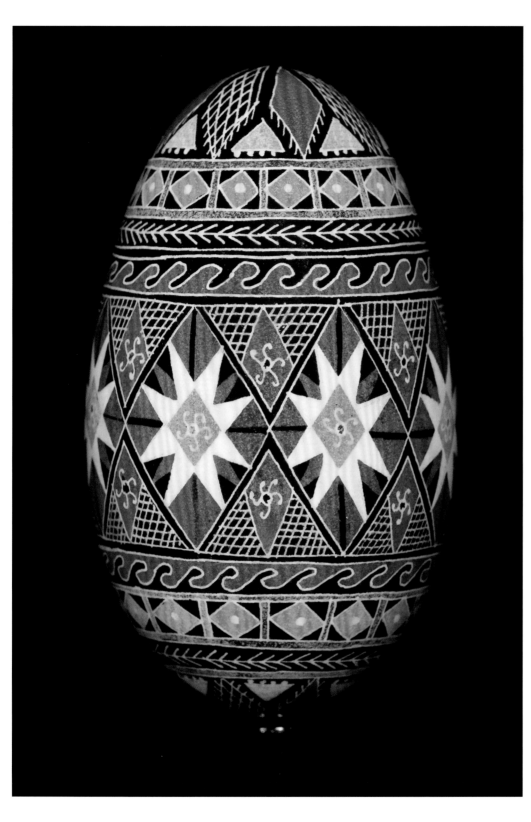

2.18

*Pysanki (Ukrainian),
decorated egg by Carol
Kostecki, 2006, goose egg
in resist-dye technique,
3 7/8 x 2 1/4 diam.
Collection of the artist*

Because of the cultural meaning of *pysanki*, Kostecki keeps the prices for her art low as a service to the community; her "egg money," as she jokingly calls it, covers supplies but rarely the time she lavishes on her creations. For her, the preservation and the sharing of culture, whether of her own heritage or the community she married into, are the true rewards.

Around the same time that Christians celebrate Easter, Jews celebrate Passover, which commemorates the Jewish liberation from Egyptian slavery. The Passover celebration revolves around a traditional ceremonial dinner known as the seder. Participants take turns reciting from the *Haggadah*, a text retelling the Israelites' exodus from Egypt. The seder is rich in symbolism derived from the stories that are told, the blessings that are offered up to God, and the foods that are served. One of these foods is matzo (unleavened bread), which some say represents the haste at which the Israelites left Egypt. A stack of three matzos is placed on a seder plate. It is customary to break off a piece from the middle matzo, wrap it in a napkin or some other type of fabric bag, and hide it in the house. The hidden piece of matzo is known as the *afikoman* and the child who finds it receives a reward. Knowing this keeps children interested and awake during the seder, which tends to be a very long meal.

This *afikoman* bag (cat. 2.19) was made by Lillian Goldberg. She chose a crazy-quilt pattern, with minimal reference to Judaica. Goldberg is a member of the Boston chapter of the Pomegranate Guild of Judaic Needlework, a gathering where women "sit and stitch" at monthly meetings. Founded by women needle artists in the 1970s, the guild promotes a shared interest in Jewish tradition and the desire to create new ceremonial objects for home and synagogue.

Amy Fagin practices the ancient art of manuscript illumination. The ceremonial art of the *ketubah* (marriage contract) originated in early Jewish history as one of the first written legal documents required by Jewish law.[11] The *ketubah* is one of the more predominant forms of Jewish art found in the home. Ornate and personalized, a couple's *ketubah* is hung prominently in the home as a daily reminder of their vows and their responsibilities to each other (cat. 2.20). Historically, the *ketubah* text spelled out the husband's responsibilities—to provide food, clothing, marital relations, and a specific sum of money in case he divorced his spouse or died before her. Some modern *ketubot*, such as the one by Fagin pictured here, reflect a more egalitarian relationship. She was motivated to create a heritage *ketubah* series focusing on the history of Jewish settlements around the world. The one seen here, "Venetian Romance," was inspired by the famous arches of the Piazza San Marco in Venice and other ornamentation found in Jewish Italian synagogue art and architecture. A frieze of stained glass panels reflects images of a flowing stream and a barren desert landscape.

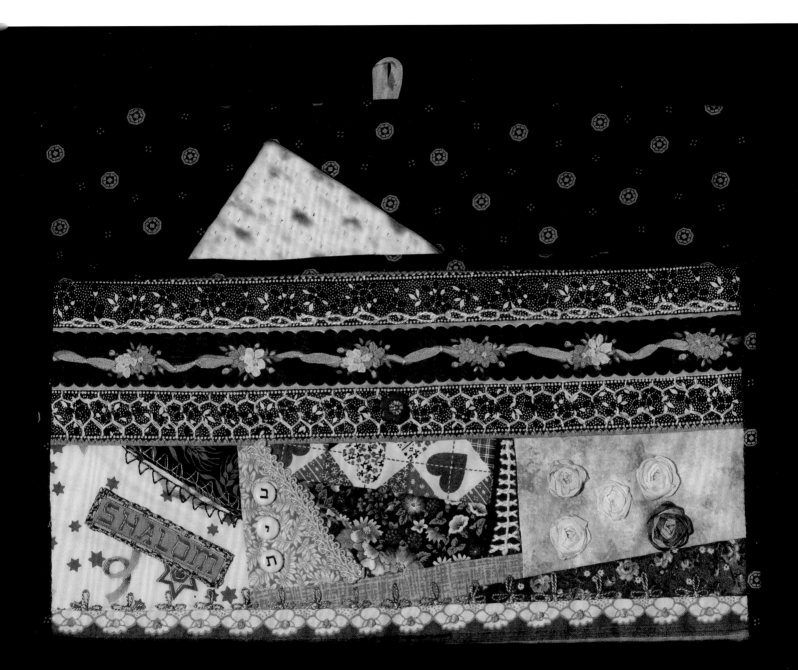

2.19
Afikomen *cover, Jewish Passover textile*
by Lillian Goldberg, c. 2002, fabric, thread,
6 3/4 x 12 5/8 x 1/2 buttoned. Collection of
the artist

MUSIC AND DANCE

The ancient art of Cambodian dance was nearly lost when the Khmer Rouge ruled Cambodia in the 1970s. Artists were among those specifically targeted for execution, and it is estimated that nearly 90 percent of the country's tradition bearers perished. Dancers who survived have strived to preserve and pass on the endangered technique, style, and repertoire, both in Cambodia and in communities where Cambodians have resettled. This includes Lowell, Massachusetts, which has the second-largest Cambodian population in the United States, following only Long Beach, California.

Tim Chan Thou, founder and artistic director of the Angkor Dance Troupe, learned Cambodian folk dance and became certified as a folk dance instructor in a refugee camp along the Thai-Cambodian border.[12] He was twenty-one years old when he arrived at Khao-I-Dang, traumatized by his wartime experiences in Khmer Rouge work camps and by the deaths of his parents and four siblings. For Thou, teaching traditional Cambodian dance became a way to keep part of his heritage alive. He went on to teach and dance at the Philippine Refugee Center before immigrating to the United States in 1982. Thou brought with him a passion to carry on and develop traditional Cambodian dance, to perform, to teach others, and to see the traditions preserved for future generations. In 1986 he and another teacher founded the Angkor Dance Troupe in Lowell. Today, the troupe is one of the most respected Cambodian dance ensembles in the country, with several highly qualified master teachers and more than forty students.

The art form is transmitted as it has been traditionally for centuries—by watching, imitating, and processing the critique of teachers. Students must perfect numerous basic hand gestures and movements, all of which have symbolic meaning. The monkey (cat. 2.21) has a role in the *Reamker*, Cambodia's version of the epic Indian tale, the *Ramayana*. In Cambodian legend, monkeys are considered soldiers who fight evil. The monkey costume is used in one particular dance called *Swva Pol*, which is performed by young boys. The dance's quick, acrobatic style, capturing the spirit and mannerism of monkeys, is particularly challenging. The troupe has incorporated hip-hop moves into the dance, melding ancient and modern traditions.

Cambodian folk dance reflects the everyday experiences of rural life—fishing, rice farming, courting. Cambodian classical (or court) dance dates back to the Angkor civilization where dancers performed blessing ceremonies in temples and for royalty in palaces to bring prosperity to the kingdom. These elegant, highly stylized dances were once reserved exclusively for Cambodia's elite (cat. 2.22). The fan dance pictured here glorifies the king for his governing of the kingdom of Cambodia. The gesture of fanning out wards off evil spirits, while fanning in brings peace, prosperity, and good health.

Many cultures around the world have both a tradition of folk dance that is participatory and a tradition of performance dance that is a display. The latter includes the Irish dance tradition (cat. 2.23) referred to as "step dance," which became widely known after the highly successful performances of *Riverdance*, first produced in 1994. The theatrical production featured the rapid leg movements, fancy footwork, and still arms of hard-shoe step dancing. Prior to this global exposure, Irish step dancing was primarily known in Ireland and wherever the Irish have resettled. Irish American children continue to study step dancing; they compete in annual dance competitions and festivals known as *feis* and perform in concerts and Saint Patrick's Day parades. A hallmark of the tradition is the remarkable costumes that step dancers wear.

Ann Horkan made these Irish step-dancing costumes (cats. 2.24, 2.25) for her daughter,

2.21

The Monkey Dance, Cambodian dance, Angkor Dance Troupe. Photograph © James Higgins

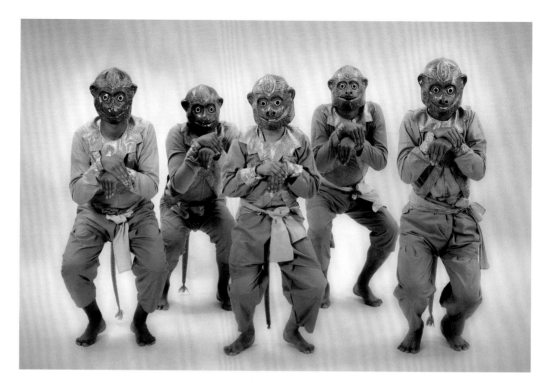

2.22

The Fan Dance, Cambodian dance, Angkor Dance Troupe. Photograph © James Higgins

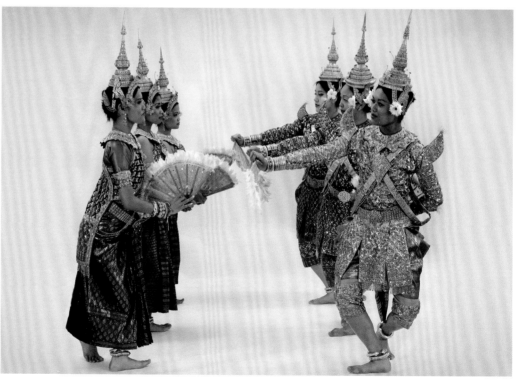

a step-dancing U.S. champion who studied with the Rita O'Shea Academy of Irish Dance. The stunning embroidery against the faded blue velvet fabric is based on patterns from the *Book of Kells*, an ornately illustrated manuscript produced by Celtic monks around AD 800. When Ann and her granddaughter came to drop off these two costumes at the museum, Ann remarked, "These days, these costumes are all store-boughten. My granddaughter just got a second-hand costume from Ireland. It's like the ones they wear in Hollywood—all glitter. I don't see nothing Irish in it. And it was wicked expensive. I think we need to hold on to old things." Her granddaughter described contemporary costumes as all "shiny and sequined. [They] lack the handmade beauty and the love that went into the older ones." The lace collar on the dress is antique; it was crocheted by the grandmother of one of Ann's friends. Ann does crochet the lace collars for these costumes, using Irish stitches such as the shamrock and the rose stitch. She says of the maroon dress, "My daughter wore this one when she took first place in the Nationals."

Horkan grew up on the Aryan Islands off the coast of Ireland. When she was only four years old, her grandmother handed her two chicken feathers as knitting needles and taught her the basic stitches.[13] She immigrated to Boston as a teenager in 1954 and went on to marry and raise a large family. "When I was single, there was no time for knitting." Like many of her fellow Irish emigrants, Ann frequented Boston's ballroom dance scene on Dudley Street. "It was a way to get in with your own crowd."

I had to swear to all those people that I would never again quit playing.
—Joe Derrane, Irish button accordion player

Born in Boston in 1930 to Irish immigrant parents, Joe Derrane developed an early affinity for the button accordion and Irish traditional music.[14] At age ten, he started studying the ten-key melodeon under the tutelage of Cork-born Jerry O'Brien. Four years later, he had become a regular player in the ballroom dance scene that was booming in the Dudley Street section of Roxbury. Five ballrooms would fill up each Thursday and Saturday night with Irish Americans and recent immigrants, who came to hear music from home, dance, and possibly meet a future spouse. Some of the halls held upward of 1,200 dancers a night. Joe was also featured regularly on live radio shows in Boston, where he sparked the interest of a local recording company. At age seventeen, Joe recorded the first in a series of eight 78-rpm recordings in the 1940s, which have since become legendary in the Irish music world. His virtuosity on the D/C# button accordion is unparalleled.

In the mid-1950s, the once thriving ballroom scene began to wane. Economic pressures drew Joe to more commercially popular kinds of music, and he gave up the "button box" for the piano accordion. "After a while, it got to the point where people didn't want the piano accordion either. The kids would look at me and say, 'Ew, Lawrence Welk. This is nerdy stuff.' Brides would tell you, 'Well I hear you have a great band, but I don't want that

2.23
Irish soft-shoe step dancer, Irish Connections Festival, Canton, 2004. Photograph by Maggie Holtzberg

2.24
Dress, Irish step-dancing costume by Ann Horkan, 1982–1983, blue velvet, cotton, satin embroidery, 39 x 20 x 3 hanging, skirt not open. Collection of the artist

2.25 (opposite)
Dress, Irish step-dancing costume by Ann Horkan, 1980, maroon velvet, cotton, satin embroidery, 37 x 20 x 3 hanging, skirt open wide. Collection of the artist

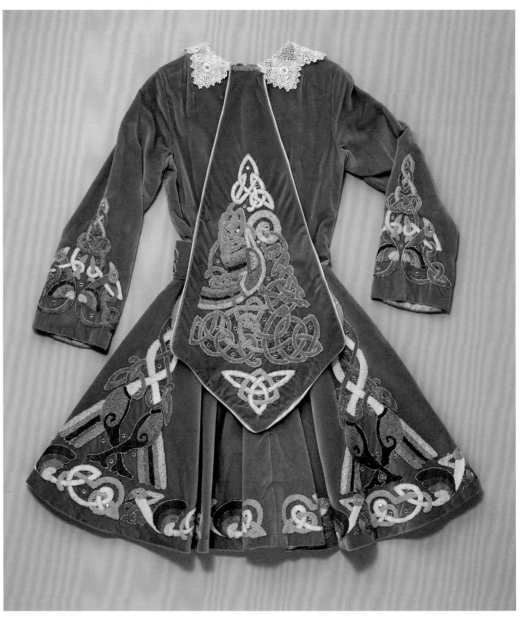

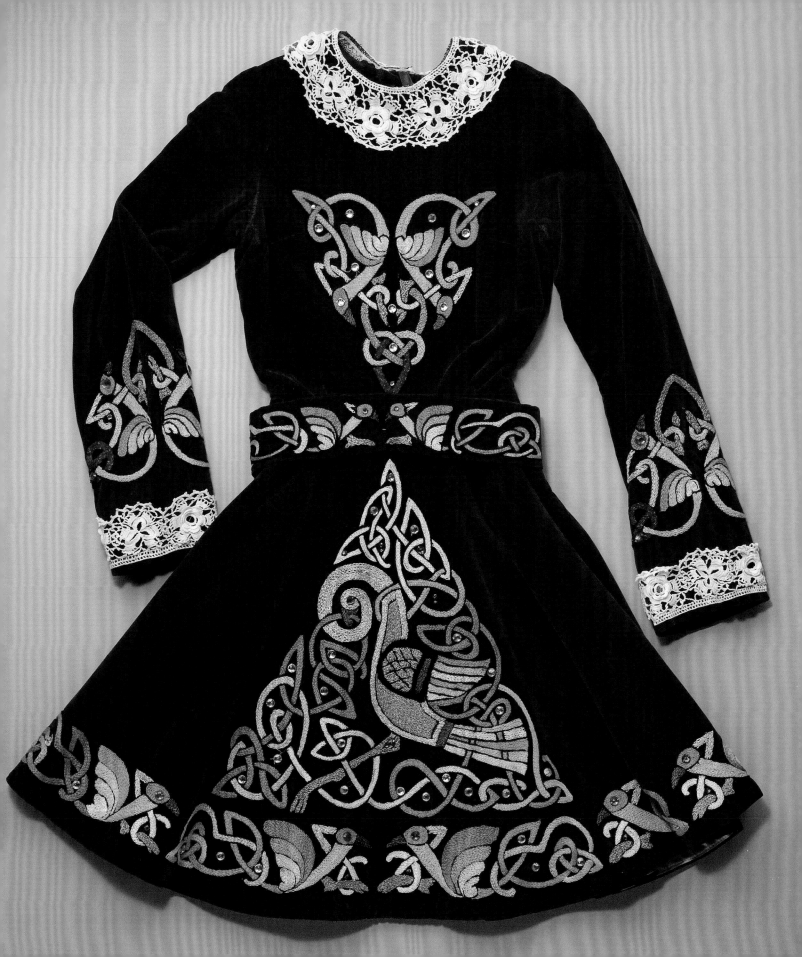

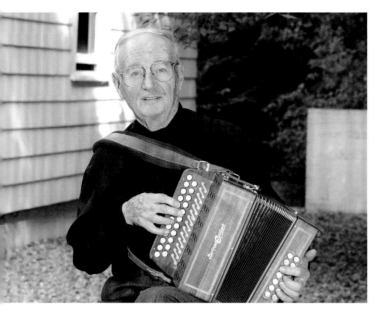

2.26

Joe Derrane outside his home, 2006. Photograph by Tom Pich Photography

accordion.'" Joe eventually switched to synthesizers and keyboards, playing show tunes, pop, Italian, and Jewish music.

"I didn't play any real traditional Irish music outside of St. Patrick's Day or at a wedding. Somebody would say, 'Do you guys know the *Irish Washerwoman?*' But everybody, even the Jewish guys, knew that." By 1990 Derrane had given up performing music altogether (cat. 2.26).

In 1993, Paddy Noonan of Rego Records bought the rights to all the old 78s and re-released Joe's original recordings on CD. Music critic Earle Hitchner, who writes for the *Irish Echo*, heard them but assumed they were recorded in the 1920s or the 1930s. He called Noonan and said, "This is *really* great playing. When did this guy die? Where did he live?" Paddy told him, "He's not dead. I just talked to him a month ago. He's living in Randolph and this is his phone number."

Earle and Joe had a lengthy telephone conversation. Earle was absolutely stunned to learn that not only was Joe not playing music anymore, but he also had not owned a button accordion in thirty-five years. "Well certainly you're going to come back and you're going to play?" "Earle, I don't think I could ever play at that level again. I'm sixty-three years old. Those recordings were done in 1947 through '50, '51. You're talking a long time here."

Every time the conversation came back to Irish music and the button box, Earle noticed that Joe's voice changed. "Your voice just takes on a different tone. It's full of life. I'm telling you, there's a fire in your belly yet." Eventually, Earle was able to convince Joe to pick up the button box again. Tremendous interest had been stirred up by the re-release of Derrane's early recordings. Michael Denny, the organizer of the Washington Irish Folk Festival in Wolf Trap, Virginia, asked Joe to perform in the 1994 festival. When this invitation came, Joe was not playing music professionally at all, but was doing part-time data entry for a local church.

"I haven't played in thirty-five years." Joe told Mike.

"Well you could just come down and talk about your playing, where you've been and what your life is like now. But if you had your druthers, would you rather play or talk?"

"Play."

"I hung up and thought, 'Now, I've got to do it. How do I approach this?'" Joe ended up practicing six to seven hours, seven days a week, until the engagement. Six months of intensive practice paid off. With its stunning ornamentation and rhythmic variations, Joe's performance electrified the crowd.

"The response was just incredible. People all over the place were crying. My daughter was sobbing. I was crying. My wife was crying. They had never heard me play the button box. We had about 1,200 people in that [festival] tent. They just raised the roof. It was like

coming home again. Without a doubt, other than the day I got married maybe, or the dates that my two kids were born, it was probably the single biggest day of my life."

Emcee Joe Wilson brought Joe back up for an encore. Before letting him leave the stage, Wilson grabbed Derrane's left arm and raised it like a prize fighter, saying, "Repeat after me: I will never ever stop playing the button box again." As soon as he stepped down from the stage, he was offered a recording contract with Green Linnet Records. Derrane went on to record three Mapleshade releases and one Shanachie CD, and he continues to perform in concerts, festivals, and on the WGBH radio show, "Says Who?" In 2004, Derrane was awarded a National Endowment for the Arts National Heritage Fellowship for his mastery of the Irish button accordion (cat. 2.27). After a thirty-five-year hiatus, Joe's efforts have led to what has been hailed as the "greatest comeback in the history of Irish music."

This white Walters button box was given to Joe by his lifelong friend, Jackie Martin, just weeks before Joe received the call from Wolf Trap. "Here's a box for you. You've got no excuse not to play now." The fifteen-key hybrid is similar to the accordion that Joe played in his youth. Joe says that playing this box is "like digging potatoes," meaning it is tough. "We used to call them dancehall boxes. They were built for power. The PA systems in those days were a joke." What the box was not built for was speed. Imagine trying to type really fast on an old-fashioned typewriter. "They were okay on the waltzes, hornpipes, and Highland two-steps, but they were sluggish on the jigs and reels." In addition to his virtuosity as a player, Joe has been composing tunes since the 1940s. His "Peter Feeney's Dream" and "The Roseland Barn Dance" have entered the Irish tradition.

Old-time musicians play fiddle tunes that have been passed down from player to player at contra dances, house parties, and festival jam sessions. Some of these tunes date back to the Civil War. Most of the time the tune has a name, but its composer is long forgotten. The same thing is true for material folk objects. A basket or quilt is recognizable as a genre or pattern of folk form—pounded-ash egg basket or double-wedding-ring quilt—yet we may no longer know the individual maker. Someone, at some point, made up the fiddle tune. If enough people liked it and continued to play it, the tune "entered the tradition." This takes time. Some fiddle tunes are more recently composed; we do know who wrote them. Mark Simos is one such composer. His "tunesmithery" draws on a long apprenticeship in a wide variety of genres—Irish, Southern Appalachian old-time, New England, Quebecois, bluegrass, and Klezmer, among others—creating a musical language grounded in traditional forms, yet uniquely his own.

Fiddle tunes are built from modes and phrase structures that lend themselves to being learned by ear rather than from written music. While they may set particularly well on the fiddle, the flute, or the banjo, they can generally be played on the different melody instruments that make up a traditional ensemble. They are naturally subject to patterns of subtle change, variation, and reinterpretation over time and may appear in variants in different regions. Individual players reshape them with each performance.

2.27

Walters button box,
accordion, c. 1957, wood,
plastic, fabric, reeds, metal
fittings, 13 1/2 x 14 x 8
closed. Collection of the
artist

Mark Simos writes,

When a player composes a new tune of this kind, he or she is working in a tightly constrained traditional model.... The tunesmith (in contrast to the art music composer) is working in an inherently fluid form, knowing that he cannot control every grace note, every inflection of phrasing, every chord choice. The piece must preserve its integrity when learned by ear, taught informally over the years in an endless game of "tune telephone," tinkered with by many ears and hands. Thus a tunesmith proper aspires to create music designed and destined to enter the repertoire of a traditional community.[15]

For nearly three decades, Mark's original fiddle tunes and waltzes have been adopted by fellow musicians and dance communities and recorded by traditional bands such as Childsplay, the Hillbillies from Mars, Laurie Andres, and the American Café Orchestra. Mark's debut solo album, *Race the River Jordan* (Yodel-Ay-Hee CD017), a collection of original fiddle tunes in a Southern old-time vein, garnered critical acclaim and is frequently played on traditional radio music programs.

One particularly fertile ground for Mark's tunesmithing is Clifftop, the Appalachian String Band Festival in Clifftop, West Virginia. The five-day event each August is essentially a gathering of old-time musicians from around the country who come to enter contests, square dance, and play for hours on end. A strong Massachusetts contingent regularly makes the pilgrimage. Most folks camp at Clifftop, setting up villages of tents and folding chairs; to walk or drive through the campground is to experience the sounds of fiddle, banjo, guitar, and upright bass from one jam session morph into another just yards away (cat. 2.28). Here are four composition notebooks of Mark's that include tunes written at Clifftop. On his latest recordings, *Clifftop Notes Vol. 1* (5-String Productions 5SP-CD05005) and *Clifftop Notes Vol. 2: Big Ears* (5-String Productions 5SP-CD05006), Mark leads the old-time stringband the Cliffhangers and other Clifftop friends in original old-time fiddle tunes, played in the improvisational "campground" style.

Mark plays a fiddle made by violin maker Bob Childs. Both are longtime participants in the annual concert organized by Childsplay—a group of more than two dozen musicians who are among the leading virtuosos in traditional and contemporary fiddle music. The group's members come from all over the United States and Sweden and represent the fiddle traditions of Appalachia, Cape Breton, Ireland, New England, Quebec, and Scotland. These far-ranging stylists are linked by their instruments—each member of the string section plays a violin or viola made by band member Bob Childs. Writing as the producer of the group's recording, *The Great Waltz*, fiddler Bruce Molsky mused about what brought the album together, "The instrumental voices you hear on this recording are all from the same family.... Bob Childs regards his lovely instruments as if they were his own children. He's almost paternalistic toward them. And all these instruments really do have voices that make them sound like siblings."

Childs has been making violins for more than thirty years. After being introduced to violin making by Ivie Mann in Maine, Bob left for six years of apprenticeships with Mittenwald-trained violin makers Anton Smith and Michael Weller before setting up his shop in Cambridge, Massachusetts. As a fiddler, Bob was immersed for many years in the Maine fiddle tradition before he became heavily influenced by Irish music. In addition to twenty years performing with Childsplay, Bob was part of the Old Gray Goose and the Moosetones, two influential bands in Maine. Years ago, after finishing a violin in Ivie's shop, they would take the instrument down to Otto Soper's house in Orland, Maine. Otto loved to talk, and two of the wisest things he said were that music will take you places that money

2.28

Composition tune books, original fiddle tunes in Southern old-time and other traditional styles by Mark Simos, vol. 71 (2003), vol. 81 (2004), vol. 86 (2006), vol. 97 (2006). Vols. 86, 97, 2 1/2 x 7 x 5 3/4 open, not flat; vols. 71, 81, 1/2 x 11 x 17 open, flat. Collection of the artist

2.29 (opposite)

Violin by Bob Childs, 2002, maple, spruce, ebony, strings, 24 x 8 1/4 x 3 3/4. Collection of the artist

won't and that you will make all your great friends through music.[16] This violin (cat. 2.29) was made by Childs for his fiftieth birthday.

"I realized that once I turned fifty and still didn't own one of my own instruments, that if I didn't make one for myself I would never have the experience of hearing a violin age and mature right under my own ear! Ever since I started making violins in my own shop I have always had orders, so I had to specifically set aside the time to make the instrument for myself. I chose wood that had mineral deposits in it, knowing that I would never use it for a commissioned instrument."[17]

When I asked violin maker Dave Golber what inspired him to get into violin making, he smiled, "Of course, there was a woman involved. Why do men do crazy things?" He laughed and proceeded with a folk tale about God making woman out of the Devil's tail. Golber grew up in Chicago, played clarinet, and became interested in Balkan music and dance. He eventually moved out to Los Angeles and married a violinist named Loretta Kelley. She had heard the dance music that comes from the Hardanger region of Norway and fallen in love with it. In 1985 Dave went to Norway with her, staying in the homes of top fiddle players, going to dances, and generally soaking up the tradition. Dave and his wife separated around 1991. Dave was not enjoying his job in computer technology and had money in the bank. He decided to indulge his midlife crisis, drove East, and enrolled at the North Bennett Street School in Boston's North End to learn violin making. After graduating from the school in early 1998, Dave set up a studio space on the fourth floor of a brick building filled

with working artists in Medford. For a decade, he has kept busy making new violins and repairing and restoring old ones.

The Hardanger fiddle (cat. 2.30) is unique in both sound and appearance. In addition to the four violin strings, five strings run underneath the fingerboard. These sympathetic strings give the instrument an ethereal sound. To decorate the instrument, Dave used the traditional methods of inlay of bone and mother-of-pearl, as well as pen-and-ink drawing. But he could not bring himself to employ the traditional Hardanger ornamentation—geometric and floral patterns. Instead, all the art on the instrument is based on Viking mythology (cat. 2.31). The birds in the middle of the back side are styled after carvings found on the Oseberg Ship, one of the richest Viking archaeological finds in the world.[18] The figure on the fingerboard is Gunnar from the story of Sigurd, the killer of the dragon Fafnir. In the story (the same story Richard Wagner adapted for the *Ring* cycle), Gunnar is thrown into a pit of poisonous snakes with his hands bound. His sister throws in his harp. He plays the harp with his feet, which calms the snakes for a while, but eventually, one bites and kills him (cat. 2.32). The head of the fiddle is based on one that was part of the Oseberg ship find. The magnificent and terrifying figure is one of the most famous single objects from Viking times.

Another individual who took up violin making later in life is Robert Langdon.[19] With forty years experience as a mechanical engineer, Langdon has held engineering positions in the aerospace, papermaking, and textile industries. In his spare time, Langdon has always built things, including musical instruments. He plays traditional music on mandolin, guitar, dobro, banjo, and violin. After retiring in 2002, he decided to make a violin. Keenly interested in the physics of sound, he began to experiment with a more homogeneous material than wood and instead used sheet aluminum he had lying around. This had been done before. In 1896, C.W.S. Hutchins Manufacturing Company in Springfield, Massachusetts, was one of a few violin makers to produce violins by machining the

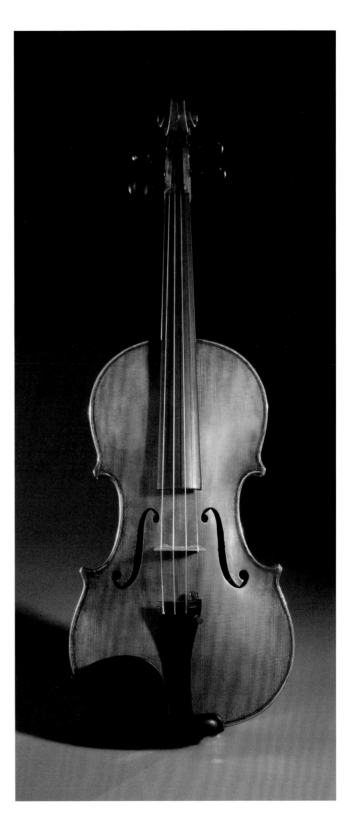

backs and sides of the instruments from aluminum blocks, while keeping the tops made of wood. "The sheet aluminum that I use was not commercially available until the 1930s and 1940s, when it was used in the aircraft industry to cover wings and fuselages. Today, I'm the only one I know of in this country who is making violins out of sheet aluminum." Robert has built eight so far. He machines patterns, jigs, and fixtures in the standard fiddle shape. Most of the time he cuts the aluminum with a jigsaw, but sometimes he roughs out a shape with scissors (cat. 2.33). "The wife doesn't have any sharp scissors in the house, by the way." What looks like rivets is decorative, and an ivy vine inlay runs the length of the fingerboard.

Langdon's violins sound remarkably like ones made of wood, perhaps a bit more hollow. He performs on one similar to that pictured here in three Pittsfield-area traditional folk bands. "It performs quite well over a microphone. . . . I try to avoid using it in electrical storms." In addition to his aluminum violins, Langdon makes what he considers his "folk art fiddles." He has constructed two out of a three-liter coke bottle and a hickory shovel handle once belonging to his father. The fingerboard is made of aluminum, the sound post is a nail, and a coat hanger serves as a shoulder rest. His coke-bottle fiddles are reminiscent of instruments that historically have been made from locally available materials, such as gourd fiddles, cigar-box banjoes, and steel oil-drum pan drums.

Peter Kyvelos has been called "the Stradivarius of oud making" by Armenian-American oud player Richard Hagopian. Both Kyvelos and Hagopian have been awarded a National Heritage Fellowship, the highest honor in folk and traditional arts in the United States given by the National Endowment for the Arts.[20] When Hagopian played at the celebratory concert for National Heritage Fellows in 1989, the year he received his award, he played an oud made by Kyvelos.

Kyvelos' interest in instrument-making was sparked by his fascination with the music. Growing up in Fitchburg, he used to listen to his father's old 78-rpm recordings of Greek music. One instrument in particular intrigued him, but his father was not able to identify it. When Peter was sixteen, he happened to attend a dance in Leominster with an Armenian friend. "I walked in, heard this sound, and my quest ended." The instrument that so captivated him was an oud. As soon as the dance was over, Peter approached the oud player who, as luck would have it, was looking to sell the instrument to be able to buy a better one.

During his college years, Kyvelos embarked on serious study of the structure of the instruments. He began making and repairing them, even though he was still performing in clubs in California to earn his way through school. When he returned home to Massachusetts, he set up a shop called Unique Strings, not far from Watertown, an area known as "Little Armenia" (cat. 2.34). Inside the shop, venerable old tools, banged-up instruments awaiting restoration, and new ones in the making vie for the attention of the many, often regular, visitors. It is a warm and inviting space for musicians to hang out, pluck a few

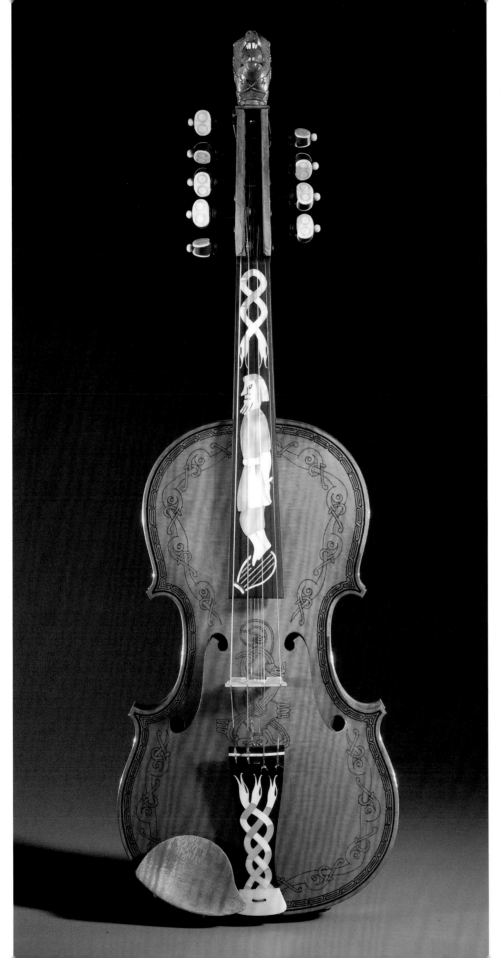

2.30

Hardangerfele, Norwegian fiddle by Dave Golber, 2003, wood, mother-of-pearl, ink, 25 1/4 x 8 1/8 x 4 5/8. Collection of the artist

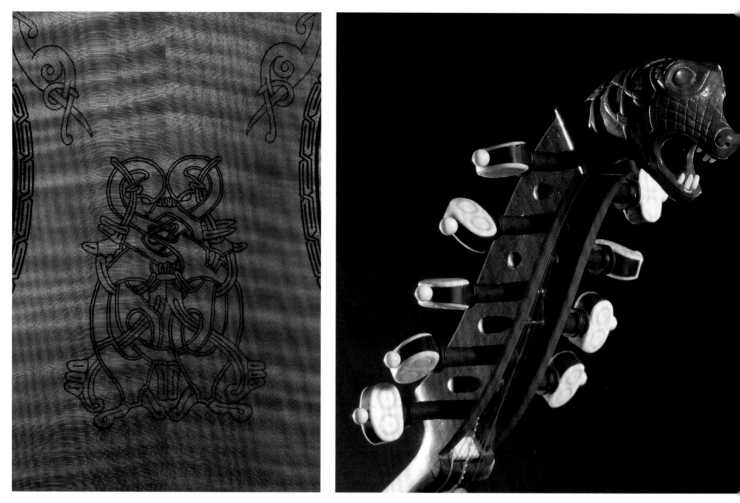

2.31

Back of Hardangerfele, Norwegian fiddle by Dave Golber, 2003

2.32

Head of Hardangerfele, Norwegian fiddle by Dave Golber, 2003

strings, tell a few stories, and talk about the next instrument they hope to own. The shop is considered the epicenter of instrument-making by Greek, Armenian, and Middle Eastern musicians around the United States. In addition to performing first-rate repairs and restoration on a variety of stringed instruments, Kyvelos has built more than 175 ouds over the course of his career. Still, it is hard to make a living. Each oud takes about 125 hours of work to complete. "It's probably up to $7 an hour now," he concedes. "I've kept at this work out of idealism and stubbornness because I think it needs to be kept alive. I've never been able to charge what an oud is worth in terms of time and skill. How could I charge that much from people who are making so little money themselves playing the instruments [and] when the ouds coming from Turkey were so cheap?" (cat. 2.35).[21]

Kyvelos' ouds are extremely light and delicate. The characteristic rounded back is made of beautiful woods such as fruitwoods, mahogany, and ash; the flat soundboard is made of spruce. To fashion the highly intricate carved rosettes—the inserts covering the sound

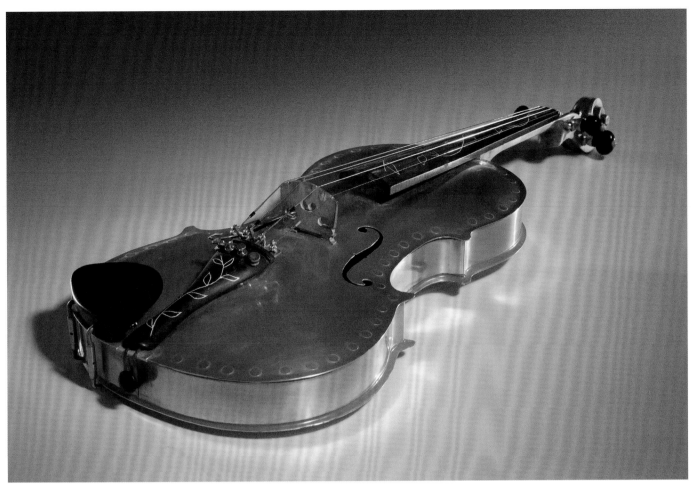

2.33

Aluminum violin by Robert P. Langdon, 2003, aluminum, strings, 24 1/4 x 8 1/4 x 3 3/4. Collection of the artist

holes—Kyvelos uses a plastic called Delrin. "It's translucent. And the great thing is, it oxidizes. Ten years from now, it'll look more like bone than bone."[22]

For Kyvelos, it is the joy of making the instrument and the satisfaction in seeing and hearing it played that inspires his work:

When the instrument is scraped and sanded down to the point where it's ready to receive its varnish or lacquer, you know that the next thing you're going to do is see the whole thing come alive. It's almost like a birth. You're hand-applying a coat of varnish, and the moment you do it, the wood starts to sparkle with all those little things you knew were there—the little knots, the little twists, and the little characters in the wood. It's magic.

But the most exciting thing, of course, is when you've created an instrument and strung it up and it goes into the hands of a professional, and then you see that

2.34

Peter Kyvelos with oud in his shop, Unique Strings. Photograph by Tom Pich Photography

professional sitting up on a stage playing your instrument. There's a certain amount of pride that you get; nobody has to say anything—I don't even want people asking whether I made it—that's not it. What matters is between me, the instrument, and the person playing.[23]

NOTES

1. Information and quotes based on interviews conducted by the author, July 15, 2001, December 22, 2006, and July 15, 2007.

2. The church is Our Lady Help of Christians Parish church on Washington Street in Newton, Massachusetts.

3. The Working Waterfront Festival, founded by Laura Orleans in 2004, celebrates the commercial fishing industry that has supported life around New Bedford for centuries.

4. Information and quotes from interview conducted by Kate Kruckemeyer, October 18, 2005.

5. Archie Green, *Tin Men* (Urbana and Chicago, 2002); as Green documents in his monograph, the use of tin men dates back to feudal legend.

6. Information and quotes from interview conducted by the author, July 9, 2007.

7. Green 2002.

8. Information and quotes from interview conducted by Kate Kruckemeyer, June 14, 2000, and by the author, August 23, 2007.

2.35

Oud, Middle Eastern musical instrument by Peter Kyvelos, 1992, curly maple, paduke, spruce, Delrin, synthetic mother-of-pearl, strings, 32 x 14 1/2 x 10. Collection of the artist

9. As told to the author, September 27, 2007.

10. Information and quotes from tape-recorded interview and field notes by Kate Kruckemeyer, June 4, 2001, and telephone conversation, September 19, 2007.

11. Information from Artist Grant application narrative, November 21, 2005.

12. Information from Apprenticeship application narrative, December 7, 2006, and from interview conducted by the author and Bronwyn Low, June 21, 2007.

13. Information and quotes from interview conducted by Eleanor Wachs, May 10, 2000.

14. Information and quotes from tape-recorded interview conducted by the author, March 7, 2003.

15. E-mail communication from Mark Simos, September 27, 2007.

16. Information and quotes from Childsplay Web site, *http://www.childsplay.org/index.html* (accessed September 2007).

17. E-mail communication from Bob Childs, September 27, 2007.

18. The Oseberg, a 70-foot oak Viking vessel, beautifully hand-carved in the stem and stern, was found in a large burial mound by a farmer at Slagen in Vestfold County, Norway, in 1903. The ship was built around AD 815–820 and was used as a sailing vessel for many years before it became a burial ship for a prominent woman who died in 834: *http://www.stemnet.nf.ca/CITE/vikingships.htm#Oseberg* (accessed October 2007).

19. Information and quotes from interview conducted by the author, December 3, 2004.

20. Information based on interview conducted by Kathy Neustadt, November 2, 1999, and on support materials nominating Kyvelos for a National Heritage Award nomination.

21. Quoted by Louise Kennedy in "Oud Fellow," *Boston Globe* (October 19, 2001), Living Arts, 5.

22. Kennedy 2001.

23. Neustadt interview, November 2, 1999.

Sacred Expressions Religious Beliefs in Everyday Life

Massachusetts is home to people of many faiths—including Roman Catholic, Protestant, Jewish, Muslim, Russian and Greek Orthodox, and Buddhist. Each creed has a long tradition of expressing religious belief in material form. The artists' works seen here are used both privately in the home and publicly in churches, mosques, and temples. They serve a variety of purposes, from devotional prayer to being a mark of cultural identity.

In his professional life, Carlos Santiago Arroyo is an educator and a social worker, tending to the hearts and minds of the community, and in his art—the carving of *santos*—he speaks to its soul (cat. 3.1). *Santos*, literally "saints" in Spanish, represent a centuries-old tradition of religious devotion practiced by Latino artisans who are called *santeros* and *santeras*.[1] Historically, such small wooden carvings of religious figures associated with the Catholic Church were made to be used in the home for prayer, or to ask for a cure.

Until several decades ago very few artisans still practiced this art in Puerto Rico, but there has been a renaissance of this art form, and hundreds of artists are actively carving on the island. As a consequence, *santos*, once valued exclusively for their religious significance, have become desired objects of art in home collections, galleries, and museums. "Although it's true that *santos* today have more weight as cultural objects than as religious ones on the island, many believers seek the support of these celestial beings to intercede for them today the same way our ancestors did." While related representations of the saints are found in most of the former Spanish colonies, Arroyo's work has an affinity with the classical style of Puerto Rican *santo* carving popular in the nineteenth and early twentieth centuries (cat. 3.2). The proportions of the figures have symbolic meaning, and the nearly expressionless facial features are reminiscent of romanesque carvings made a thousand years ago. Three-dimensional figures (*bultos*) were sized to fit home altars instead of churches, reflecting the physical isolation of many living on the island at that time. The identity of a saint is expressed through the attribute that accompanies and defines the figure, for instance the book and quill pen of Saint Teresa, the dove of Saint Francis, or the Christ Child and Bible of Saint Anthony. Arroyo notes that the Flight to Egypt, a notable event very early in the life of Christ, is highlighted in the island's iconography (cat. 3.3).

Arroyo was born in Ponce, Puerto Rico, in 1947, and raised in Puerto Nuevo. After briefly attending seminary, he began a small collection of old *santos* through the inspiration of his friend and avid *santos* collector Father Felipe Lopez. While studying at the University of Puerto Rico, Carlos often saved his lunch money to spend on these beautiful treasures, reminding himself, "I'll be hungry, but I'll have my *santos*." In 1971 he immigrated to Boston to teach in a predominantly Latino public school, bringing his passion for *santos* with him.

3.2

Carlos Santiago Arroyo at home with four of his santos. *Photograph by Kate Kruckemeyer*

Most of Carlos' energy was directed toward his education, career, and family. He earned a graduate degree in education from Harvard University and later, after moving to the Pioneer Valley, a graduate degree in social work from Smith College.

In 1998 Arroyo had an epiphany. On one of his regular trips to Puerto Rico, he visited an exhibition of *santos* in Old San Juan. As he gazed at a partially completed icon of the Three Kings, he realized that he himself could carve such figures. He began that very afternoon and has continued creating *santos* to this day. As is traditional in Puerto Rico, he carves the *santos* from tropical *cedero hembra*, wood from the female cedar tree, and paints them primarily with acrylics. He travels to Puerto Rico every year to meet with other carvers who have been so generous in sharing their expertise with him.

Beyond the religious symbolism of each saint, Arroyo's *santos* are imbued with cultural meaning reflecting Puerto Ricans' long struggle for self-determination. Some of the carvings depict saints and miracles with deep cultural value for Puerto Ricans that are not officially recognized—and sometimes explicitly shunned—by the hierarchy of the Catholic Church (cat. 3.4). Two of the most deeply rooted devotions on the island—those of the Virgin Mary and the Three Kings—converge in this carving. Arroyo is quick to point out that the proportions of the figures in this icon are purely arbitrary, as is true for many other carvings in Puerto Rico. "The Three Kings are presented in a frontal manner, at the feet of the Virgin, of a much smaller stature than she, affirming her preponderance in the

3.1 (opposite)
La Mano Poderosa
(The Most Powerful Hand),
Puerto Rican woodcarving
by Carlos Santiago Arroyo,
2003, tropical cedar, gesso,
acrylic, 15 1/4 x 9 1/4 x 4.
Collection of the artist

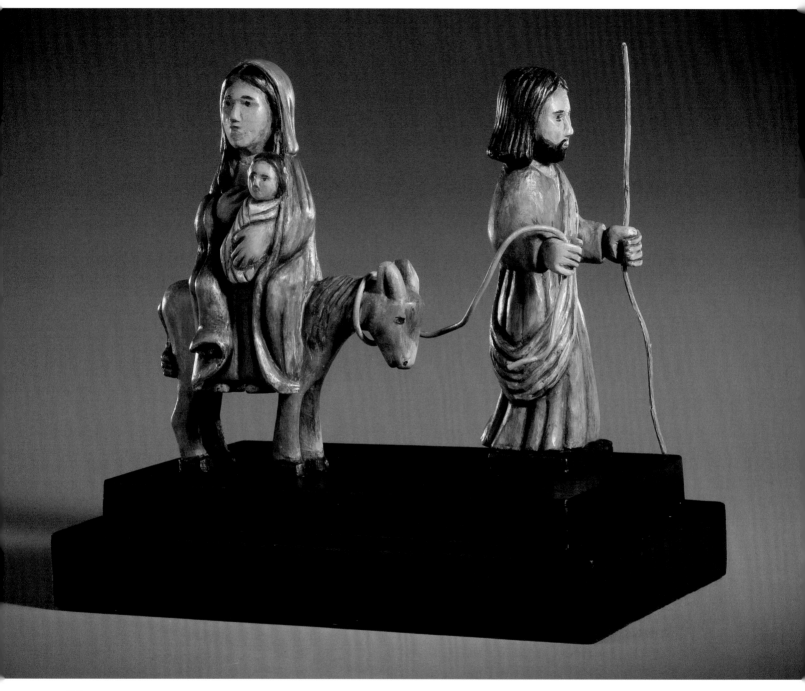

3.3
La Huida a Egipto *(The Flight to Egypt),*
Puerto Rican woodcarving by Carlos Santiago Arroyo, 2006,
tropical cedar, gesso, actylic, metal, 11 1/4 x 12 1/4 x 7 1/2.
Collection of the artist

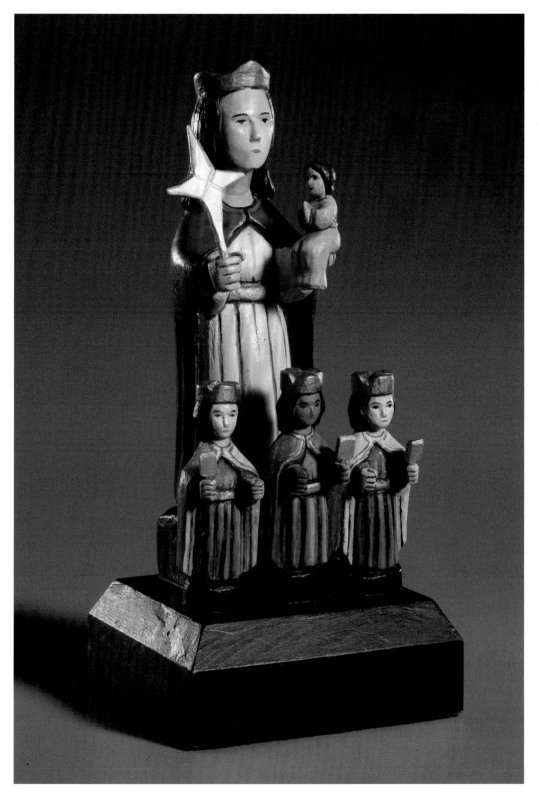

3.4

La Virgen de los Reyes
(The Virgin of the Kings),
Puerto Rican woodcarving
by Carlos Santiago Arroyo,
2003, tropical cedar, gesso,
acrylic, 10 3/4 x 5 x 4 7/8.
Collection of the artist

scene. This Virgin holds in one arm Baby Jesus, while on the other she carries the star that guided the Magi to the town of Bethlehem. This is one of the most popular carvings in homes throughout the island, although it would not be found in chapels as the official church does not recognize this icon; it is a creation of the popular religious culture of the country."

Despite the fact that Arroyo has little time to pursue his craft, his art has been recognized in exhibitions from the University of Massachusetts to the Museo de Las Américas in San Juan. Regionally, he has also become known as an outstanding presenter on *santos* and Puerto Rican culture. "I love . . . bringing the *santos* to the classroom, to Latino students, because here [in the United States] they don't talk about Puerto Rican culture. It's just amazing to me," he says. With his beautiful *santos*, Arroyo reminds us of the power that a sacred art form can have in the preservation of cultural values and history.

If you are a real iconographer, you feel absolutely free in this place. It's like a field, and in this field you are free.—Ksenia Pokrovsky, Russian iconographer

3.5

Ksenia Pokrovsky applying paint. Photograph by Maggie Holtzberg

The "writing" of Russian icons is a tradition that began in the catacombs of the early Eastern Orthodox Church. Icons depict images of saints and sacred history and lie at the heart of Orthodox Christian belief. Their stylized figures and religious themes are conventionally created with natural pigments in the egg-tempera medium. The centuries-old artistic tradition requires the application of very specific painting techniques and image representations that have been passed down from artist to artist through the ages. Authentic icons that have been blessed in appropriate church ceremonies are considered holy images (cat. 3.5).

Ksenia Pokrovsky learned at a time when the old method of painting icons was nearly lost in Russia. She began painting icons in Moscow during a time of severe Soviet restrictions on religious expression. "In Russia, it was [an] equal crime to make weapons, to make drugs, to make pornography, and to write icons." Pokrovsky is widely credited with reviving the writing of traditional Russian icons.[2] She was encouraged in 1967 by a priest, Reverend Aleksander Men, whom she considers her "spiritual father." For artists like Pokrovsky, writing icons is religious practice in material form. Icons are said to be images of the invisible and to have enormous spiritual significance.

Pokrovsky and her family moved to Massachusetts as political refugees in 1991. Her daughter Anna and even her four-year-old granddaughter Ksenia also make icons. The artist, her husband Lev, and her extended family live in a rambling three-story house in Sharon.

Several rooms are empty save for icons leaning against walls to dry. The hallway is filled with books. One floor up, facing the street, is the studio, a large room with lots of natural light. Icons are everywhere—hung on the walls and leaning against furniture—and scholarly monographs line the bookshelves. A long workbench is cluttered with paint palettes, gold leaf, a sheet of thick glass, a mortar and pestle, and sculpting tools. The surface of the bench displays a blend of pigments from previous projects. Shelves on one wall hold jars of colored powder; these are natural pigments—clay, minerals, rocks, ore, and semiprecious gems—many of which Ksenia grinds and refines herself because they are not easily available commercially. She says of the pigments, "Colors are so noble and natural . . . strong and tender" (cats. 3.6, 3.7, 3.8).

Orthodox iconography expresses spiritual truths in symbolism that has developed over the centuries. Not only the lines and colors, but also the materials themselves have symbolic meaning. Ksenia explains that the natural stones from which she grinds pigments symbolize eternity because they never fade (icons are meant to last forever), and that gold leaf symbolizes the heavenly light made manifest on Mount Tabor.

One of the hallmarks of icon writing is inverse perspective, which Ksenia describes as "a very special way to organize space."

> The space of [an] icon is not realistic, physical space with depth shown by perspective. It appears on one plane, having inverse perspective, in which all persons and objects are close to the center of the icon. You can compare [an] icon not with [a] picture but with [a] window because when you look at something through [a] window, you can look from different positions. From here, you will see one picture. From there, you will see [an]other picture. And all together you put on [an] icon. [The] icon doesn't have [just] one point of view—from here, you can see [the] sky. You compress them in [the] space of [an] icon.

Reverend Gallaway of Saint Andrew's Orthodox Church in Lexington, Kentucky, commissioned Pokrovsky to create an iconostasis (the screen decorated with icons that divides the sanctuary from the nave of an Eastern Orthodox church). He elucidates the concept of inverse perspective this way: "The reason they didn't use naturalistic perspective was that they were dealing with a different kind of reality—not visible, not earthly, but spiritual."[3]

 Feridun Özgören began practicing *ebrû* (marbling) in the 1980s, at a time when only a handful of practitioners were left in his native Turkey (cat. 3.9). The origin of marbling is unknown; most likely, however, the art developed in the cultural centers of Muslim India, Iran, and Turkey sometime in the fifteenth century.[4] Much like the writing of Russian icons, the making of *ebrû* also has a devotional aspect. The majority of texts incorporated into *hatli ebrû* (*ebrûs* with calligraphy) come from the Holy Qur'an and the Hadith (Traditions of the Prophet) literature. Some include secular sayings, such as the universal expression, "This too shall pass."

3.6

Triptych of the Holy Nativity of Christ, *Russian icon by Ksenia Pokrovsky, 2000, egg tempera, mineral pigments, gold leaf, wood, 14 1/2 x 8 7/8 x 2 closed. Collection of the artist*

3.7

Triptych of the Holy Nativity of Christ, *Russian icon by Ksenia Pokrovsky, 2000, egg tempera, mineral pigments, gold leaf, wood, 14 1/2 x 17 5/8 x 1 open. Collection of the artist*

3.8

Detail of Triptych of the Holy Nativity of Christ *by Ksenia Pokrovsky, 2000*

Özgören learned directly from Niyazi Sayın, the greatest living ney (reed flute) player and a *hezarfen* (master of a thousand arts) residing in Istanbul. When Europeans first noticed *ebrû* paper and transferred the technique from the East, most probably from the Ottomans, they called it "Turkish paper." As time passed, this art came to be called "paper marbling." *Ebrû* is made by floating water-based pigments on the surface of a liquid medium and then creating swirling patterns with a stylus or comb. Özgören uses ox gall (bile he obtains from local slaughterhouses), a wetting agent that helps the drop of color expand in perfect circular form. The more ox gall he uses, the larger the circle (cats. 3.10, 3.11). Paper treated with alum is laid on the liquid surface and picks up the patterns. "The technique seems simple: you float pigments and pick them up on paper. But it doesn't work that way in reality. So many other factors are involved—the humidity, the dust, the pigments, and the size; it's a complicated process. Fascinating things happen the minute you drop the ox gall. The fat component of ox gall forms a ring around the perimeter of this drop, so no two drops actually mix. They just push each other. When you drop, there is a big struggle going on.

3.9
Praise Be to God,
ebrû *with calligraphy,*
Thuluth script in Arabic,
calligraphy anonymous,
by Feridun Özgören, 2005,
water-based pigments on
paper, 40 x 25 3/4 sheet,
45 x 31 mounted. Collection
of the artist

3.10

Feridun Özgören dropping ox gall. Photograph by Maggie Holtzberg

3.11

Güliz Pamukoğlu combing a pattern. Photograph by Maggie Holtzberg

Who is going to get the empty space? It's very metaphorical; it's like a society."

Ebrû papers are generally used in bookbinding and in various types of calligraphic works, such as *kitas* and *murakka* albums, and as background for calligraphy. They are also used to form elegant borders around *levhas* (panels) that employ the *celi* sizes of scripts, calligraphy large enough to be read from a distance. These calligraphic works decorate the walls in places of worship and are similarly placed in homes to provide a spiritual environment. Özgören has contributed an impressive body of *ebrû* work in large format. His art combines the complex patterns of *ebrû* with the beauty and elegance of Ottoman Turkish calligraphy. He has also mastered and incorporated a second nearly lost technique, *kaat'i* (decoupage), which is used to create paper stencils. These stencils block out parts of a sheet of paper, enabling artists to overlay multiple layers of marbling. Özgören's work is represented in the collections of Harvard University's Houghton Library, the Cooper-Hewitt Museum, the Museum of Fine Arts, Boston, and the Beit Al Qu'ran in Bahrain, in addition to many private collections.

Güliz Pamukoğlu became acquainted with *ebrû* in 2000 while assisting Feridun Özgören with the preparation of a major exhibition at the Beit Al Qu'ran. This opportunity allowed her to observe and participate in all aspects of this art: making brushes and tools, grinding pigments and making paints, treating and pressing paper, and preparing the liquid medium. She has worked closely with Özgören ever since, creating her own work, giving studio demonstrations, and teaching. "The best part is you create designs that you can never replicate. That's the most exciting part. You always hope to make better ones." Her first exhibition was held at Regis College, Weston, Massachusetts, in 2003.

This *ebrû* of turquoise hues (cat. 3.12) was done by Güliz in 2006. The calligraphy is written in *Thuluth* script, the script most commonly used by Turks for panels. Güliz notes that the calligraphy is done with a reed pen, not a brush, as in Chinese and Japanese calligraphy. She describes a tradition in Islamic calligraphy, "When young calligraphers start sharpening their reeds, they always save the shavings. They save them all their lives. When a calligrapher dies, they make a fire using those shavings to warm the water with which they wash the body."[5] When asked if she is following this tradition, she smiles and says she has a small pile of shavings saved.

In the Roman Catholic Church, the tradition of palm weaving continues in its simplest form among the many families who fashion crosses and other religious symbols from the blessed fronds they receive during Mass on Palm Sunday. For master palm weaver Lise Galarneau, however, this sacred craft occupies most of the winter and spring, as long as her annual supply of up to one hundred pounds of palm can last.[6] Galarneau views her work as deeply religious, and she does not teach the craft to anyone who does not embrace its spiritual meaning. Yet she also believes her work can bring the solace and protection of God's love to all who appreciate it, regardless of their faith. For example, when a visiting priest from Africa blessed a set of rosary beads she had woven, saying that the rosary

3.12

Oh Submission
(To the Beloved God),
ebrû *with calligraphy,*
Thuluth script in Turkish,
calligraphy by Circirli
Ali Efendi; by Güliz
Pamukoğlu, 2006, water-
based pigments on paper,
40 x 25 3/4 sheet, 45 x 31
mounted. Collection of
the artist

would bring special blessings to its recipient, Galarneau decided to hang the beads over her workshop door so that all who enter may share in that gift.

Galarneau's own gift comes from an unexpected place: she spent much of her childhood in an orphanage run by French-Canadian nuns at Sacré Coeur convent in Sherbrooke, Quebec. Under the tutelage of the sisters, Galarneau learned to weave all the basic shapes with the palm, such as the Cross, the Crown of Thorns, and the *cocotte* (pinecone) (cat. 3.13). The sister in charge of the Sacristy recognized her talent and that of another girl, and together the two wove palm blessings for residents in the convent hospital. "It was," she says now, "our way of helping with Palm Sunday; and it was a joy."

At age fourteen, Galarneau immigrated to Holyoke, Massachusetts, to sew in the mills. As a young wife and mother in the early 1970s, she moved with her family to suburban Hampden. There she continued to weave on Palm Sunday, and she regularly taught fellow parishioners at Saint Mary's Church to weave on the holiday. While most needed to relearn the basics each year, in 1992 Galarneau was inspired to devote more time to this art. Over the years she has developed many intricate designs of her own and has earned a reputation as a master at weaving everything from simple inserts for family bibles to ornate traditional crosses. After nearly thirty-five years in Hampden, Galarneau and her husband recently moved to Ocean Isle Beach, South Carolina, where she continues her work.

Each of Galarneau's palm weavings incorporates the Crown of Thorns (cat. 3.14), which has particular meaning for her. In addition to its connection to the story of Christ's death and resurrection, the crown is a sign of victory in the home, as well as protection. Galarneau believes it has had protective power for her family, noting: "I had two fires and I never lost a thing." This work, *The Crown of Thorns*, is made of one piece of palm frond and is displayed in a glass dome along with a branch from the crown of thorns tree. The roses, gathered from Galarneau's garden, signify the heart of Mary. The deer moss on which the crown sits represents the Calvary, the site of Jesus' crucifixion. "When He died on the cross," she explains, "He was crucified with a crown of thorns. When you really look at the crown of thorns, you have to feel it, feel the love of Christ. And then when I weave it, I also pray for the people who asked me to make them.... It shows the love that God has for us, and that's the meaning of it. It's very powerful."

Another example of art that references Christ's Crucifixion is this wood carving by semi-

3.13

Detail of Angel Asleep, *Franco-American palm weaving by Lise Galarneau, no date given, dried palm fronds. Collection of the artist*

3.14

Crown of Thorns,
*Franco-American
palm weaving by
Lise Galarneau, 2007,
dried palm fronds, 10
3/4 x 6 3/8. Collection
of the artist*

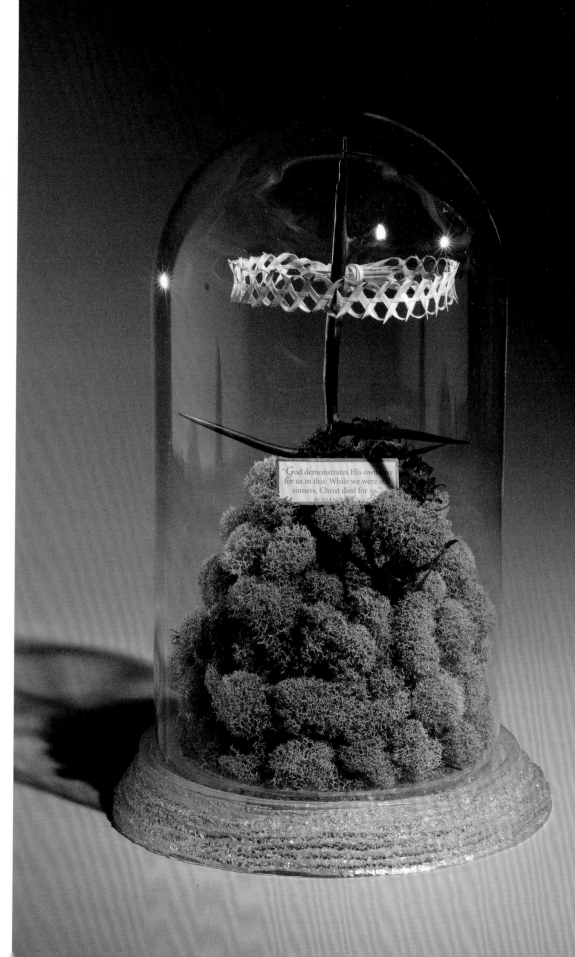

retired cabinetmaker Charles Cerone (cat. 3.15). Unlike his statue of Saint Mary of Carmen, which is used once a year, this piece is on display in his home as a daily reminder of Christ's love. Several months after he finished it, he decided to add an olive branch as a symbol of peace and reconciliation. The letters I-N-R-I stand for the Latin inscription IESVS NAZA-RENVS REX IVDÆORVM, which translates, "Jesus of Nazareth, King of the Jews."

Japanese Buddhist monks inspired Thomas Matsuda to study in Japan.[7] He apprenticed under the sculptor Koukei Eri for two years, learning the traditional as well as the technical aspects of Buddhist sculpture. He then lived in a remote mountain village, carving more than two hundred sculptures for various temples, shrines, villages, businesses, and individual patrons. A decade later, Matsuda returned to the United States, where he continues to carve Buddhist sculpture and to teach. He strives to bring out human qualities in statues, which tend to be suppressed in traditional Buddhist sculpture. Roko Sherry Chayat of the Abbot Zen Center of Syracuse writes of Matsuda's sculpture, "The work takes place in the enduring tradition of Buddhist art: work made not as an extension of the individual artist's ego, but as an expression of one's own gratitude and awakened condition of mind."

In Buddhist thought, a Bodhisattva is a person or being striving to attain full enlightenment (cat. 3.16). This sculpture of Avalokiteśvara (Sanskrit for the bodhisattva of compassion) is made of Japanese judas wood and can be used as a focus for meditation and daily ritual. Matsuda is a practicing Buddhist and this bodhisattva will be returned to its place in the Matsuda family home altar. In addition to sculptures for home altars, Matsuda has been commissioned to create numerous larger Buddhist sculptures, for example for the Leverett Peace Pagoda in Leverett, Massachusetts, and the Hiroshima Peace Pagoda in Hiroshima, Japan. His work has been exhibited at monasteries, Buddhist temples, and Zen centers across the United States.

In Cambodia, Buddhists pray on a daily basis, yet temples and pagodas are often built far from villages (cats. 3.17, 3.18). Many Cambodians construct their own spirit houses in the yard in front of their houses. These structures are powerful symbols of spirituality in everyday Cambodian life. Typically, spirit houses are highly ornamented wood or cement structures limited to a handful of standard designs.

The one shown here is made of clay by Yary Livan, a Cambodian master ceramist who came to Massachusetts in 2001. He is the sole survivor of his generation of artists trained in traditional Khmer ceramics at the Royal Academy of Fine Arts in Phnom Penh. Yary chose to make the spirit house of clay because he wanted to combine his skills as a ceramist with his Khmer heritage. The form and design are based on Cambodian temples. Yary's wife, Nary Tith, states, "Cambodian people believe that the spirit house is up at heaven, the place where all the angels are who come to take care of their house, their families, as well as the world. They usually put a picture or statue of Buddha, a glass of water, a pot of flowers, and a pot for incense inside the spirit house. Cambodian people believe that their messages will be brought up to Buddha or to the angels by the smoke of the incense they light."[8]

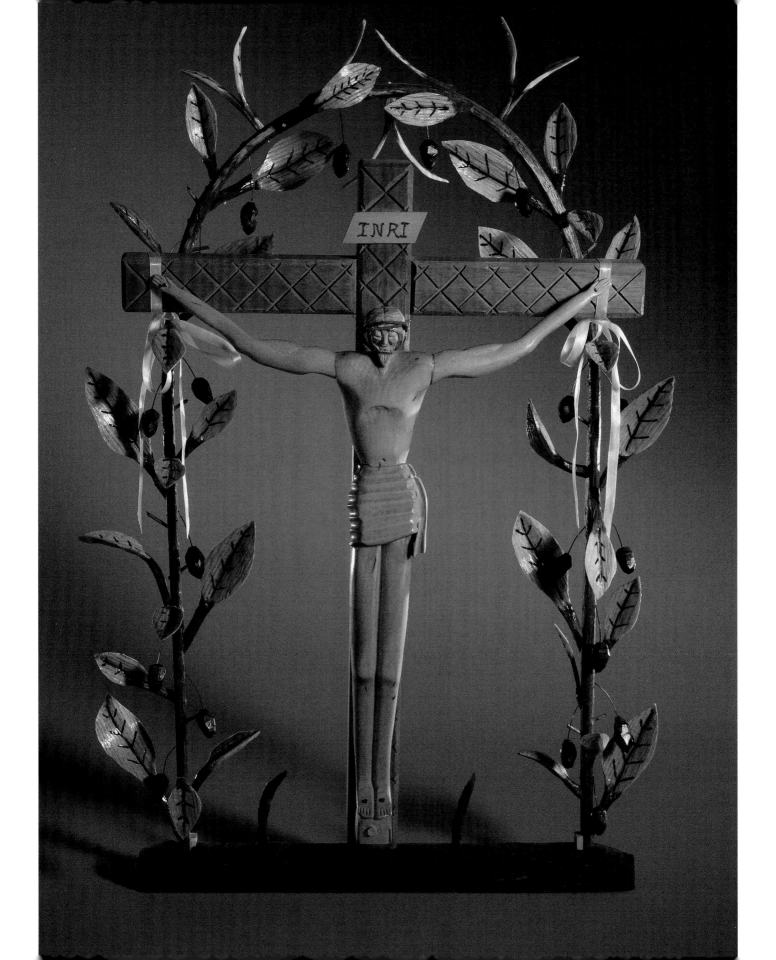

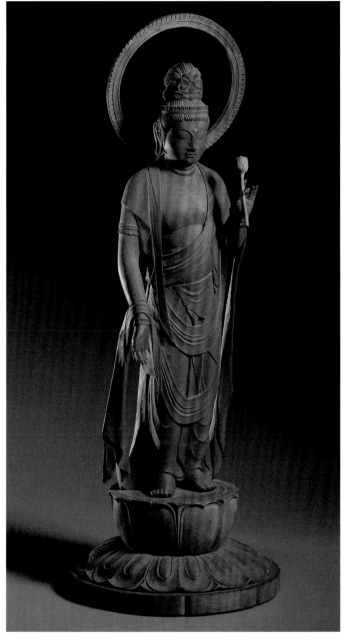

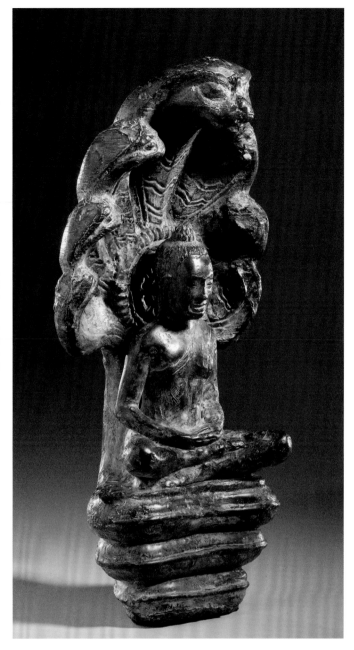

3.16 (left)
Kannon Bosatsu, *Japanese Buddhist sculpture of Avalokiteśvara
by Thomas Matsuda, 1985, wood, 27 x 10 x 10. Collection of the artist*

3.17 (right)
Buddha Protected by Dragon, *Cambodian sculpture
by Yary Livan, 2004, bronze, 15 3/4 x 7 3/8 x 5. Collection of the artist*

3.15 (opposite)
*Crucifix with olive branch, occupational craft
by Charles Cerone, completed 2007, basswood
and ribbon, 30 1/4 x 21 x 6 1/2. Collection of
the artist*

3.18
Spirit House,
Cambodian ceramic sculpture
by Yary Livan, 2007,
white stoneware clay, glaze,
38 1/4 x 12 1/2 x 12 1/2.
Collection of the artist

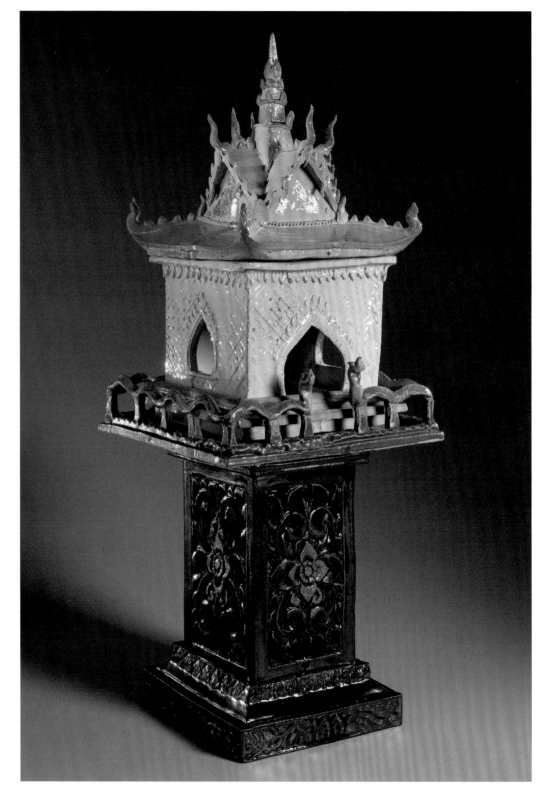

NOTES

1. Information and quotes based on a tape-recorded interview and field notes by Kate Kruckemeyer, November 10, 2005, and e-mail communication with the author, September 25, 2007.

2. Information and quotes based on interviews conducted by the author, November 10, 2001, and April 19, 2006, and e-mail communication, September 27, 2007.

3. Quoted by Zoya Tereshkova in "Windows to Heaven," *Ace Magazine* (December 1995), 42.

4. Information and quotes based on interviews conducted by the author, November 6, 2001, and December 4, 2002.

5. As told to the author, September 14, 2007.

6. Information and quotes from tape-recorded interview conducted by Kate Kruckemeyer, March 27, 2002.

7. Information and quotes from Artist Grant application narrative, December 2000, and personal communication with the author, August 16, 2007.

8. Described in e-mail of August 8, 2007.

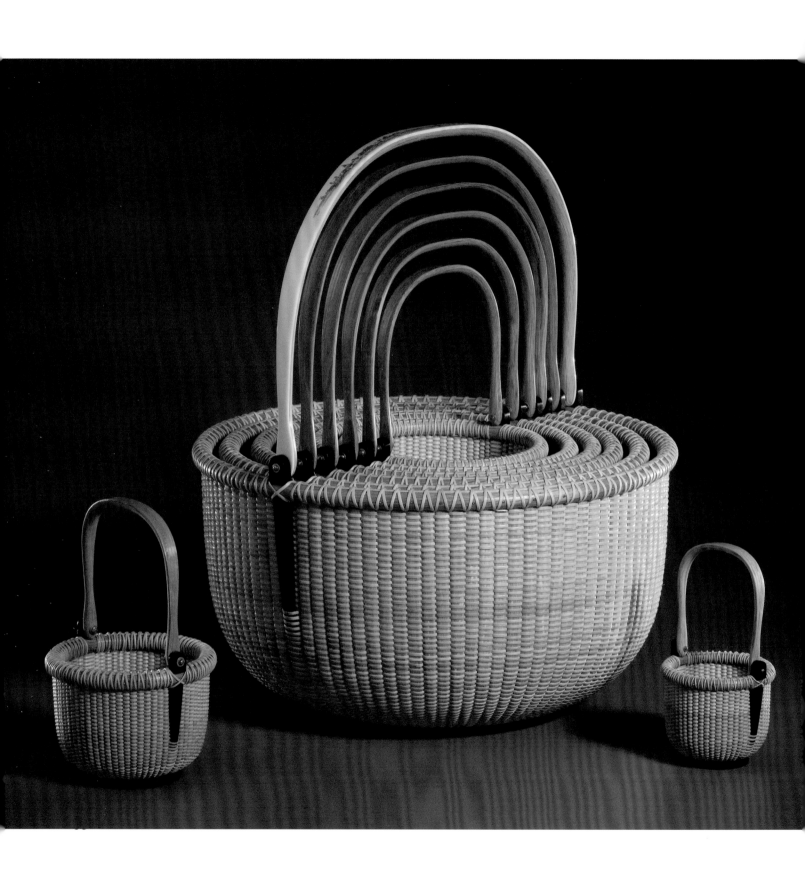

Useful Things Made Beautiful

AT HOME

No one would carry a handmade Nantucket lightship basket (cat. 4.1) out to collect blueberries or potatoes, although at one time, those were typical uses. Indeed, many folk art forms developed as a way of addressing practical problems—carrying things, storing food, keeping warm. Economic reality necessitated making do with what one had on hand. Today, we have Tupperware and electric blankets and Target. Mass production and a global market have made objects for everyday use in the home readily available commercially. By contrast, the same objects that were once made for practical use are now made to be collected, displayed, and admired. This is a kind of use too, just categorically different. The aesthetic appeal of the object now supersedes its original practical purpose. The Nantucket lightship basket is a perfect example.

The traditional lightship basket dates back to the mid-nineteenth century. Distinct in resting on a wooden base, it is extremely sturdy and well-formed. Its tightly woven staves are shaped over a wooden mold. In 1854, the United States Lighthouse Service commissioned the *No. 1 Nantucket South Shoal Lightship* (cat. 4.2) to serve as a floating lighthouse. She was anchored twenty-four miles out, off the southeast coast, and her powerful light warned ships away from the hazardous shoals, an area nicknamed "the graveyard of the Atlantic." For many years the *Lightship*'s crew consisted entirely of Nantucket men. As a way of battling the boredom between chores at their lonely outpost, sailors spent their leisure time at handicrafts, including scrimshanding, carving, making swifts (for winding yarn), and basketry. While the name "lightship basket" derives from baskets made on this nineteenth-century floating lighthouse, the term later included baskets made on the island of Nantucket (cat. 4.3) as well.[1] Indeed, utilitarian basketry became a thriving local industry on Nantucket. Earlier baskets were somewhat crude, made with thick, wide staves and sturdy enough to carry potatoes. Most local households owned a nest of baskets in different sizes, one fitting inside the next. Some were used for picking blueberries and cranberries, others for gathering eggs.

Wooden splints were later replaced with more pliable rattan canes, which were brought to the island in the holds of homeward-bound whaling ships. For a time, these baskets were referred to as rattan baskets. By the time the *New South Shoal Lightship* was placed in service in 1856, Nantucket's "rattan basket" was a fully developed form, and when the first crew of ten men boarded the lightship for duty, they brought with them the makings of these baskets. Within another two decades, the designation had changed from "rattan"

But the thing worth doing
well done
has a shape that satisfies,
clean and evident.
Greek amphoras for wine
or oil,
Hopi vases that held corn,
are put in museums
but you know they were
made to be used.
The pitcher cries for water
to carry
and a person for work that
is real.
— *Marge Piercy, "To Be of Use"*

4.1 (opposite)
Nest of Nantucket lightship baskets by Karol Lindquist, 2007, oak staves, cane weave, cocobola base, ebony ears, nested, handles up, 16 x 13 7/8 x 13 7/8. Collection of Donna and Greg Brown

4.2

Number 1 New South Shoal Lightship. *Photographer unknown*

4.3

Detail of handle on nest of Nantucket lightship baskets, 2007; note the portrayal of the red lightship on left. Baskets by Karol Lindquist, scrimshaw on handle by Robert Frazier

to "Nantucket lightship" basket as dozens of these handsome pieces were created by the lightship's crew.

In the 1940s José Reyes, a Filipino who settled on Nantucket, adapted the basket by adding a lid to create a lady's handbag. Since then, the making of lightship baskets has turned into a fine craft; the baskets now feature narrow staves and a tight weave, and a well-made topped purse can cost upward of $2,500.

In 2002, basket maker Karol Lindquist and her daughter, Timalyne Frazier, completed a yearlong apprenticeship funded by the Massachusetts Cultural Council. Timalyne had grown up with the basket-making tradition (cats. 4.4, 4.5).[2] The two women work in a freestanding studio just steps away from Karol's Nantucket home. Inside the studio are workbenches, wood-cutting tools, a lathe, and shelves stacked with loops of rattan and walnut basket molds. Blue ribbons won in competitions hang on the wall. Nearby is a black-and-white photograph of Karol as a young mom, with four-year-old daughter Timalyne snuggled beside her. Just above this family portrait is a photograph of Reggie Reed, the man who taught Karol during her apprenticeship. Reed is from a direct line of some of the island's earliest basket makers (cat. 4.6).

Karol, who has lived on Nantucket most of her life, speculates how her baskets are used by customers, "People decorate their houses with them. At this point we have expensive houses here [on Nantucket]. They'll come in and say, 'That would look nice here and that would look nice there.' And they'll just pick out their home decorations that way." "They

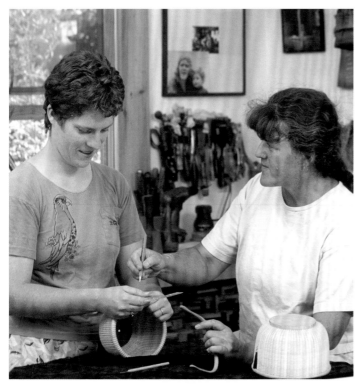

4.4

Timalyne Frazier (left) learning about placement of handle from Karol Lindquist. Photograph by Jeffrey Allen

4.5

Tall Nantucket lightship basket (left) by Karol Lindquist, 2006, cane staves, oak rims, cocabola base, handle up 13 1/2 x 7 7/8 x 6 1/4. Collection of Donna and Greg Brown; round Nantucket lightship basket by Timalyne Frazier, 2002, canes, staves, oak, walnut, purple heart wood, 9 1/2 x 7 x 6 5/8. Lent by Karol Lindquist and Timalyne Frazier

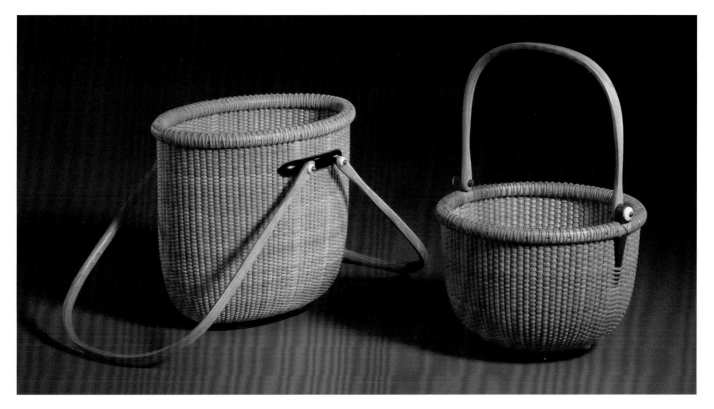

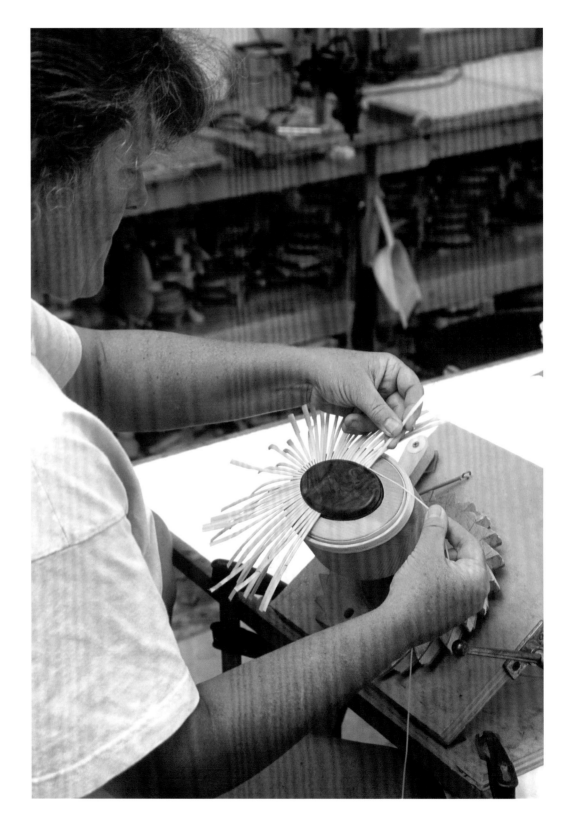

4.6
Karol Lindquist working on Nantucket lightship basket. Photograph by Jeffrey Allen

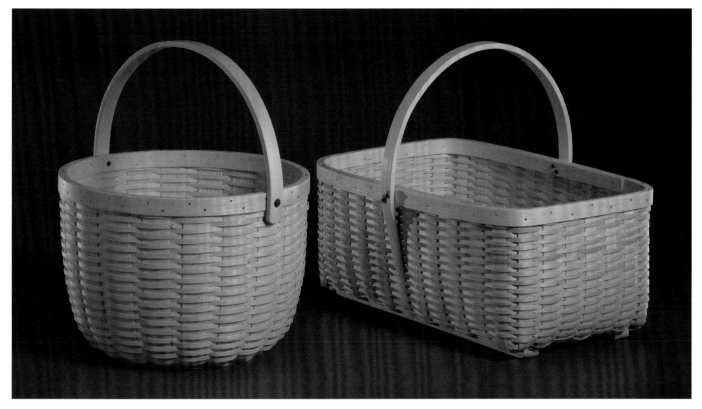

Peck basket (left),
New England pounded-ash
basketry by Milt Lafond, 2007,
ash and bass wood, nails,
14 1/4 x 12 1/4 x 11 3/4, and small
market basket, New England
pounded-ash basketry by Milt
Lafond, 2007, ash and bass
wood, nails, 13 1/2 x 17 x 10 3/4.
The Basket Shop—Milton and
Janet Lafond

might put some yarn in it that they'll never use," Timalyne adds. "It's more like buying a painting. Put it up to look at it, admire it." There is no question that the lightship basket has become a popular and expensive status symbol and an icon of the island. Well aware of this, Timalyne says, "Can you imagine somebody spending as much money as they [do] now and then taking one out to pick blueberries with it? Getting stains on the inside?"

The finer the basket, the harder it is to let go. "I was just thinking about handbags and how they are used," Timalyne ponders, "and the fact that we watch them go out in pristine condition and then the world happens to them. I remember seeing two kids, probably eight or nine, each with their own little miniature purse. One girl tripped on uneven bricks and the basket just slammed into the ground—my worst nightmare of what would happen to a basket that I sent out into the world. Who knows how much time went into that particular basket—it was just heartbreaking to see. But you hope that your basket does get used somehow, so it's sort of a mixed feeling."

Basket making in the Berkshires differs in both form and material. Milt Lafond continues a style of basket making that has been passed down for three generations in the same shop, using the same molds, tools, and method of construction.[3] His pounded-white-ash baskets are noteworthy for their lasting sturdiness, the uniform quality of their weave, and the beauty of their form (cat. 4.7). The sturdiness of Milt's baskets reflects the history

4.8

Milt Lafond using a drawshave.
Photography by Jessica Payne

of their use in rural agricultural communities like the hill towns west of the Pioneer Valley, where he was born and now lives and works. With farming as a primary livelihood for the majority of families, baskets were essential utilitarian tools for harvesting crops. These baskets were used by women to do their shopping and to carry their pies and picnics, but they also needed to be especially well-constructed and strong enough for loading, carrying, and storing potatoes, onions, cucumbers, squash, and other local produce.

Milt's father-in-law, Ben Higgins, was able to earn his living making and selling hundreds of these baskets a year—he became so renowned that his work is known regionally as "Higgins Baskets." Milt doesn't produce the volume that Higgins did, but he maintains a lively business. People buy his picnic baskets, pie baskets, hampers, plant holders, and bushel baskets as gifts, anticipating that they will be used but knowing they will be appreciated primarily for their decorative beauty. He remains one of few who still execute the whole process, from cutting the tree to weaving the basket. White ash trees are selected from native woodlands. The logs are split into wedges and roughly shaped with a drawshave (cat. 4.8). The trees must be broad enough so the knotty heartwood can be discarded. The four-inch wedge that remains is shaped by a planer for pounding. Only ash can stand up to the pounding hammer and has the unique characteristic of splitting between the growth rings. The split ash strips, each representing a year's growth of the tree, are planed smooth and are now ready to be woven. A variety of wooden molds are used for the weaving, and a basswood bottom with thick vertical ash strips makes the sturdy base for each basket. The rims and handles are made from quarter-sawed white ash, which is steamed and bent over forms and then attached with small nails to complete the basket. Baskets vary in size from five to six inches in diameter to peck, half-bushel, and bushel. Styles include pie baskets, egg baskets, picnic baskets, wood baskets, fruit and berry baskets, hanging plant holders, pack baskets, and clothes hampers.

JoAnn Catsos and her husband Steve harvest and process black-ash splints from trees felled near their home in the southern Berkshire Mountains. They also make the wooden molds over which each basket (cat. 4.9) is woven, and the hardwood handles and rims. JoAnn first learned to work with reed, but she soon discovered black-ash splint basketry. The experience was transformative, she says: "It was like magic. There was something really special about that material."[4] JoAnn is known for her original black-ash designs. Having won numerous awards, she teaches at basketry guilds, conventions, and crafts schools

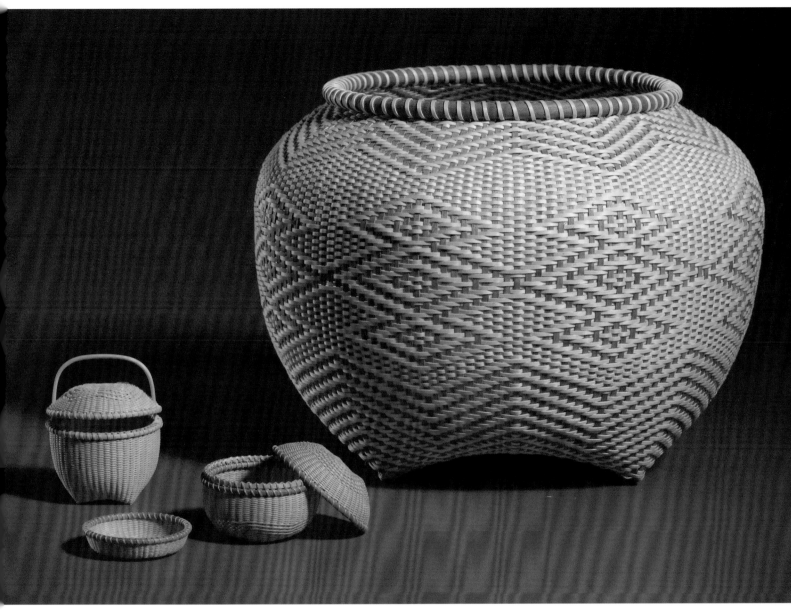

4.9

Three baskets by JoAnn Kelly Catsos. Jewel, *miniature quadrafoil lidded cat-head basket, Shaker basketry, black ash splint, 2 1/2 x 2 diam.;* Charm, *miniature quadrafoil lidded sewing basket with quadrafoil tray, New England basketry, black ash splint, 1 3/4 x 2 1/8 diam.;* Cherry Jubilee, *octafoil twill basket, 2006, black ash splint, 6 7/8 x 9 3/8. Collection of the artist*

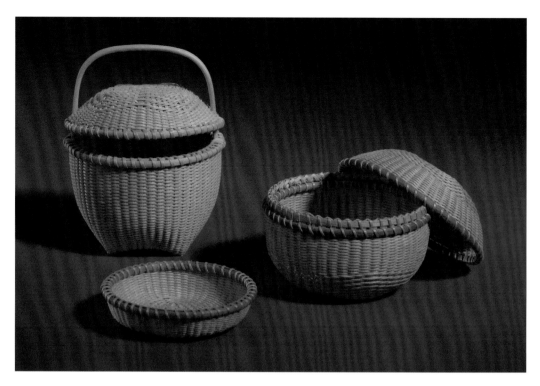

across the country. With a busy teaching schedule, she has time to weave only a handful of her special baskets each year. These baskets are displayed in invitational basketry exhibitions nationwide. Miniatures are her passion, like the ones pictured here, which measure two inches in diameter and are woven of splint that is 1/64 inch wide. In JoAnn's words, "There are sixty-four rows to an inch. We call the splints square hair because it feels like working with a splint of hair." It is hard to imagine how she weaves with such precision on such a tiny form (cat. 4.10).

Before wood-splint basketry became widespread, Native peoples throughout New England made soft-form baskets out of other natural materials such as corn husks, rushes, bark fibers, and grasses. Few of these survive save for archaeological fragments, but there has been a revival of twining among the Wampanoag and Narragansett tribes. Julia Marden is an Aquinnah Wampanoag who grew up in Falmouth. She learned the art of twined basketry while working at Plimoth Plantation. Twining is a technique in which one wraps and twists two weft strands around a warp strand. Marden's work is notable for the fine, tight quality of the twining. These two pieces (cat. 4.11) are from the permanent collection of the Mashantucket Pequot Museum. Historically, this type of soft-form basket was used to store food such as dried fruit, seed corn, and berries. The quiver for arrows is easily carried over the shoulder. Marden also twines sashes and garters for ceremonial dress.

The use of porcupine quills to decorate baskets, boxes, garments, and other items was practiced by woodlands and Great Plains Indians prior to European contact. The tradition

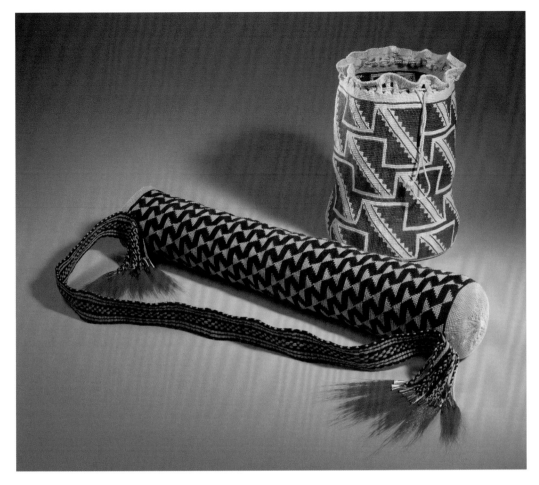

4.11

Quiver, Aquinnah Wampanoag twined basketry by Julia Marden, 2005, natural undyed linen twine, 3 1/2 diam. x 22 1/2; soft-formed basket with drawstring top, Aquinnah Wampanoag twined basketry, 1998, 11 x 7 1/2 diam. at base. Mashantucket Pequot Museum and Research Center

has been revived by Dave Holland, who makes a form of regalia that dates back to the early eighteenth century. The designs are inspired by the Anishanaabe peoples of the Great Lakes region.

This tobacco pouch (cat. 4.12) is patterned after an early eighteenth-century accoutrement that Native people in this region carried. It is made from smoked, brain-tanned (a traditional way of softening a hide by using brain matter as a tanning agent) deerskin. The quill work on the thunderbird uses what is called a netting technique. The quill is wrapped around a pair of threads: "The last couple of turns, I make a loop—then the tail end of the quill is pulled up inside of itself, locking it in place," states Dave. He uses linen rug yarn but notes that years ago, Native peoples employed leather thong fibers from bark or nettles. The triangular shapes in black and brown are made in a zigzag technique with a pair of parallel threads. Each thread catches the surface of the quill, just 1/32 of an inch, not all the way through the quill. The quill is softened and flattened before it is applied.

This shoulder bag (cat. 4.13) is patterned after a mid-to-late eighteenth-century bag. Its square shape is said to be an imitation of the bags European soldiers carried. The quills

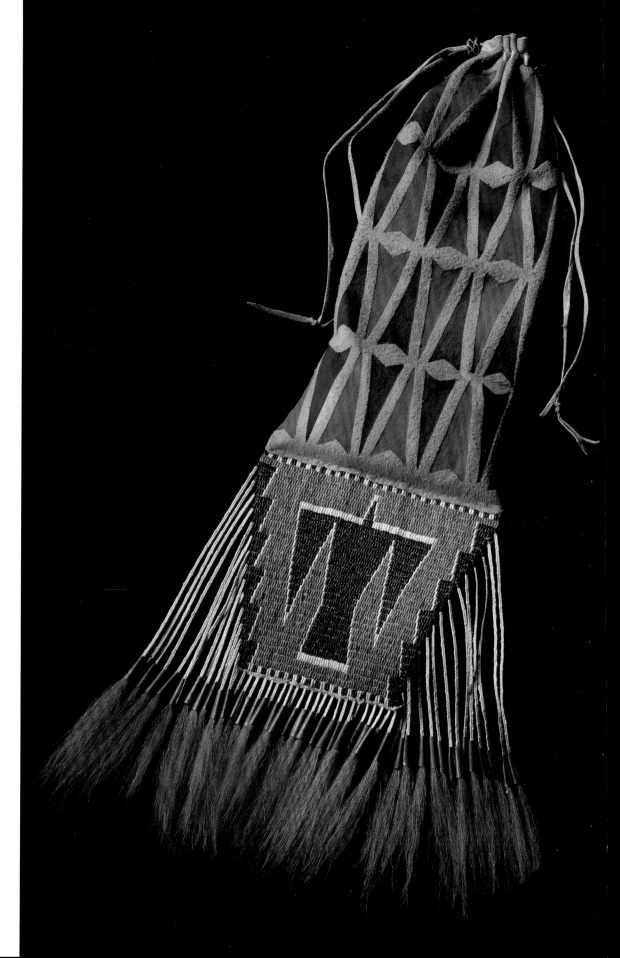

4.12

Tobacco pouch, Native American regalia inspired by eighteenth-century Anishinaabe design, by Dave Holland, 2007, deerskin, porcupine quills, 23 x 6 1/2 x 1 1/2. Collection of the artist

4.13
Shoulder bag, Native American regalia inspired by eighteenth-century Anishinaabe design, by Dave Holland, 1997, deerskin, porcupine quills, 32 x 11 x 2. Collection of the artist

are sewn to the leather with an artificial waxed thread. The decorative tassels are made of white deer tails that have been dyed red, and they are fastened with copper cones.

Holland's work is highly respected by people who know quill work.[5] Pieces he makes are used by pow wow dancers and reenactors, as well as in film work, including films made for the Mashantucket Pequot Museum. When asked how he got started making regalia, he responded, "I used to do some reenacting myself but I couldn't afford to buy the regalia.

4.14
Ben's Sampler,
*New England
cross-stitch
embroidery by
Susan Hadley-
Bulger, 1995,
single-strand
silk and linen,
9 3/8 x 4 1/4 x 1 1/4
framed. Collection
of the artist*

[But once] I found a road kill, and the rest is history." A friend from the Penobscot tribe in Maine recently gave Dave a huge box with 80,000 quills in it.

It is a gift to my children. To do something from the hand is to do something from the heart. It connects me to my ancestry. —Susan Hadley-Bulger, cross-stitcher

Hadley-Bulger learned the exacting art of cross-stitch embroidery from her grandmother, Margery Elizabeth Baker Wilkish. The tiny stitches are made with single-strand silk thread on band samplers, a traditional English form of needlework. "My grandmother did indeed teach me how to stitch the simple marking stitch when I was five years old. Her 'lessons' were held in my great-great-grandmother's house, in Davisville, East Falmouth," says Susan.[6] Her grandmother was a demanding teacher. No knots were allowed; instead, the tail threads had to be woven back in. The implicit lesson was that if you are going to do something, do it right.

In the old days, not everyone could afford a pattern book, so patterns were shared. Numerous patterns incorporate elements of nature, for example the stylized strawberry, rose, honeysuckle, and acorn. Some date back to the sixteenth century. The band samplers were used to decorate clothing or to teach a schoolgirl her elementary needlework. The patterns that were traditionally rolled up for future reference in sewing baskets have now been revitalized and reworked for the next generation's heirlooms.

Susan's samplers are small, ranging from 4 by 8 to 5 by 11 inches. On the smallest, the thread count is high; forty counted stitches up or down make not quite 1,600 stitches to the square inch! Susan traditionally counts two threads warp and weft per stitch. Stitched on a beige linen background, the silk thread colors are subtle. These samplers are basically family registers, with children's names and ages. Some of the samplers have thirty different kinds of stitches. One of her samplers lists all the women in the family, dating back to 1620 (cat. 4.14). She made one for her son Benjamin, her first attempt to duplicate early English and Italian laces.

For Susan, these samplers are acts of love. Most have been made for family members, including each of her ten children—Eliza Hope, Jeremy, Zachary, Emily, Samuel, Jonathan, Nathaniel, Joshua, Benjamin, and Amanda. She frames the samplers without glass to keep moisture from being trapped. Attached to the back are sentimental items: a birth certificate, a hospital birth bracelet, a first grader's attempts at writing a Mother's Day card, and a personal letter (cat. 4.15). An excerpt from this letter, to her daughter Eliza, reads, "Eliza Bourne Fuller Davis would have spoken your siblings' names in her day; theirs, too, are gleaned from family lore. . . . At four months of age, you caught your reflection in the same mirror your forebearer had as a young bride. Could you see even then the face of both our future *and* our past? Welcome, Baby Eliza. May you learn the tales of whales and fishermen, long swishing skirts, and dancing bears for another time, another day."[7]

4.15
Eliza's Sampler,
New England cross-
stitch embroidery by
Susan Hadley-Bulger,
1998, single-strand
silk and cotton,
8 7/8 x 4 7/8 x 7/8
framed. Collection
of the artist

Aline Drivdahl was born in the United States to Norwegian parents, but lived with an aunt in Norway from age eight to age eighteen.[8] She resides in Fairhaven, a coastal town in southeastern Massachusetts that attracted many Norwegians for its work opportunities in the fishing industry. Aline is primarily self-taught in the art of Hardanger embroidery, a form of cutwork embroidery that originated in the Hardanger region of Norway. Typical Hardanger pieces include tablecloths, runners, curtains, and baptism dresses. She observed her aunt's mother doing the embroidery and then took one of the pieces and dissected it to learn the technique. Her preference is for white thread on white cloth, as seen in this white cutwork table runner (cat. 4.16). Needles have to have a dull point, and incredible precision is required in counting stitches. The cutting happens after all the stitching is complete; the threads are then pulled out to make holes. "The stitches need to be very tight. You cannot use a frame to achieve this. It must be sewn over your finger." When the piece is finished, it is boiled in a pot of soapy water to tighten the threads.

Aline is very well respected for her skill in the local Norwegian community of Fairhaven and was asked to make the altar cloth for Trinity Lutheran Church. Like many accomplished needleworkers, she has never sold anything except for small pieces to raise money for the church. She makes the pieces as wedding, birthday, and Christmas gifts for her family. The beauty and exactitude of her craftsmanship are captured in this detailed image (cat. 4.17).

*Finnish weaving (reversible)
by Helmi Salo, 1985, fine
wool, 49 x 20. Collection of
the artist*

As beautiful as they are, I'm sure they were made for warmth first.
—Helmi Salo speaking about Finnish weavings

Salo's parents grew up in Finland and later settled in Maynard, Massachusetts, along with other Finns who found work in the American Woolen Mill.[9] She realizes now that growing up with immigrant parents, she took Finnish weaving for granted. But she became interested in weaving only after she started working at the Perkins School for the Blind in Watertown. The school had many looms, and she began taking courses in weaving from various guilds in the region.

Salo (cat. 4.18) and her husband joined the Finnish Heritage Society in the 1950s. "I think we danced every Saturday night for 90 percent of the fifty-five years we had together. That was how we met." When her younger daughter was an exchange student in Finland, Helmi met her there and traveled for three weeks. "It was like going home," she says. In Finland, she toured craft shops and met many weavers among friends and family, and she learned from them. She now focuses specifically on Finnish weaving.

It was in an orphanage in Aleppo, Syria, that Almas Boghosian learned how to make lace (cat. 4.19).[10] When Almas was seven years old, her family fell victim to the Armenian genocide. She describes being given just enough food to stay alive, and that she was taught to make lace to sell for export to America in support of the orphanage. At age sixteen, Almas was sent to live with her aunt and uncle in Whitinsville, Massachusetts. Other Armenians had settled in the area to work at the Whitin Machine Works. Her aunt and uncle had seven children and very little money, so they encouraged her to marry one of their board-

ers, twelve years her senior. "They fixed me up. My auntie, she fixed my hair just like [a] grown-up and she put me in her dress. I look in the mirror, I'm grown-up. [Katchador] my husband, boarded [with my relatives]. At that time, [boarders] come from all countries. And they fixed me with him. I didn't know anything from life. Nothing! God be my witness." Once married, Mrs. Boghosian focused her time on raising her three children and began making lace again when they were teenagers.

Almas, who turned one hundred this past July, makes her lace collars, doilies, and handkerchiefs without the use of patterns. The round needle laces shown here are characteristic of fine Armenian lacework. The delicate design is started at the center and gradually expanded. A circular lace doily measuring eight to ten inches requires six hundred yards (six football fields) of thread to complete (cat. 4.20).[11]

It's not delicate, but requires skill and complexity.
—Anahid Kazazian, *marash* embroiderer

Anahid Kazazian learned to make *marash*, a complex form of Armenian embroidery, from her mother, whose family came from Marash in Cilicia. The colorful needlework is used to decorate sturdy fabrics in the home, for example tablecloths, pillows, and comforters. The popular name for this kind of embroidery is *khach kordz* or "cross work," because it is made up of a series of cross stitches. "*Marash* is peasant work. It's usually very colorful, on velvet. It's an art form to do the design. It is intricate, continual work, and you can't make a mistake. It's exactly like the frame of a house. If you make a mistake, the house will someday fall apart (cat. 4.21)."[12]

During the Armenian massacre, Anahid's parents fled with many others from their hometown to Aleppo, Syria, and eventually resettled in Beirut. Although Anahid grew up in Syria and Lebanon, where her father was a rug merchant, she identifies herself as *Marashti*, meaning "from Marash." "I am not the work I do. Whatever I have is a continuation of what my mother is. Everybody is not simply who they are, but also part of what came before. There is always a source for the brook."[13]

The Armenian women continued to stitch *marash* embroidery in Syria, but they had also brought old, treasured pieces of needlework with them. Anahid saw these beautiful pieces and wanted to learn. When she was eleven years old, she had to stay home from school for two months with a broken leg, and during this time she persuaded her mother to teach her *marash* work. "It was like a puzzle, the way the crosses went together, and I loved it." Anahid says that in her mother's time (her mother, Marie Janzuzian Dakessian, was born in 1901 and died at the age of one hundred), all the women embroidered. But as Anahid was growing up, there was already less of it. "Now it seems that *marash* embroidery has almost disappeared." This makes the family heirloom pieces that much more precious. One was made nearly 150 years ago by Anahid's paternal grandmother, Lucia

4.19

*Doily, Armenian needle lace by Almas
Boghosian, c. 1950s, cotton and polyester
thread, 11 5/8 x 11 5/8 x 3/4 framed. Collection
of the artist*

4.20

Detail of Armenian needle lace.

Collection of the artist

4.22

Anahid Kazazian holding marash *work done by her paternal grandmother, c. 1866. Photograph by Maggie Holtzberg*

Dakessian, for her daughter's trousseau. The denim fabric was woven on a foot loom and the embroidery thread was hand-dyed and hand-spun (cat. 4.22). Even though *marash* is known as a peasant form of needlework, it is anything but simple. "We refer to it as *gaghtnaker* or "secret needlework" because you can't tell how the pattern is made by looking at it—you have to be taught." One begins by printing designs on heavy cloth such as velvet, wool, or thick cotton.

Anahid Kazazian was one of the Massachusetts craft and performing artists featured on the National Mall during the 1989 Smithsonian Folklife Festival. It had been twenty years since she and her family emigrated from Lebanon, but she felt she had not set down roots. "I was a mother, I immigrated, I am a citizen. But I had not made roots." She looks back at her participation in the festival as a transformative experience. "These fifteen days were my christening of being a citizen. I really felt it. From then on, I really feel I have to give too. It's not take, take, take. Because the immigrant comes, works, is paid. There is money, there is car . . . but what do you give back? You don't think of it."

One of the first things Jeanne Fallier told me after welcoming me into the family room of her Westford home was, "I've been hooking for fifty years."[14] At age eighty-seven, Fallier looks ten to fifteen years younger—lovely skin, wavy white hair pulled up in a bun, beautiful hands free of arthritis, and her agility going up and down stairs belying her age. She lives alone, having lost her husband years ago. Evidence of Jeanne's needlework is in every room of her house. Not only is she a prolific rug hooker, but she also paints. The majority

4.21 (opposite)

Marash, Armenian embroidery by Anahid Kazazian, 1951, velvet, cotton thread, 30 x 24 x 1 1/2 framed. Collection of the artist

of her work is inspired by extensive travel. In place of snapshots, she designs rugs and creates paintings to commemorate trips taken throughout the world: to China, New Zealand, Australia, Norway, Scotland, and the American Southwest. Every surface in her house is covered either with rugs, rug-making supplies, or numerous papers. She also makes miniature scenes, including a rug-hooking studio, "the way a rugging room is supposed to look," a theatrical set for a castle fairy tale, and human and animal characters (cat. 4.23). In fact, the studio has a theatrical flair. Swooped, stagelike curtains hang in the entranceway, and an embroidered sign with the lettering "Rug hooking studio" rests on an easel nearby.

As a child, Jeanne learned embroidery and tatting from her grandmother, but she found her calling in hooking rugs, which is "faster and more satisfying." She adds that a good "hooker" combines "artistic ability with a versatile craft." She learned hooking through the Home Bureau, a more urban version of the Grange (grange hall, a fraternal order for American farmers), on Long Island. After moving to Massachusetts in the 1970s, she was founder and first president of the Massachusetts and Maine chapter of the Association of Traditional Hooking Artists (ATHA), the guild of rug hookers.

Traditional rug hooking uses a hand hook, similar in shape to a crochet hook, to form a looped pile from fabric strips or yarn on a burlap or linen backing. The origins of this technique are unknown, but hooking is said to be centuries old and established in various parts of the world. It gained popularity in nineteenth-century New England as a way to recycle old clothing and feed-bags, and it became popular again during the Colonial Revival of the 1920s, when cottage industries sprang up to sell hand-hooked rugs. By the mid-twentieth century, when Jeanne began hooking, the art had evolved into a means of personal expression as well as a practical pastime, and it also helped keep handicrafts alive when machine-made items were becoming widely available.

Jeanne designed Westford's 250th anniversary rug, and she made twelve reproduction rugs for Beauport, Historic New England's house in Gloucester. She also does repairs and restorations, currently working on a late eighteenth-century rug that, like many, is coming apart because its burlap backing has deteriorated.

Several of Jeanne's rugs are featured on recent book covers, and she has exhibited her work at the Chelmsford (Massachusetts) Arts Society, the Eastern States Exposition, the National Heritage Museum in Lexington, and elsewhere. She also writes for *Rug Hooking* magazine, edits the ATHA newsletter, and has published several books on her designs and techniques. When asked what satisfaction she gets from rug hooking, Jeanne answered, "It's the best therapy in the world. I couldn't have gotten through my husband's illness without it."

The view from the back window of Jeanne's home inspired this hooked winter scene (cat. 4.24). You can spot animal tracks in the snow. The view motivated her to compose the poem, "The Patterns of Winter." Two stanzas appear below:

4.23 (opposite)

Turkey, New England hook work by Jeanne Fallier, 2004, wool on linen backing, 7 1/2 x 7 1/2. Collection of the artist

4.24
Winter Scene,
New England
hooked rug by
Jeanne Fallier,
1989, wool strips
on burlap backing,
40 1/2 x 29 x 2
framed. Collection
of the artist

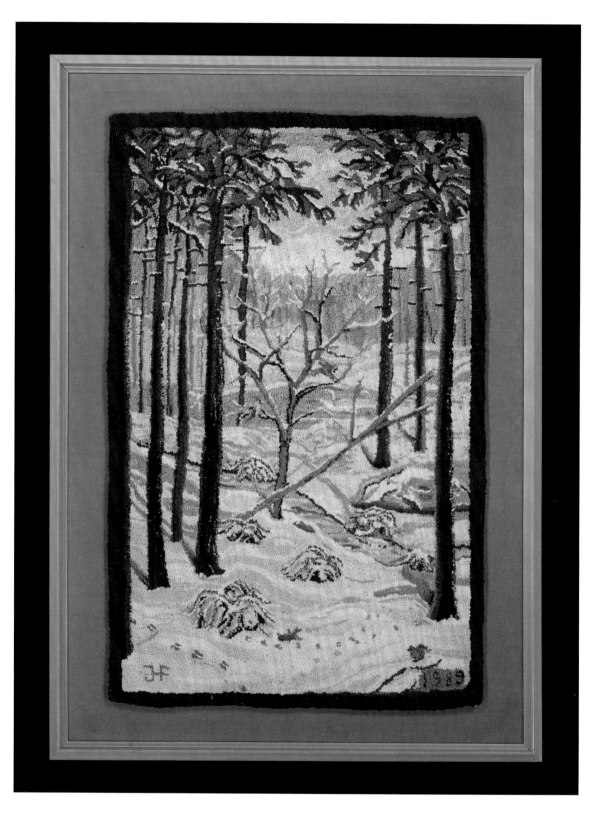

Black ice, visibly encasing
Fine green water foliage
With crewel-designed rows of bubbles
Frozen en route to the top.

Fire—a flash of brilliant red
Streaking through the darkness
Of winter woods, on wings
Of a cardinal in flight.

A native of Lowell, Sally Palmer Field (cat. 4.25) says she's "been sewing since I could hold a needle."[15] She learned quilting from an aunt on the family farm in Maine who showed her how to use a quilting frame, and she made her first quilt with old wool carded and spun on the farm. She also helped her mother with tied quilts. "Lots of people look down on tied quilts," she observes, "but they're very practical. Mother had five children. She made quilts that kept them all warm."

Sally and her work have strong local connections. Her father was an agent for Locks and Canals and had his office in the Merrimack Mill. As a child, she collected scraps of fabric from manufacturers like the Ideal Dress Company on Bridge Street. Ideal Dress made housedresses and housecoats sold in local shops, and "lots of women learned to power machines there"—skills that were useful in World War II production plants. Sally later worked some of those Ideal-made fabrics into quilts. This *Mile of Mills* wall hanging (cat. 4.26) features the Merrimack, Boott, Hamilton, Newmarket, Wannilancit, and Hockmeyer mills and is sewn with Meyer's thread. It also incorporates tiny pieces of locally made corduroy and nylon woven for parachutes during World War II.

Sally ran a quilt shop out of her Chelmsford home for many years. She taught quiltmaking classes there to scores of women. This quilt of brown hues, called the *Sampler of Miniatures* quilt, was ideal for teaching quilt patterns. Every one of the 176 squares shows a different pattern (cat. 4.27).

Dianne Zimbabwe makes Malian mud cloth paintings known as *Bogolan*. She learned from AlFousceiny Kelly who grew up in Songhai, Mali, where he mastered the art of mud painting.[16] *Bogolan* translates as mud or clay painting; *bogo* means mud or clay and *lan* is the process of painting the clay on a surface. *Bogolan* means fine (cloth). The cloth is cotton woven in Songhai. Dianne traveled to Mali in January 2007 to study with master mud painter Nene Thiam. She was drawn to the fact that this painting is done with nontoxic materials. In Mali, mud painting has traditionally been done by women. Dianne uses a dried plant substance called *n'galama*, which grows in Mali. It is used to dye the cotton

4.25

Sally Palmer Field (b. 1922) standing in the doorway to her home. Photograph by Maggie Holtzberg

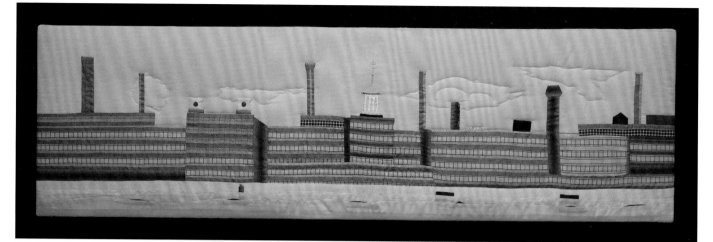

4.26

Mile of Mills, wall hanging,
New England appliquéd quilt
by Sally Palmer Field, Lowell
textile mills cotton fabric,
18 1/2 x 63 1/2 x 1 1/2. Collection
of the artist

4.27

Sampler of Miniatures
quilt, New England pieced
quilt by Sally Palmer Field,
cotton fabric, thread, 88 x 61.
Collection of the artist

4.28

Niger River *(left), Malian mud*
cloth by Dianne Zimbabwe,
2007, yellow Malian cotton
cloth, mud, 88 x 5; Pilgrimage,
Malian mud cloth by Dianne
Zimbabwe, 2007, yellow
Malian cotton cloth, mud,
and n'galama *leaves, 64 x 5.*
Collection of the artist

cloth and gives it a golden color. Mud from a riverbed is used for the brown color and is applied two to three times. A tree bark called *m'pekou* is used for a reddish brown color.

These long strips of hand-woven, hand-painted cloth (cat. 4.28) can be used as part of traditional clothing, or as a wall hanging. Dianne was inspired to make these after a trip to Mopti, Nigeria. "I went to the River Niger and saw fishermen out casting their nets. I went to the Island of Boso. The people are very friendly." Notice the fish motif, an eye or earth motif, and a water motif.

The art of rosemaling, or "rose painting," is emblematic of Norwegian ethnic identity (cat. 4.29). Itinerant painters traveled throughout rural Norway decorating interior walls, ceiling beams, corner cabinets, furniture, and wooden dinnerware with floral patterns. The tradition flourished during the eighteenth and nineteenth centuries, but then dwindled when many Norwegians immigrated to America during the nineteenth century. Some say it all but vanished in Norway because it was considered a "peasant" art.[17] The tradition was revived in this country by Norwegian immigrants. The greatest number of Norwegian Americans lives in the upper Midwest, but smaller communities settled in other regions,

4.30

*Rosemaling bowl,
Norwegian decorative
painting by Rebecca
Wilhelmsen, 2001–2002,
wood, paint, 10 diam.
Collection of the artist*

including one in the New Bedford and Fair Haven area where immigrants came to work in the fishing industry.

These Norwegian rosemaling pieces were made by Rebecca (Becky) Wilhelmsen. Her mother-in-law, Helen Wilhelmsen, was reputedly the best rosemaler in the local community of Dartmouth, Massachusetts. While Rebecca did not learn directly from Helen because of Helen's failing health, she did study with National Heritage Fellow Eldrid Skjold Arntzen of Windsor, Connecticut, the teacher who taught Helen. *C* and *s* strokes form the basis for most of the rosemaling designs, and fine details and clean brushstrokes make a fine-quality piece.

This bowl (cat. 4.30) was actually "turned" by a cousin of Rebecca's father-in-law, an eighty-one-year-old woodworker who learned the craft in his homeland of Norway before coming to the United States. His name is carved into the bottom of the bowl: Harald Thuestad. Written in Norwegian along the rim of this wooden bowl is the following invitation:

> Pour ale in me
> And set me on the table for the guests
> To give them a lift
> And quench their thirst
> So they dance the *halling* freely.
>
> (The *halling* is a vigorous dance for men.)

4.29 (opposite)
*Rosemaling Ambar,
porridge container,
Norwegian decorative
painting by Rebecca
Wilhelmsen, 2001–2002,
wood, paint, 11 x 6.
Collection of the artist*

4.31
In wetu,
cooking pot,
Wampanoag
pottery by
Ramona Louise
Peters, no date
given, clay,
composite, pot
17 x 9 1/4 diam.,
assembled on
rocks 19 x 16 x 16.
Collection of the
artist

Ramona Peters, also known as Nosapocket, is a member of the Mashpee Wampanoag tribe of Massachusetts. As a potter, she has been central to the revival of seventeenth-century Wampanoag forms in clay from her tribal tradition. Her work resembles Native cultural expression before European contact. "Pottery was, and is, elaborate, sacred, and magical. In addition to these properties, the shape teaches about combined male/female energies used as the foundation of cooking pots. The body of each pot is female; it is round and full and the place of nurturance where animal, vegetable, mineral, plus the elements of fire, water, and air combine to strengthen human life forces. The collars or tops of the pot are male, [and they] often have four points representing the four directions where people seek food and knowledge. The bottom of the pot is pointed, yet not sharp, allowing it to sit in the coals without smothering them."[18]

Traditional Wampanoag potters were keenly aware of chemical combinations best suited to their wares. By crushing specific rocks and shells and adding prepared solutions, they created clay bodies that attracted favorable magnetic energies from the atmosphere. These vessels enhanced food as medicine and increased tribal members' potential, in Ramona's words, "to become vessels of love and wisdom" (cat. 4.31).

Ramona has been commissioned to make reproductions for Plimoth Plantation based on archaeological artifacts, including two seventeenth-century Wampanoag cooking pots. These works are particularly meaningful, she says, "allowing me the honor of reviving my ancestors' choice of functional art that endures time. In giving thanks, they mold me."

While the making of folk craft, dance, or music is a life force for the majority of the artists whose work is featured here, it is rarely as dramatically a matter of life and death as it has been for Yary Livan. A Cambodian master ceramicist, Livan is the sole survivor of his generation of artists trained in traditional Khmer ceramics at the Royal Academy of Fine Arts in Phnom Penh.[19] Forced to hide his education to survive under the Khmer Rouge, it was ironically his knowledge of traditional wood-burning kilns that saved him from certain starvation.

Yary's mother, a fashion designer skilled in both traditional and contemporary creations, first inspired his interest in art. He was among the top ten applicants from throughout the country in the entrance exam to the Royal Academy in the early 1970s. He was assigned to specialize in traditional Khmer ceramics,[20] which included knowing how to build and operate a kiln and how to make molds. He learned firsthand from traditional Cambodian master artists and craftsmen, and he has kept their traditions alive despite the intense persecution of these artists that eradicated the cultural and economic life of Cambodia.

The development of Cambodian ceramics throughout the Khmer imperial rule (ninth through thirteenth centuries) was largely overshadowed by the highly evolved tradition of Chinese ceramics. Ceramics as a fine art was first introduced into the teaching curriculum of Cambodia's Royal Academy of Fine Arts in the 1960s. By this time, the work of restoring

and repairing Angkorian ancient monuments had already begun. Yary incorporates elements from the ancient Angkorian tradition of design in his ceramics, similar to those seen in the bas reliefs at Angkor Wat (cat. 4.32).

Yary was nearing the end of his art training when the Khmer Rouge suddenly took control of the country in April 1975. He joined the more than two million people who were marched out of Phnom Penh, resettled in the countryside, and forced to dig ditches and perform agricultural tasks. More than 90 percent of artists, artisans, musicians, and intellectuals were systematically eliminated during the reign of terror. Admitting to anything suggestive of an elite upbringing meant risking execution. Three years of unspeakable hardship followed. Yary's mother became aware that the Khmer Rouge soldiers were desperate for kilns in which to fire roof tiles and informed them of Yary's skills as a ceramicist. He was working on building wood-burning kilns when the Vietnamese routed out the Khmer Rouge and freed Cambodia in early 1979.

Yary returned to Phnom Penh, but his refusal in 1983 to accept an "invitation" to be trained in Hanoi as a communist party official led to accusations that he was a member of the resistance movement. Anticipating imminent arrest, he fled with his family to Khao-I-Dang, hoping to be resettled outside Cambodia. Eventually they were granted the status of political refugees and allowed to live freely in a Thai refugee camp. But in 1991, Yary was repatriated as part of the Paris Peace Accord. Because of his previous refugee status, the Royal Academy refused to give him institutional sanction and he was forced to return to his hometown of Battambang. There he was part of the ceramics project run by a Japanese art organization in Battambang Province in the early 1990s. He began to work on small commissions at Buddhist temples that were being rebuilt, decorating them with painted scenes from the life of Buddha, but threats on his life continued. Thanks largely to his wife's job as a translator for the United Nations, Yary's visa was granted and he finally left Cambodia on July 13, 2001, for Lowell, Massachusetts (cats. 4.33, 4.34).

"It was by chance or rather by destiny," writes Samkhann Khoeun, then-president of Lowell's Cambodian Mutual Assistance Association (CMAA), that he encountered Yary while searching for a design director for the CMAA's third annual Cambodian New Year's Festival. Khoeun offered Livan his patronage, his basement for a studio, and his friendship. "As an artist, Yary is able to express himself well," Samkhann explains. "I find this true myself, that so much suffering and so much pain cannot be easily spoken. But, I find him to be more articulate, but still emotional, than most people I come into contact with."

Samkhann is not alone in this response to Yary. People in the arts education community have been unusually forthcoming in providing Yary with opportunities to share his knowledge of traditional Khmer ceramics and culture. Nancy Selvage, director of Harvard University's ceramics program and a nationally recognized potter, has given Yary the opportunity to teach at the studio for several years. Marge Rack at the School of the Museum of Fine

4.33

Elephant pot, Cambodian ceramics by Yary Livan, 2006, white stoneware clay, glaze, 9 x 10 x 10 1/4. Collection of the artist

Arts, Boston, brought Yary on board to help with a community-based program, Youth-Art-in-Action, which introduces young people to art.

It is clear that people feel deep affection for this man. Sally Reed, a graphic designer and well-regarded Massachusetts artist, met Yary just a few months after he had relocated to Lowell. She writes, "Yary is a diminutive person, and he was wearing donated clothing far too big. Pant legs and shirt sleeves were rolled up many times. With the help of a Cambodian friend I had a conversation with Yary who in that brief exchange let me know, artist to artist, holding a hand tenderly over his heart, that he wanted nothing more from life at this moment than the means to do his work. . . . I was immediately taken by the shadow of suffering in his face and by the brightness of his spirit. A few weeks after that first meeting, Yary spoke to me in English. His first complete sentence—perfect pronunciation, a reverend expression on his face, and his hands folded prayer-fashion in front of his chest: 'I love clay.'" Soon after, Sally visited Yary in the ceramics studio, after he had begun his residency at the Harvard ceramics program. She was overwhelmed by the amount of work he had ready for firing. It seemed to her the production of three or four full-time potters.

4.34

*Detail of elephant pot.
Collection of the artist*

"How could one man do this?" Yary answered her seriously, "In Pol Pot time, I work like an animal. An animal with fear. Now, I work like an artist. In Pol Pot time, my art spirit was almost dead. Now my art spirit is big, is strong, is on fire!"[21]

Michael L. Burrey is a timber framer by trade and a potter by passion (cat. 4.35).[22] Burrey apprenticed himself to Deborah Mason, Master Potter of Plimoth Plantation, where he developed his skills in using traditional methods to make reproductions of English and early American ceramics. He has spent years researching the materials, methods, and products of some of the earliest documented English potters who settled in Charlestown, Massachusetts, as well as those of the eighteenth- and nineteenth-century local potters. Working with local sources of clay, Burrey throws exclusively on a kick wheel and burns his ware in a seventeenth-century-style draft kiln at his Chittonville Pottery.

Numerous trips to England afforded Burrey the opportunity to research museum collections whose wares are typical of those exported to the colonies, and to learn firsthand from individual potters who are preserving early techniques (cat. 4.36). One form found on both sides of the pond is the Devon harvest jug, so called because of its use as a way to

4.35

Owl jug and cup, English and colonial American redware pottery by Michael L. Burrey, c. 2005, red clay and slip, 8 5/8 x 5 x 6 together. Collection of the artist

4.36 (opposite)

Devon harvest jug, English and colonial American redware pottery by Michael L. Burrey, c. 1999, red clay and slip, 9 1/4 x 8 (with handle) x 7 1/2. Collection of the artist

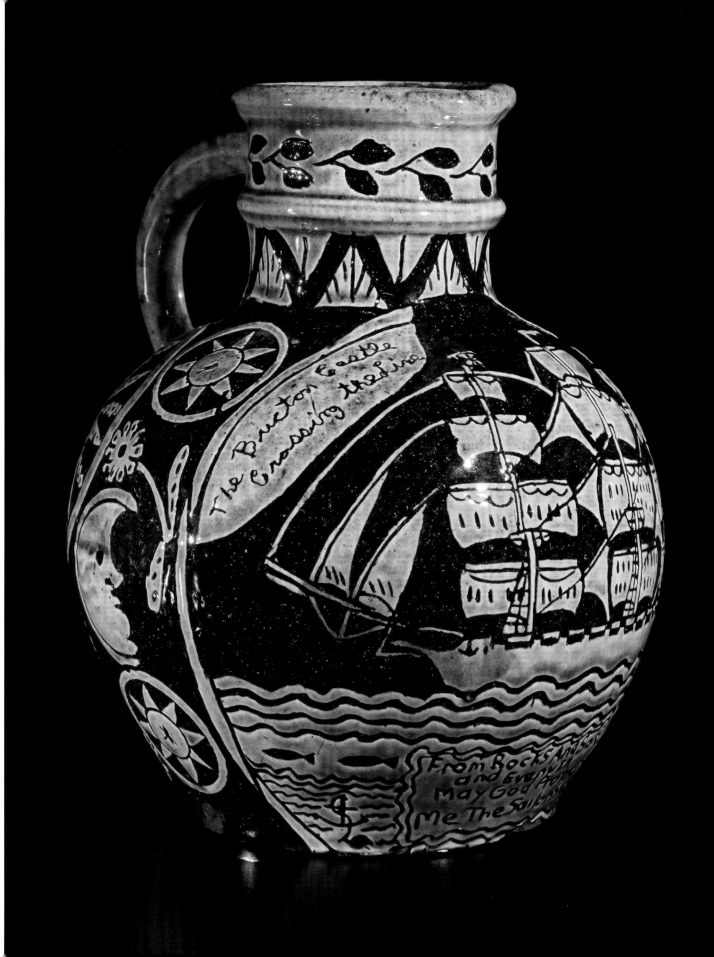

4·37

Detail of compass sgrafitto
*on Devon harvest jug by
Michael L. Burrey, c. 1999.
Collection of the artist*

carry beer out to farm workers at harvest time. The distinctive decorative glaze work on this jug is known as *sgraffito* (Italian for '"scratched"). This is done by coating the dried body of the pot with slip, a watered-down clay of a lighter shade. The decorative maritime motifs were formed by scratching away part of the dried slip to reveal the darker body underneath (cat. 4.37).

Rick Hamelin is another potter who operates in the historical redware pottery tradition.[23] At his Pied Potter Hamelin Redware in Warren, Massachusetts, he produces redware pottery that is relatively plain; he uses a clear glaze over red clay in a functional shape. The colors that decorate the ware are largely limited to golden hues (cat. 4.38). Because Hamelin is trying to make a living with his pots and related teaching activities, he has conformed to market demand by modifying his ware, including the patterns, to meet contemporary taste. He collaborates with his wife of seventeen years, Gariné Arakelian. This jug was hand thrown by Hamelin and decorated with *sgrafitto* by Arakelian (cat. 4.39). Hamelin explains the symbolism of the *sgrafitto*, "This vessel, from which life pours forth, is made of earth, fire, and water. It celebrates life with the symbolism of the elder berry-leaf pattern signifying love; the bearded face signifies knowledge. The simple spiral means both cosmic and personal spirituality."

Carl Close Jr. comes from a family of craftsmen on the North Shore. Born in Middleton, he began his study of metal working at the age of ten in his father's forge.[24] He also learned from his uncles and others in his community. He served as a welder in the Navy and later

4.39

Detail of bearded man's face on Ode to Longfellow's "Kéramos" *jug. Lent by Pied Potter Hamelin and Kulina Folk Art*

4.38

Ode to Longfellow's "Kéramos" *jug, English and colonial American redware pottery, a collaborative work by Richard Hamelin, potter, and Gariné Arakelian, sgraffito artist, 2007, red earthenware thrown and sculpted with slip and glaze decoration, 14 1/4 x 12 1/2 x 7 1/2. Lent by Pied Potter Hamelin and Kulina Folk Art*

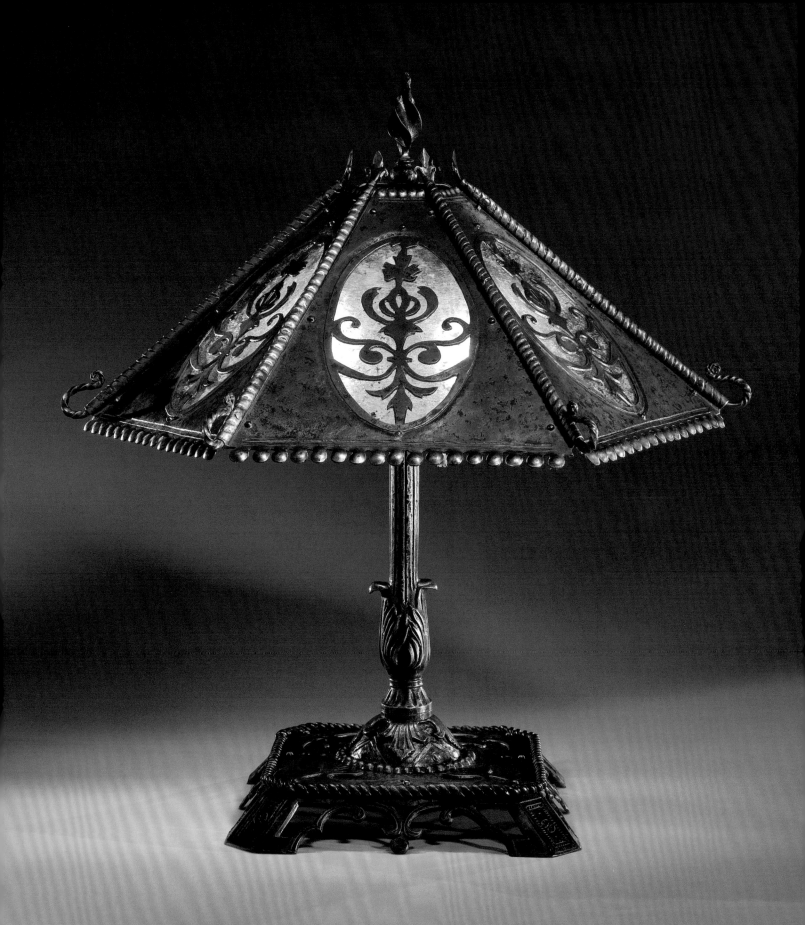

worked in an architectural ironwork company in Rowley, Massachusetts, before going out on his own.

Carl's iron artistry is reminiscent of the classical design revival of the early twentieth century, during the arts and crafts period. His work is marked by graceful lines, subtle texture, chased and chiseled openwork, hand forging, and repoussé (the shaping of metal by hammering from the reverse side) (cat. 4.40). Carl runs a business with his wife Susan out of a warehouse in West Concord. The gas-powered forges may be modern, but most of his anvils and tools were made in England in the 1890s. His materials come from scrap yards and modern companies making wrought iron. Carl demonstrates regularly at the National Park Service's Saugus Iron Works and at the Topsfield Fair; he teaches at trade fairs and to people from all over the world through the Artists Blacksmith Association of North America (ABANA).

George F. Martell is another highly respected metal worker.[25] He began as an apprentice to a Medfield blacksmith and then went on to work at a company as a machinist. Knowing of Martell's training as a blacksmith, the company's owner asked him to make some tools. Martell has also done work for companies that refine gold and silver. After a decade, he decided to focus strictly on custom ironwork and now runs Martell's Metal Works Corporation in Seekonk. He stresses the importance of being able to keep up with today's technology, for example computer-aided design, while remaining proficient in yesterday's technology, such as forge welding. Among his ironwork, 90 percent is for interior purposes. This section of stairwell railing (cat. 4.41) is the same as a railing for a home in Wellesley. In addition to making traditional railings, gates, and furniture, Martell has built an aviary for macaws and sculptures for both the Foxwoods and Mohegan Sun casinos in nearby Connecticut.

OUTSIDE

Much of a blacksmith's work can be found outside the home, on the landscape, or in the liminal space between. Here is an example of an English-style doorknocker made by Carl Close Jr. (cat. 4.42).

It makes sense that the best decoy carvers also tend to be lifelong hunters. Successful hunters have to be keen observers of waterfowl in its particular habitat. The carving of decoys has evolved to a fine and collectible art—and yet its origins are practical: the pursuit of fowl as a food source.

Jonathan Detwiler, an avid duck hunter from Norwell, explains, "Duck hunting originally got really big because it was a source of income for people. Hunters sold the birds they gunned down; it was market hunting. Consequently, they went to the utmost means to be successful. They meticulously designed and crafted boats that were low profile and that could be grassed. [The boats] had grassing rails on them so [hunters] could tie the

4.40 (opposite)
Hand-pierced and hand-carved lamp with mica shade, hand-crafted metalwork by Carl Close Jr., 2004, metal, mica, 23 x 22 5/8 x 19 3/4. Lent by Hammersmith Studios

4.41

*Section of interior
stairwell railing,
hand-crafted metalwork
by George Martell, 2006,
iron and bronze, 39 x 30 x 5 1/2.
Collection of the artist*

marsh grass to them. If the decoy wasn't of the proper proportions, if it didn't have the proper coloring or didn't ride in the water right, the ducks wouldn't come to it" (cat. 4.43).[26]

Bob Brophy would know. He grew up on a small farm in Easton. Both his decoy carving and hunting began in his early teens.[27] The family hunted for fowl and game, especially deer, in the Halamonk Swamp. Hunting was a natural part of the calendar year and a necessary food source during the winter months. Brophy is a superb wildfowl decoy carver who has won numerous decoy competitions (cat. 4.44). He has been known to say, "If it doesn't have feathers on it, I don't carve it." When asked what kind of birds he carves, Bob answers, "All the waterfowl that is native to New England." He has shelves full of decoys—and he puts them to use. The coldest day in February won't stop Bob from taking his gunning float (see cat. 5.17) out on the marsh by Hog Island. "There are quite a number of people carving, but they're not doing the old-style decoys. That's a lost art. I'm carrying it on but there aren't many left that do decoys. They can do a chickadee and sell it quicker than they can sell a black duck."

Brophy carves with knives, chisels, and files rather than power tools and is known as a "knife man" in the trade (cat. 4.45). He uses eastern white cedar for the body and basswood for the head, one block of wood for each. That way, he can direct the grain of the bill and keep it running with the bill. When describing the gluing together of these parts, he uses a boat expression—"to fare in the lines," which means he will smooth the wood up until the whole bird just flows together.

Brophy finishes his decorative birds with a small burning iron that can burn fine lines. "You can reproduce the veins of the feathers. And the feathers, as you noticed, they're stepped. They're carved in with a knife. Each feather is stepped up; it's like shingling a house." Painting has its secrets—to make the bird lifelike, he takes a very fine brass bristle brush and brushes the carbon out of the veins of the feathers. Otherwise, the carbon will burn through the paint. Brophy maintains a rig of working decoys and sells a few birds to a locale clientele. His decorative birds are convincingly lifelike and detailed (cats. 4.46, 4.47).

Bill Sarni grew up next door to Joseph W. Lincoln (1859–1938), a famous decoy carver whose decoys are sought after by collectors today, both here and abroad.[28] Community life at that time revolved around the natural environment, and Bill spent much of his youth hunting and fishing in the woods. He carved his first duck decoy in the early 1980s and soon took his first lessons in carving. But he clearly draws inspiration from the work of

4.42

Hand-wrought English-style doorknocker, hand-crafted metalwork by Carl Close Jr., 2004, metal, 16 3/4 x 10 1/8 x 2 1/2. Lent by Hammersmith Studios

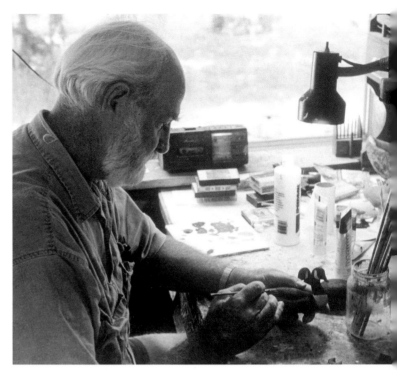

4.46

Black Duck, working decoy, Native and colonial American hunting tradition by Bob Brophy, 1974, wood, 6 3/4 x 15 1/2 x 7 1/2. Collection of the artist

four famous decoy carvers the town of Hingham produced: Joe Lincoln, Alfred Gardner, Russ Burr, and Ralph Laurie. He is largely self-taught and has collected and researched decoys made throughout the United States. He started carving full-time after taking an early retirement from structural engineering. Bill continues to observe songbirds, ducks, and shorebirds from his current home overlooking the Weir River.

Many would be envious of his workshop—a spacious, timber-framed building with a pot-bellied stove. His greatest joy comes from carving working decoys, those that are used by hunters to lure ducks and are called "smooth bodied" or "slick." They are copies of traditional period gunning birds. He also works on "contemporary" decoys, those that duplicate the living bird and take many more hours of intricate labor (to carve individual feathers, paint, and so forth). Bill uses only traditional tools. He has earned several awards and ribbons for his decoys, which are sought after by private collectors and on exhibit in several museum collections. Most recently, *Early American Life* selected Bill for the second time as one of the top two hundred traditional craftsmen in the country.

The wood drake duck (cat. 4.48) on the left is a copy of one made by Joseph Lincoln. Bill carved this decoy from native northern white pine, used glass eyes, and painted it in acrylics. The black-bellied plover is a shorebird carved from white cedar, with glass eyes and painted in oils. Shorebirds were hunted for legal game, along with the golden plover and the lesser and greater yellowlegs. They were removed from the hunting list in 1928, and all shorebird hunting ceased at this time. Note that the plover's dowel stick can be planted directly in the sand.

4.43 (opposite top left) *Jonathan Detwiler goose hunting on the North River with silhouette decoys in the background. Photograph by Maggie Holtzberg*

4.44 (opposite top right) *Bob Brophy working on a decoy. Photograph by Frank Ferrel*

4.45 (opposite bottom) Five Steps of Making a Green Winged Teal Decoy, *Native and colonial American hunting tradition by Bob Brophy, 1990, wood, paint, 6 1/4 x 35 1/4 x 11 plus pattern block. Collection of the artist*

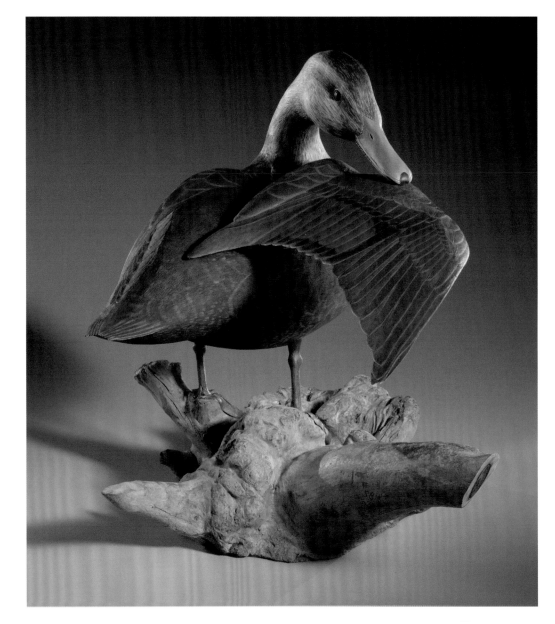

A distinctive feature in the New England landscape is walls built of stone. The ones you see winding through the woods in New England were built hundreds of years ago by residents who farmed the land. Before spring plowing, farmers had to clear their fields of rock boulders, which had been deposited more than ten thousand years earlier as a result of the receding glaciers.[29] Farmers piled up these round boulders to create freestanding walls without the use of mortar. These "dry" fieldstone walls were used more as makeshift barriers than to keep livestock in, which would require much taller walls. Eventually, much of the farmed land went fallow and returned to forest. While this is the pattern throughout

4.48

Wood Duck Drake, working decoy, Native and colonial American hunting tradition by William Sarni, 1986, cedar, 5 3/4 x 13 x 6 1/2; Black-Bellied Plover Shorebird by William Sarni, working decoy, 1993, pine, 14 1/4 x 12 1/2 x 3 1/2. Collection of the artist

most of the state, certain areas of Massachusetts have distinctly different-looking stone walls. "The walls on Martha's Vineyard seen standing in the fields have holes in them and are three to four feet high. They were used to keep sheep from wandering. The holes allowed the wind to pass through the taller walls so they didn't get blown over in wind storms."[30]

Nick O'Hara cares deeply about old fieldstone walls. His firm, O'Hara & Company, specializes in building dry fieldstone walls with indigenous boulders carefully harvested from farmland and forest. Over the past twenty years, this kind of hardscape (stone used

4.49

Dry fieldstone wall and home in Sudbury, O'Hara & Company. Photograph by Maggie Holtzberg

4.50

Detail of dry fieldstone wall, O'Hara& Company. Photograph by Billy Howard Photography

in landscape design) has become increasingly popular in high-end residential neighborhoods (cat. 4.49). A Sudbury family moved into this 1870 farmhouse and asked O'Hara & Company to build a wall matching the stone walls that line the property. Homeowner Renata Pomponi recalls, "It took Nick a year and a half to find the stones [and they came] from a farmer who was selling them off. It was important to us to use stones from a similar geologic formation. Once you cross Route 495 the rocks are different." O'Hara carefully disassembles a wall and lays the rocks on a bed of mulch in a truck to transport them, keeping the stones intact and preserving any lichen.

Building dry fieldstone walls (cat. 4.50) requires both brute strength and an artistic eye. Few gaps are left between the stones. This is very difficult to achieve when you are working with round yet irregularly shaped rocks. One stonemason described building dry fieldstone walls as "trying to put a bunch of basketballs together."[31]

Every hammer blow is an aesthetic decision.
—Travis Tuck, weather-vane maker

Another characteristic example of material culture found across the New England landscape is the weather vane. Simple banners used early on were replaced by highly decorative objects, which can still be seen crowning the tops of barns, meeting houses, and church steeples. Made to turn freely on a vertical rod, a weather vane was invaluable in foretelling the weather long before more modern ways of forecasting became available. One had only to observe which way the vane pointed to know the direction the wind was coming from. Boston is the site of some of Massachusetts' earliest weather vanes, including the famous gilded grasshopper vane atop Boston's Faneuil Hall made by colonial silversmith Deacon Shem Drowne in 1742.[32] During the nineteenth century, many manufacturers mass-produced weather vanes with the use of cast-iron molds made from wooden carvings, including L. W. Cushing & Sons of Waltham, Massachusetts, and E. G. Washburne & Company of New York. Most weather vanes available today are mass-produced using a mold and dye. However, a handful of individual artisans still create hand-wrought weather vanes without the use of molds. They have revived the repoussé (French for "to push up") technique, a way of hand-hammering malleable metals from the reverse, and the chase-work technique, a way of refining the design on the front of the weather vane by indenting the metal. Each weather vane made in this free-form technique is one-of-a-kind.

One such maker is Marian Ives. As a child visiting her grandmother's farm in Leominster, Massachusetts, Marian was impressed with the large horse weather vane on the barn. But she did not make her first weather vane until 1973, when her brothers built a small boathouse on the Annisquam River for their parents. "I decided that a codfish weather vane would be perfect. That was my first attempt at making a vane, so I had to figure out just

4.51

Cow weather vane, hand-crafted metalwork by Marian Ives, 2007, copper, 53 x 39 3/4 x 15 1/2 with pole. Collection of the artist

how to proceed, including how to make it three-dimensional, watertight, and functional as an accurate indicator of wind direction."

Her six-foot, gold-leafed lobster is a landmark on the Boston waterfront. It is mounted on the roof of James Hook & Company, a purveyor of live lobsters since 1925. Ives received this commission while gold leafing at E. G. Washburn & Company. She had gained basic metalsmithing skills at the School of American Craftsmen at the Rochester Institute of Technology, then went on to learn machine techniques while working at a musical instrument company.[33]

Marian made this cow weather vane (cat. 4.51) in her studio in northwestern Massachusetts. She uses traditional smithing techniques of forming and raising to build the body. Intricate details are added by repoussé and chasing, taking special care to indicate the musculature of the animal. The vane is made in two separate halves, sawn out with a jeweler's saw, and then soldered together with a torch. The edges are finished by filing and sanding; then the piece is polished by hand.

Clear across the state, on the island of Martha's Vineyard, hand-wrought weather vanes are being created at Tuck & Holand.[34] The metal sculpting studio got its start back in 1974, when Travis Tuck created his first weather vane as a prop for the movie *Jaws*, which was being filmed near his home on the Vineyard. Anthony Holand began as an apprentice to Tuck in 1996.

We visited with Tuck in 2001. After driving to Falmouth, we boarded the *Island Queen* over to Oak Bluffs. Travis met us there in his green pick-up truck. We were treated to a tour of the island, with commentary by Tuck, who pointed out numerous weather vanes he had made: the first a stork for the local obstetrician, a quill for the *Vineyard Gazette*, the Perry Whaling ship for the Edgartown Town Hall, a gilded grasshopper for the local market, and many more (cat. 4.52). Travis had several assistants in his studio, but Holand had been there the longest. He is a young fellow who takes the work very seriously. Travis called him the "heir apparent." Holand recognized his passion for metal sculpting early in life. While harvesting wheat and barley on his family farm, he found himself drawn to the metal tools used on a farm as a means of artistic expression. In 2002 Travis formed Tuck & Holand Metal Sculptors, making Holand a partner in the business; four months later Tuck died of a recurrence of cancer. Under Tuck's guidance, Holand had worked on more than forty custom weather vanes. Together they completed one of the largest full-bodied weather vanes in the world: the ten-foot-long, two-thousand-pound Nittany Lion weather vane commissioned for Penn State's Beaver Stadium.

Just down the road from the Tuck & Holand workshop in Vineyard Haven is the Flying Horses Carousel in Oak Bluffs, the oldest continually operating platform carousel in the United States (cat. 4.53). It is one of two known carousels built by Charles W.F. Dare in 1876. In 1884, the Flying Horses were brought to Martha's Vineyard. Holand made this weather vane in the likeness of one of its horses, "Maggie Bell."

4.52

Cow weather vane made by Travis Tuck, atop the Martha's Vineyard Agricultural Society building. Photograph by Maggie Holtzberg

Gneal Widett, owner of Artistic Sign & Carving Company, has been making hand-carved signs for local businesses since the 1970s. Some of the best-known landmark signs of Boston are his creations, including the one for Charlie's Sandwich Shoppe in the South End on Columbus Avenue. These imaginative signs harken back to the colonial era when merchants advertised their wares by placing pictorial wooden sign boards or representational figures outside their shops, enticing a populace that could not read. Certain Boston neighborhoods are loaded with Widett's signs, including a stretch on Charles Street on Beacon Hill where one finds signage for Blackstone's, The Sevens, Beacon Hill Chocolates, The Hungry I Restaurant, and Charles Street Supply (cat. 4.54). Widett is also the maker of the signs outside the Brattle Book Shop Sign, Upstairs at the Pudding, and Trinity Church in Copley Square. The one seen here originally hung outside a market (cat. 4.55) in a residential neighborhood near Boston's theater district. The oversize apple has a convincing bite taken out of it—the teeth marks of a giant. Widett works with his wife, Janet Lomartire, who does the painting and gilding while he takes on the design and carving. Their studio is located in a complex of working artist spaces in Dorchester that once housed a dry-cleaning business.

Nicholas Lonborg is another woodworker who specializes in hand-carved signs.[35] Lonborg learned the trade in an informal apprenticeship, starting at age thirteen, with Scituate, Massachusetts, woodcarver Paul McCarthy. The following year, he became a paid

4.54
Hardware store sign by Gneal Widett and Janet Lomartire on Charles Street, Boston. Photograph by Maggie Holtzberg

4.55
Bay Village Market shop sign, hand-carved signage by Gneal Widett and Janet Lomartire, 1993, wood, paint, gold leaf, 25 3/4 x 51 x 17 1/2. Lent by the artists

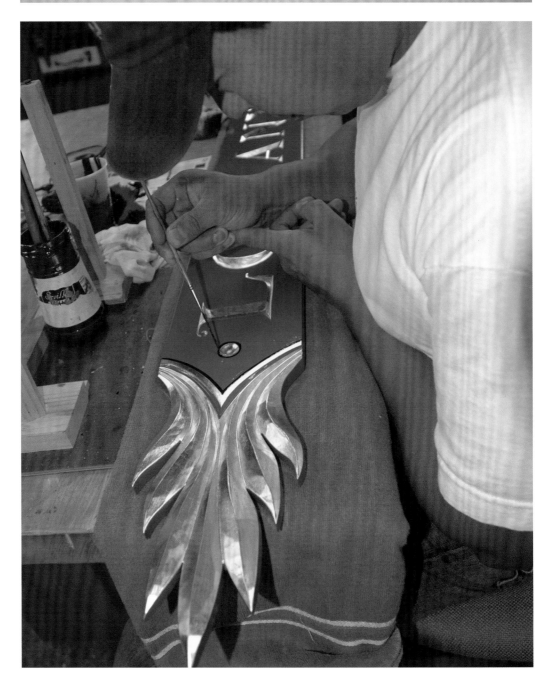

employee at Paul's shop and worked there until he turned seventeen and joined the Navy. Fours years later, Lonborg went to work for William Rowe on Nantucket Island as a carver. After college, Lonborg set up his own shop in Halifax, Massachusetts.

One of Lonborg's specialties is highly finished quarterboard signs (cat. 4.56). Nineteenth-century sailing vessels displayed their names along the bow on decoratively carved and painted signs called quarterboards. Once associated exclusively with ships, a tradition of signage marking personal property has evolved, especially on the seafaring island of Nantucket. Lonborg makes these signs using hand tools. Letters are incised or carved with a single utility knife; relief carving is done with chisels and gouges. He applies five coats of oil paint to the boards and then gilds the letters in 23 karat gold leaf. To sharpen the contrast, he outlines the letters in black using a very fine brush (cat. 4.57).

NOTES

1. Robert Reed, *What Is a Lightship?* and John Madden, *A Short History of Nantucket Lightship Baskets, http:www.nantucketlightshipbasketmuseum.org/* (accessed June 2007).

2. Information and quotes from tape-recorded interview conducted by the author at Karol Lindquist's studio, July 8, 2002.

3. Information based on tape-recorded interview conducted by Jessica Payne, January 4, 2000, and National Heritage Award nomination letter, December 2000.

4. As told to Ashleigh Catsos, JoAnn's daughter. "JoAnn Kelly Catsos: Black Ash Splint Basketmaker and Teacher," *Basket Bits Magazine* (2003).

5. Information from interview conducted by Tom Carroll, June 20, 2000, and from telephone conversation with the author, October 7, 2007.

6. Information from e-mail, May 30, 2000, and interview conducted by the author, May 27, 2005.

7. Letter from Susan Hadley-Bulger to her daughter Eliza, August 11, 1998.

8. Information and quote from tape-recorded interview conducted by Laura Orleans, February 22, 2000.

9. Information and quotes from tape-recorded interview conducted by Kathy Condon, June 21, 2001.

10. Information from tape-recorded interview conducted by Kathy Condon at Boghosian home in Milford, June 21, 2001.

11. Levon Abrahamian and Nancy Sweezy, eds., *Armenian Folk Arts, Culture, and Identity* (Bloomington, Ind., 2001), 169.

12. Information and quotes from interview by Kathy Neustadt, November 17, 1999.

13. Quoted by Scot Alarik, "Their Mission: To Keep Folk Crafts Alive," *Boston Sunday Globe, Northwest Weekly* (May 28, 2000), 7.

14. Information and quotes from interview conducted by the author, May 16, 2007.

15. Information and quotes from tape-recorded interview conducted by Millie Rahn, April 2, 2003, and by the author, May 16, 2007.

16. Information and quotes from interview conducted by the author, June 7, 2007.

17. Information from tape-recorded interview with Rebecca Wilhelmsen by Laura Orleans, February 2, 2000.

18. Information and quotes from personal communication with the author, and artist's Web site, *http://www.wldwind.com/rpeters/pottery.htm* (accessed October 15, 2007).

19. Information and quotes from tape-recorded interview and National Heritage Award nomination packet by Kathy Neustadt, February 25 and August 18, 2003.

20. The miles of bas-reliefs carved into temple walls, however sculptural, were considered architectural decoration.

21. Quoted from letter by Sally Reed in support of Livan's nomination for a National Heritage Award, dated September 26, 2003.

22. Information taken from 2001 Artist Grant application narrative, December 18, 2000, and telephone conversation with the artist.

23. Information from interview conducted by Tom Carroll, June 8, 2000.

24. Information based on interview by Millie Rahn as part of the Lowell Folk Festival, July 2001.

25. Information and quotes from telephone conversation with the author, October 1, 2007.

26. Quote from tape-recorded interview conducted by the author, February 2001.

27. Information and quotes from tape-recorded interviews conducted by Stephen Matchak, July 14, 1987; Frank Ferrel, August 23, 2000; and the author, April 23, 2007.

28. Information from tape-recorded interview conducted by Eleanor Wachs, April 13, 2001; apprenticeship application narrative, September 27, 2001; personal communication with the author, May 2007; and "A Meeting of the Crafts," *Boston Globe Magazine* (December 10, 2006).

29. I recall a saying I heard during my teens from an old-timer in Vermont, "God created the earth in six days and on the seventh, he threw rocks at Vermont."

30. Peter LaBau, personal communication, March 2004.

31. Stonemason Derek Stearns of Stearns Stoneworks quoted in Steve Grove, "Wall Art," *Boston Globe* (August 2004).

32. *http://www.celebrateboston.com/sites/faneuilhallgrasshopper.htm* (accessed October 4, 2007).

33. Information and quotes from Artist Grant application narrative, December 4, 2000.

34. Information and quotes from tape-recorded interview conducted by the author, July 19, 2001.

35. Based on tape-recorded interview conducted by the author, June 20, 2006.

Life and Work by the Sea

FUNCTIONAL TRADITIONS

Although, as a designer, I rely on my skills as a logger, sawyer, loftsman, shipwright, mechanic, plumber, electrician, spar maker, sail maker, and rigger, it is without question that my skill as a mariner makes my boats uniquely effective at what they do.

—Harold A. Burnham, shipwright

Harold Burnham is a wooden-boat builder whose ancestors arrived in Essex, Massachusetts, in 1635. Ask him just how many generations of boat-building Burnhams that makes and he jokes, "That depends on whether you count incest or bastard children. Discounting those, I'm the eleventh generation." Burnham credits not only his familial heritage but also the maritime heritage of his hometown for his ability to develop his skills as a traditional wooden-boat builder. In his words, "Given that the shipbuilding industry has continued uninterrupted in Essex since the town's first settlement, the number of vessels built here, their average tonnage, and the town's relatively small population, it is hard to imagine a place on earth where shipbuilding is more deeply embroidered into the fabric of the community."[1]

By the mid-nineteenth century, during the height of the industry, the town of Essex supported fifteen shipyards and launched more than fifty vessels a year (cat. 5.1). After World War II, the industry collapsed. For nearly fifty years, the work was carried out in small shops away from the water. It was from these small shops that Burnham gained firsthand experience of traditional Essex shipbuilding techniques. "A traditionally built boat is still just as functional as a new modern boat. The problem is that there are so few people that know how to build them. The thing about these traditional methods is that it's an art form. It's taken thousands of years to develop this art form and for people to get to the point where they understand it and can do it effectively" (cat. 5.2).

Because few wooden ships are being built these days, there are also very few suppliers of ship timber. Therefore, Harold cuts much of the timber for his boats himself. Most of the wood—white oak and locust—comes from local sources, donated by two conservation organizations: the Essex County Greenbelt Association and the Trustees for Reservations. To get the best use out of the natural curves of the wood, Harold not only cuts his own timber, but he also mills it. Pointing out the mill at the top of the Burnham Shipyard, Harold says, "As you can see, the logs come in at the top of the yard. They're unloaded by

logging trucks, and the boats go out. All we do is take those piles of logs and make them into boats." He uses hand tools familiar to a nineteenth-century shipwright, works out-of-doors through the New England winter, and launches vessels the old way using wedges, grease, and gravity.

As the twenty-eighth Burnham to operate a shipyard in Essex since 1819, Harold has carved out a place in history as a master boat designer and shipwright. When he constructed the *Thomas E. Lannon* in 1997, commissioned by Captain Tom Ellis, she was the first sawn-frame, trunnel-fastened vessel built along the Essex riverbank in nearly fifty years. Ellis wanted to show what a fishing schooner is all about. The 65-foot *Lannon* has become a landmark on the Gloucester Harbor as a passenger-carrying charter schooner. Harold was hired as the builder, but soon after became the designer by default. He sought the advice of local shipbuilding elders like Dana Story, whose collection of historic photographs was invaluable in learning about long-dormant Essex shipbuilding techniques. He went with a Fredonia style-boat because Ellis needed something very seaworthy.

The lines of the *Lannon* were taken from the half model pictured here (cat. 5.3) and then drawn full-scale on the loft floor (the loft space above the shipbuilder's shop). Modelmaker Erik Ronnberg Jr., who painted the scrollwork on the *Lannon*, explains the use of half models in wooden boatbuilding,

Building a half model is a real American tradition. Building up a hull in layers with the use of wooden toggles or screws so it could be taken apart and traced was invented by shipwrights who had no training in drafting. The half-model style developed in Essex shipbuilding yards. While layers are fastened together, you shape the hull. You

carve it and sand it. Before you take it apart, you mark where each frame is going to go. Those marks are drawn across each layer, called a "lift." Then using a carpenter's rule, you measure those width lines (half breadth lines). The measurements are scaled up to full size and put on paper. Then you go to the mould loft floor and lay out a grid, in order to reconstruct it.[2]

5.2

Harold Burnham at home. Photograph by Maggie Holtzberg

The *Lannon*'s keel was laid on Christmas Eve 1996. Harold and a crew of six to eight members worked outside through the winter and spring, completing the vessel in June 1997. Here the frames are being erected (cat. 5.4). Dana Story was amazed at how Harold solved problems. "The boat that he built is strong. He did things that we didn't do in the old shipyard—like put mortise-and-tenon joints on the forward cant frames.... A stern is not an easy thing to build; building an oval transom is the thing that separates the men from the boys. Harold figured out how to do it, and he did a splendid job."[3] Since completing the *Lannon* (cat. 5.5), Harold has worked on a number of major commissions, including the schooner *Fame* and the schooner *Isabella*.

It's an art; it's also, in essence, a piece of marine hardware.
—Bob Fuller, ship's wheel maker

Fuller's family has been in Massachusetts a long time (cat. 5.6). "We're related to Samuel Fuller, the surgeon on the *Mayflower*." Fuller runs South Shore Boat Works in Halifax, Massachusetts. "I'm a woodworker and a boat builder and a builder of ship's wheels. I'm the third generation doing this."[4] In addition to building wooden boats and custom interiors, Bob may be the only one in Massachusetts who makes hand-turned ship's wheels, which he has done since 1977. He uses a lathe to turn the mahogany spokes. A minimum of five coats of varnish is required to achieve this high-gloss finish. The wheel is built around a bronze-plated hub with decorative engraving. "Some people have considered it to be a piece of furniture. But I look at a ship's wheel as being far more than a piece of furniture. I mean furniture isn't made to stand up on the ocean in a really harsh environment. A ship's wheel needs to perform."

This scale model (cat. 5.7) is a working half model for a *Gurnet Point 25*, a lobster boat that was designed for Fuller by Jamie Lowell, a third-generation boat designer from Maine. Fuller is building it on spec and realizes that it will probably serve as someone's pleasure boat. "It's a good New England boat that's good for the rough water." Bob reflects on his line of work, "I know this is a viable business and it certainly is a niche. It also is part of our heritage."

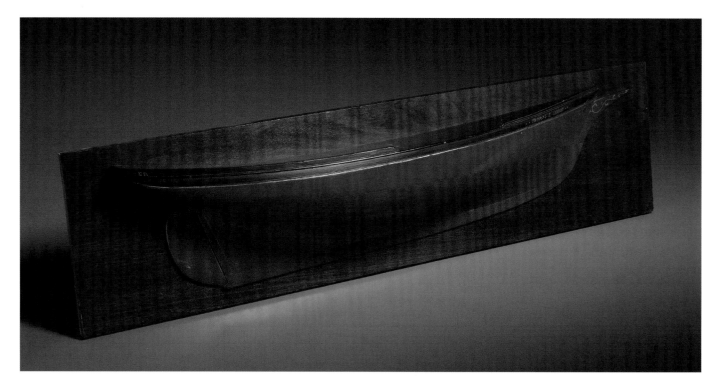

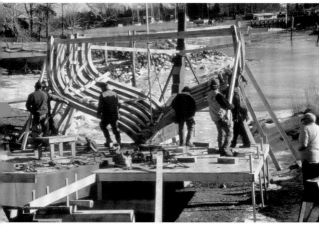

5.3
Thomas E. Lannon, *half-hull model, New England maritime working model by Harold Burnham, 1996, wood, 9 3/4 x 39 x 5 1/8. Collection of the artist*

5.4
Framing the Thomas E. Lannon.
Photograph by Lew Joslyn

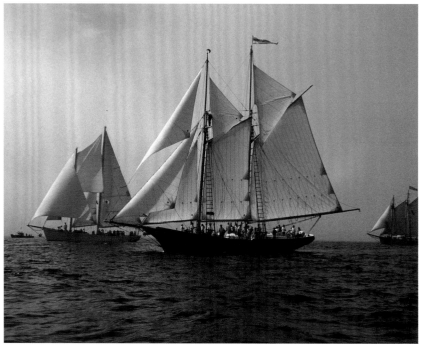

5.5
Thomas E. Lannon *under sail (center), during Gloucester Schooner Race, 1997.*
Photograph by Lew Joslyn

5.6
Gurnet Point *ship's wheel, New England maritime*
hardware by Bob Fuller, 2007, wood and brass fittings,
36 1/4 diam. x 4 7/8. South Shore Boatworks

COMMEMORATIVE TRADITIONS

Rob Napier knew he was "a boat guy" from an early age.[5] He spent four years in the Navy, did a little commercial fishing, and ran a boat yard for a year and a half. The boat yard did not work out, "not because I didn't like boats, but because I quickly discovered that the scale was wrong." Napier realized he could get the exact same intellectual experience from doing ship-model work as he could from full-size ship and boat building. "The work for me was a lot more enjoyable because, actually, I'm kind of lazy. And I don't like moving great big forty-foot things around. That's an awful lot of work." To see Napier's ship-model work (cat. 5.8), one would hardly guess him to be lazy. His models are stunning in their detail and accuracy of scale. In fact, attention to scale seems to be what distinguishes a good ship model from a lesser one. "If you place yourself in the model's environment, ask yourself if things look right for the size you would be were you on that boat; 98 percent of the time, the answer is no. Oars would be the size of telephone polls; belaying pins are the wrong shape and wouldn't hold the line in real life."

Napier makes the point that ship models, like most objects that end up being part of the decorative arts, started out being applied practice runs. The half- or full-hull ship model was basically a tool to help build the real thing.

They started doing models both as preliminaries for building a ship and also to document how a ship was built. And finally, as ways to commemorate certain ships that had achieved things. The idea was you build a simple half-model form in the shape of a hull only and it's very sculptural and abstract. And then through various techniques, ship builders know how to take that shape and convert it, through lofting,

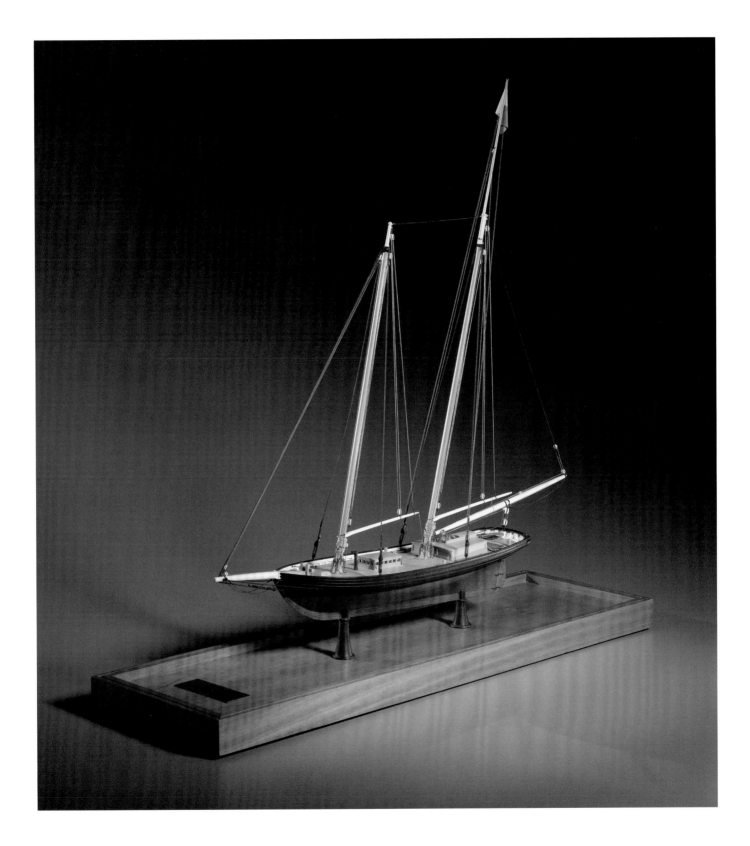

into a ship. That worked on vessels from rowboats to clipper ships. . . . An awful lot of half models were destroyed because once their efficacy as a tool was over, their efficacy as fuel came to the fore!

Lightning (cat. 5.9), a half-hull ship model, was commissioned by Kurt Hasselbalch at the Hart Nautical Collection of MIT Museum in Cambridge as part of an exhibition on American clipper ships from the 1850s. Donald McKay was a prominent Boston clipper ship builder. There is speculation that Donald's son Cornelius converted lofting information into sets of lines for some of their ships, and Hasselbalch was interested in having a model built directly from one of Cornelius McKay's plans.

This half-hull model is unique in that Napier wanted to find a different way to express the hull shapes. Rather than carve a big solid block of wood in the shape of a hull, he set up thin sheets of wood as the bulkheads used at the station line (one of a series of equally spaced cross sections of the hull), with a rail on top and a keel on the bottom.

When I visited him in his Newburyport studio, Rob talked about one of his favorite pieces, a model of a flat bottomed-boat with broad square ends that is used mainly for transporting bulk materials (cats. 5.10, 5.11).

"This is a scow. When the fishermen were using them, you probably called it a trap boat. But the historians call it a pound net scow because it's a scow used for tending fish pounds." The thing on the bow is a piledriver.

"What are those long things on the deck?" I ask him.

"Those will be the stakes that they put down in the sandy bottom of the water."

"What is the scale of this one?"

"It's 1/8 of an inch to the foot. Which happens to be the same scale of *Lightning*. This is one of my favorite things I've ever built. I don't know why anyone has never bought it. Because

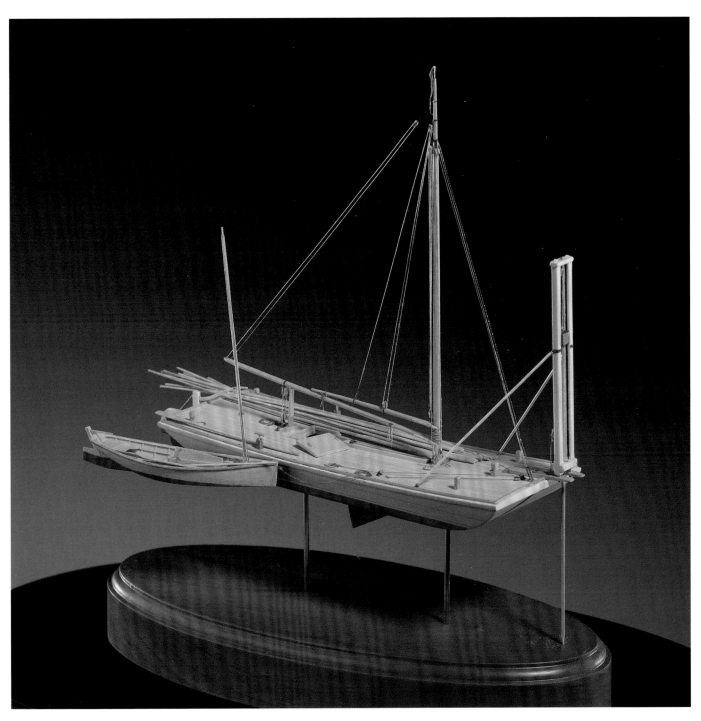

5.10

Scow and *Skiff, full-hull models, New England maritime commemorative models by Rob Napier, 2001, holly, basswood, pearwood, boxwood, nickel chromium wire, ebony, brass, flytier's nylon, silk, with dome 10 1/8 x 9 1/2 x 6 1/8; without dome 8 3/8 x 9 1/2 x 6 1/8. Collection of the artist*

5.11

Detail of Scow and Skiff.
Collection of the artist

it's too prosaic of a subject, is the answer. It has no romance. It's just a scow. People who collect ship models want them to have some romance and grace. And elegance and beauty. So you make a model of a scow, a *gorgeous* model of a dumb vessel, or a silly vessel, people won't get that."

"It would be like making a model of a sanitation truck?" I say.

"Uh-huh. Here is the proof in the pudding. Say you build an average model of *Constitution* and you put it in an exhibition. And you build a model similar in size of this [scow], that's a really good model, say. And then you invite the public to vote for their favorite model. They will always vote for the model that is bigger, has more rigging, and looks like is has more parts."

Erik Ronnberg Jr. was born into a seafaring family. He is a highly respected ship-model builder, carver, and maritime historian. He learned to carve from his father, Erik Ronnberg Sr. (1909–1989), an internationally known model maker from Sweden who was first mate aboard the last square-rigger to deliver a cargo in Boston harbor. Ronnberg Sr. was rigger in the Swedish Merchant Marine before immigrating to New England. Born in 1944, Erik Jr. apprenticed in his father's Rockport, Massachusetts, workshop before joining the industrial model firm Atkins & Merril in Sudbury (cat. 5.12).

There he learned about the structure of ships by drafting and interpreting plans. Mentored by William A. Baker, curator of the Hart Nautical Collection at MIT, Erik apprenticed at the Newark Museum in New Jersey and spent four years as associate curator of maritime history at the New Bedford Whaling Museum. Returning in 1973 to help his father run a hobby and model shop, Erik also designed kits for commercial manufacturers and scratch-built models, including ten pieces at 3/8 inch scale commissioned by artist Thomas Hoyne. Erik is the 2002 recipient of the Ship Modelers Association Harold Hahn Award. Ronnberg's models can be viewed at the Smithsonian Institution's National Museum of American History, Mystic Seaport, Plimoth Plantation, the New Bedford Whaling Museum, and the Hart Nautical Museum. Like many of the finest ship-model builders, Erik is a consummate perfectionist, combining nautical research with precision craftsmanship (cat. 5.13).

Ronnberg notes that while ship modeling in England was more akin to portraiture, there is an element of narrative in American ship models, "They tell stories." Father and

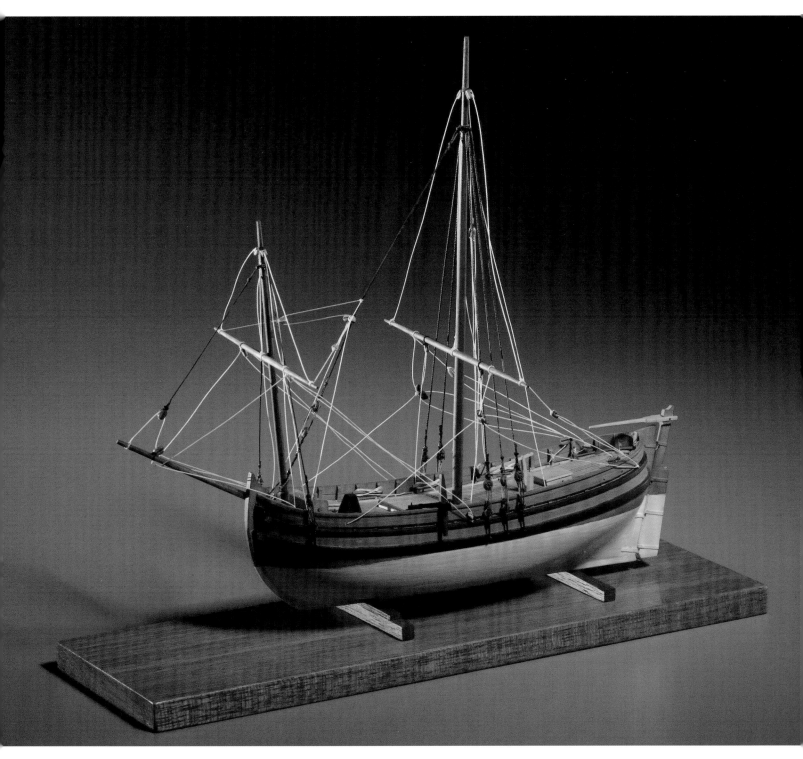

5.12
Colonial Bark, *full-hull model, New England maritime commemorative model by Erik Ronnberg Jr.,*
1968, wood, 8 x 9 x 4. Hart Nautical Collections, MIT Museum, Cambridge

son often collaborated on accurate depictions of Cape Ann maritime history—models of schooners, harbor tugs, shadowboxes, and dioramas. Their model building suggests a narrative companion to the yarns that Cape Ann fishermen and boat builders might spin— like the shadowbox *The Duel off Davis Ledge, 1892,* which depicts the annual Fisherman's Race for the Hovey Cup held on August 26, a chilly day with heavy winds and lashing rain. The triangular course of forty-one miles started from Eastern Point to a buoy off Marblehead, then to a buoy off Davis Ledge outside Boston Harbor, and finally back to Gloucester. In this scene, the schooner *Harry L. Belden* has already rounded the Davis Ledge buoy. The *Joseph L. Rowe* and the *Nannie C. Bohlin* are close behind. Erik Jr. describes the moment, "These schooners are in the process of rounding the race mark at Minot's Light. What I had to do in designing that was to convey the sense of motion around the buoy. I didn't want to give the illusion that the *Joseph L. Rowe* was about to sail right off the edge of the shadowbox. You'll notice that her jibs are luffing, which to a sailor signals that she is getting ready to come about." The *Belden* was victorious, while the *Bohlin* took second place.

Marco Randazzo came to Gloucester to fish (cat. 5.14). Marco emigrated from a small town outside of Palermo, Sicily, in 1969 and spent more than twenty years on a dragger fishing for cod and haddock. He recently retired from fishing, but evidence of his life's work fills the home he shares with his wife and children. Mounted on one wall of the living room is a display of more than fifty types of nautical knots. In his spare time, Marco discovered that his facility in tying knots would lend itself to making sculptural objects out of rope. Every surface of the living-room furniture is covered with examples of Marco's rope sculptures—crosses, anchors, sea captains, ships, and life rings—all made of differ-

5.14
*Small Cross,
occupational
craft by Marco
Randazzo, 2007,
nautical line,
10 x 3 x 2 with
string, 5 x 3 x 2
without string.
Collection of the
artist*

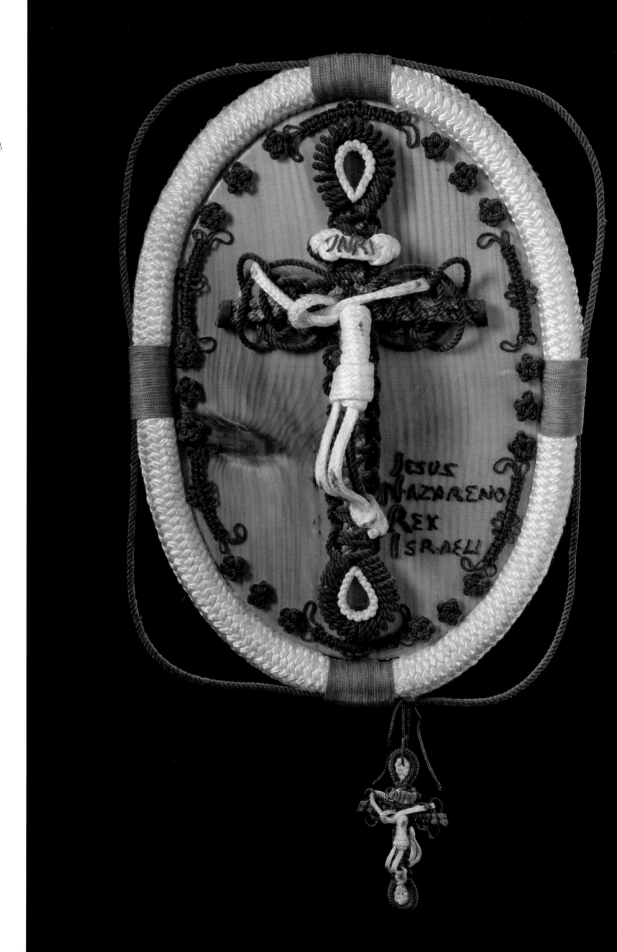

5.15

Large Cross and Life Ring, occupational craft by Marco Randazzo, 1997, nautical line, 31 1/2 x 18 x 4 (includes crucifix below). Collection of the artist

5.16

Caffé Sicilia, Gloucester; note Marco Randazzo's Cross and Life Ring in upper left corner. Photograph by Maggie Holtzberg

ent gauges of line used in the fishing industry. Not recognized as a traditional art form, this former fisherman's rope sculptures are unique creations inspired by occupational and spiritual associations.

Marco started making crosses twenty years ago. The cross can be done with one piece of line, but he sometimes uses two, "[because they] look better." His life rings (cat. 5.15), which consist of a nautical life ring circling a crucifix, are a direct reference to the fisherman's dangerous working life. "If the boat goes down, the last thing you think of is Jesus Christ—to save your soul." He does not give rope crosses to fishermen for luck because too many would want them if the fishing boat came back with a mother load of fish. He did, however, grant one request to Paul Ciaramitaro, the co-owner of Caffé Sicilia, an authentic Italian pastry shop on Gloucester's Main Street, who fished with Marco for twenty years. Paul asked Marco, "Why don't you make me a cross?" Marco obliged him. One of Marco's life rings has hung on the Caffé wall since Marco made it in 1997. Black lettering against white rope says, "to fishermen who rest at sea" (cat. 5.16).

In addition to being a superb wildfowl decoy carver, Bob Brophy is an expert on the history and evolution of the boats used for salt-marsh waterfowl and bay hunting, called gunning floats. On the coldest of midwinter days, Brophy will take a gunning float out to hunt waterfowl from his duck camp on Hardy's Creek, a live-in duck blind on the marsh that he built in 1978. His is one of a handful, but years ago there were hunting camps all

5.17

Gunning float, full-hull model, New England maritime commemorative model by Bob Brophy, 2002, wood, 4 3/4 x 47 x 12 1/2 (beam); with sculling oar 57. Collection of the artist

over the marsh along the East Coast. "We don't see anybody under thirty years old hunting anymore. It's a dying tradition." Brophy fashioned this model after a 1930s gunning float (cat. 5.17).

One- or two-man gunning floats are used to approach ducks, which necessitates a low profile. Depending on the season, there are different ways of camouflaging the boat—from tied-up bunches of marsh grass to snow and ice on the front deck. "These boats are used basically for open water hunting. When you get a flock of birds sitting out on the water, you scull out to them. It works best in the wintertime when there are ice cakes floating around. You put an ice cake on the bow and an ice cake on the crossdeck. Put on your white parkas and you can come within a boat length of geese sleeping on the ice."

Brophy has made half a dozen full-hull models of gunning floats. He has a collection of more than twenty antique gunning floats. As you can see from this full-hull model, the gunning float is narrow with a square transom (flat surface across the stern). "You move the scull oar back and forth through the water. Your hand goes in a figure eight, propelling you forward."

Mark Sutherland pursued boat building in his early twenties, working in several yards and on the renovation of a few large wooden yachts. He spent his summers in Nantucket and in the late 1970s found his passion in building models of nineteenth- and early twentieth-century vessels. Models made of whale bone have been a specialty, along with the

restoration of scrimshaw artifacts. Mark credits ship-model builder Charlie Sayles and antique dealer Morgan Levine with giving him guidance. Mark is partial to working with whale bone; the texture, patina, and grain are distinctive, giving a rich finish to a piece (cat. 5.18). Here is one of Mark's ditty boxes made of antique whalebone (cat. 5.19). Ditty boxes were made by whalemen and sailors to hold small personal items on board, such as thread, needles, razor, and comb, and they were given away to sweethearts. This one is constructed like a traditional oval Shaker box.

During the nineteenth century, when the whaling industry rose to prominence in New England, a vernacular folk art called scrimshanding was perpetuated by working and retired seamen. Making both functional and decorative objects from salvaged parts of the whale skeleton was a way of passing the time on long whaling voyages. Useful items included sailmaking tools, bodkins (for piercing holes in fabric), pie crimpers, and swifts (for winding yarn). Decorative objects commemorated life at sea. Whale teeth were engraved with scenes of clipper ships and whale hunts. The art of scrimshaw has persisted into the present time. In the 1940s, Jose Reyes introduced the use of decorative carvings of whale ivory or bone on the lids of Nantucket lightship baskets. Ever since the Marine Mammals Protection Act of 1972, modern-day scrimshanders must either find antique whalebone or ivory with which to work or use a range of composite materials (cats. 5.20, 5.21)

In the late 1960s, Michael Vienneau's parents rented a house on Nantucket. Michael and his older brother Larry started buying whale teeth from local gift shops. "Back then, they used to sell them by the barrel, two dollars a piece."[6] The brothers learned scrimshanding together, always trying to outdo each other. "By 1974, I was making a living scrimming on the Island, with my brother Larry doing the same thing just down the street." Though he is self-taught in the art of scrimshaw, Michael earned a BFA in printmaking at Southern Massachusetts University. The skills he acquired there in etching, engraving, and carving are directly applicable to the making of scrimshaw. After incising a design, he applies ink, dyes, or oil paint to the surface, then wipes it away. The lines that are incised fill in with color. Vienneau uses antique whale's teeth and whalebone from pre-1972 stockpiles (cat. 5.22). This carved whale was made from a five-ounce whalebone. Notice how the tail curves slightly? This is the hollow part of the tooth. In 1990, after sixteen years of working and selling his work in several local galleries, Michael opened his own, called The Scrimshander Gallery, on Old South Wharf, Nantucket.

Charles Manghis is another scrimshander of exceptional talent.[7] He grew up in Boston and Cape Cod, captivated by the sea and the history of the old whaling days. Like Vienneau, Manghis first tried scrimshaw as a youngster. (He remembers the same barrels of whales' teeth on Nantucket.) He admits his early pieces were pretty crude, but he has spent a lifetime refining his skills. Manghis is one of the few practitioners who have made a conscientious effort to study the scrimshaw of the nineteenth-century whale men, going to great lengths to ensure that his scrimshaw images are historically accurate. He works with

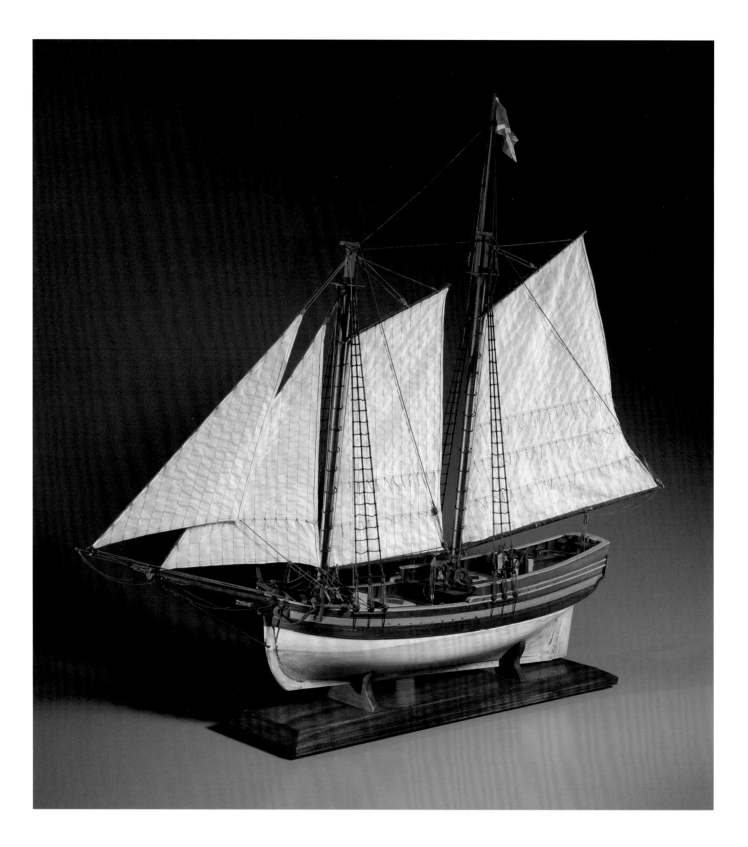

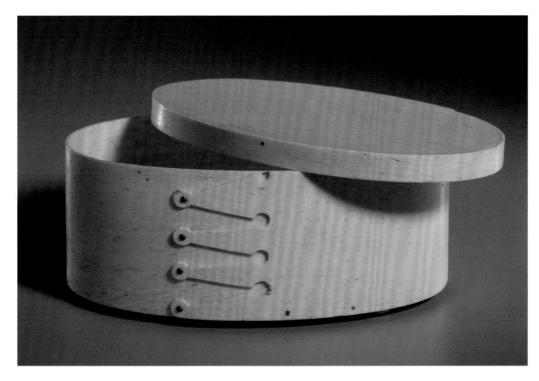

5.19

Ditty Box, maritime craft by
Mark Sutherland, 1992, antique
whalebone, 2 1/4 x 6 1/8 x 4 1/8.
Collection of the artist

traditional tools and antique materials, many inherited from his mentor, John Mitchell. He works closely with a carefully developed network of antique dealers (pickers) to seek out the materials, including this lower mandible of a sperm whale (cats. 5.23, 5.24). For Mang-his, there is nothing like working with genuine antique whales' teeth, "To me, it's the most beautiful; it cuts the finest line . . . the natural materials are unparalleled canvases."[8]

In addition to commemorative ship models and scrimshaw, which are primarily (but not exclusively) made by men, women have created textiles that pay homage to seafaring vessels and the fishing industry. A prime example is this narrative quilt created by the members of the Gloucester Fishermen's Wives Association (GFWA) (cat. 5.25). While honoring Gloucester's historic fishing heritage, the quilt also tells the story of the association's struggles against factory trawlers, fish farming, oil drilling, and other environmental threats to the ocean. The quilt was created in conjunction with nationally known quilt maker Clara Wainwright, who met with GFWA members every Wednesday night during the summer of 1998 to conceive and create the quilt.

Aline Drivdahl, whose Hardanger lace table runner appears on page 95, made this wall hanging depicting the Norwegian fishing trade (cat. 5.26). Her father left Norway in 1930 to seek work elsewhere. Like many Norwegians in the New Bedford and Fairhaven area, he found employment in the fishing industry. This piece of cross stitch illustrates various aspects of harvesting the fruits of the sea.

A Currier & Ives print of the U.S.S. *Dreadnaught* gave Jeanne Fallier the idea to make this

5.18 (opposite)
The Schooner Primrose of
Marblehead, *full-hull model,*
New England maritime
commemorative model by
Mark Sutherland, 2002, wood,
cotton, 31 3/4 x 39 x 7 1/2.
Collection of the artist

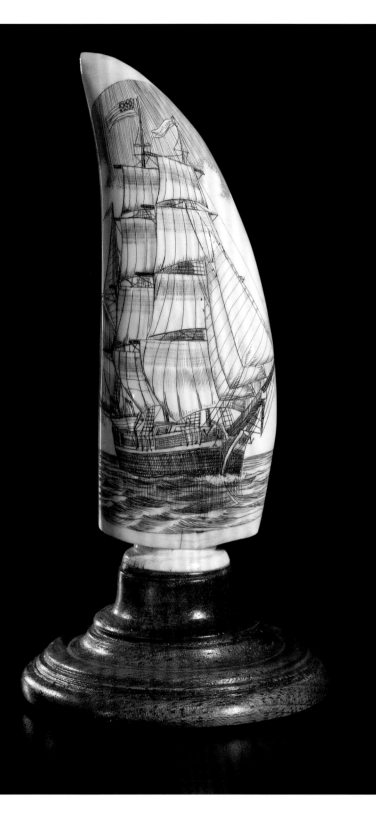

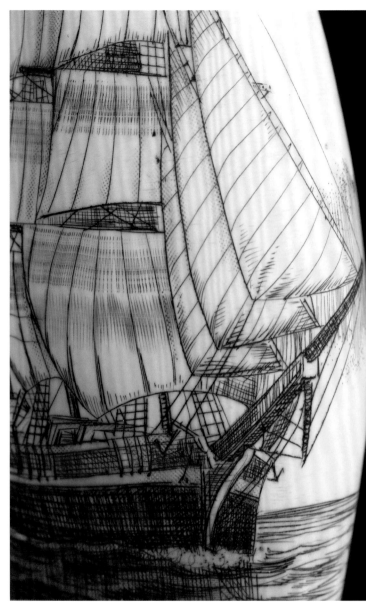

5.21

Detail of prow on Whaling Bark Scrimshaw. Collection of the artist

5.20

Whaling Bark Scrimshaw, New England maritime craft by Michael Vienneau, 2006, whale ivory, mahogany and whalebone base, 8 oz. sperm-whale tooth, 6 1/2 x 3 1/8. Collection of the artist

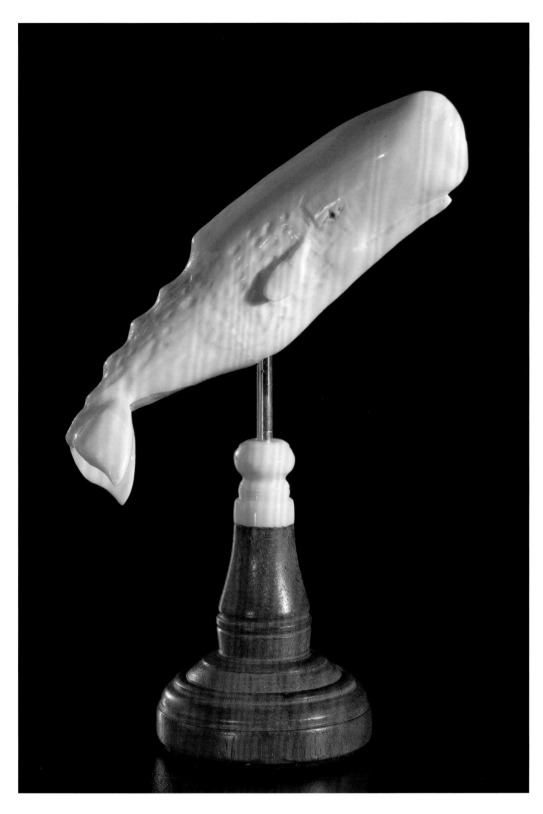

5.22

Carved Sperm Whale, New England maritime craft by Michael Vienneau, 2007, whale ivory, walnut and ivory turned base, 6 oz. whale tooth, 5 1/2 x 3 1/4 x 1 3/4. Collection of the artist

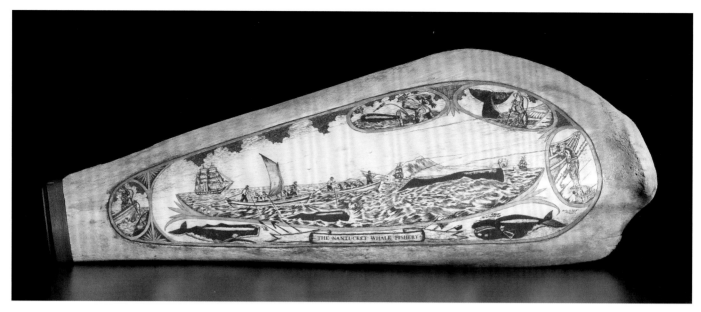

5.23
The Nantucket Whale Fishery,
scrimshaw, New England
maritime craft by Charles
Manghis, 2003, ivory and
lower mandible of sperm
whale, ink, 15 x 39 3/4 x 4 1/2.
Private Collection

5.24
Detail of harpooning on
The Nantucket Whale Fishery.
Private Collection

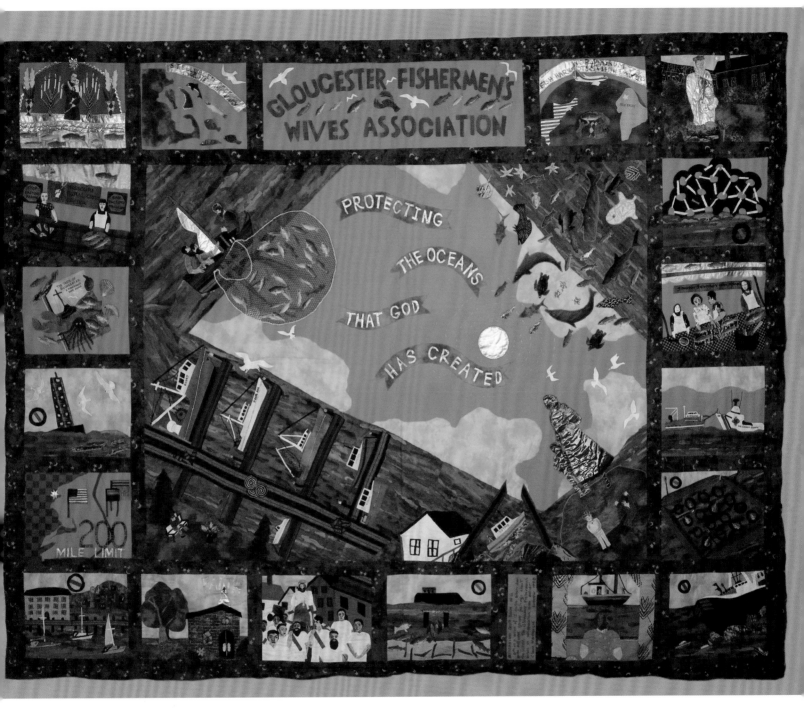

5.25
Protecting the Oceans That God Has Created, *New England narrative appliquéd quilt, Gloucester Fishermen's Wives Association with Clara Wainwright, 1998, fabric, thread, 86 x 108. Gloucester Fishermen's Wives Association*

clipper-ship hooked rug for her son, Robert (cat. 5.27). Similarly, sheet-metal worker Dan Hardy was inspired to fabricate this clipper ship of copper after having seen *Tall Ships 2000* in Boston Harbor, a large gathering of traditionally rigged sailing vessels. He modeled it after an artist's rendition of a nineteenth-century ship that brought Irish immigrants to Boston (cat. 5.28). "Copper is a very malleable, easy-to-form metal. It's very forgiving. In the process of working in the trade, you come up with your own ideas. You have to come up with the design. It's like a form of art."[9]

Alice Morais lives on the edge of Prospect Heights in Milford where a large Portuguese population has been settling since the early 1900s.[10] Like most of the Milford Portuguese community, she is from northern Portugal, specifically the town of Morais in the area of Chaves in Villa Real (cat. 5.29).[11] She is a consummate needle worker, known for the evenness of her crochet work. Growing up in Portugal, she learned to make crocheted coverlets, runners, curtains, and doilies. Some of her crocheted coverlets have embroidered linen insets, made of flax she grew and wove herself. The fish represents Morais' Portuguese heritage: "The Portuguese love fish."

Rockport and Gloucester are quintessential New England seaside villages, but these towns at the tip of Cape Ann have many more dimensions that come together in the story of block printer Isabel Natti:[12] working fishing port and farming town, site of quarries and an artists' colony, and home to a large population of Finns (cat. 5.30). Natti's maternal grandfather was the sculptor Paul Manship; his neighbors in the Lanesville section of Gloucester included Natti's paternal grandparents, immigrants from Finland who came to work in the quarries.

It was Natti's father, Ilmari Mattius Natti, nicknamed "Jimo," who first taught her printmaking. Jimo Natti was affiliated with the famous Folly Cove Designers (1938–1970), a loosely formed local guild of linoleum block printers led by Virginia Lee Burton Demetrios (who is perhaps best known as the creator of classic children's books, for example *Mike Mulligan and His Steam Shovel*). From her father, Isabel learned the principles of design and a reverence for nature that the local Finnish community shared with the Folly Cove Designers. As she notes now, "It was in the awareness of nature that this community found inspiration."

In 1974 Natti joined Libby Holloran, who had been a member of the Folly Cove Designers for twenty-seven years, in running the Rockport printmaking shop Sarah Elizabeth (cat. 5.31). Since Holloran's retirement in 2002, Natti has continued the local linoleum-block-printing tradition on her own. Natti's designs include representational images reflecting local life and regional flora and fauna, as well as bold graphics. Many of the prints depict life by the sea, scenes ranging from majestic clipper ships to the workaday beauty of aspects of fishing life. One print, *Whiting Factory*, shows a fish-processing operation where the artist herself once worked. In the tradition of the Folly Cove Designers, Natti's images are almost all single-color prints on cardstock or fabric. Also following local tradition, these

5.27
USS Dreadnaught,
*New England hooked rug
by Jeanne Fallier, 1961,
wool strips on burlap,
29 3/4 x 37 1/4 x 3/4 oval.
Collection of the artist*

5.26 (opposite)
Norwegian Fishing Industry, *wall
hanging, Norwegian cross-stitch
embroidery by Aline Drivdahl, c. 1982,
linen and thread, 38 1/4 x 6 x 1/2.
Collection of the artist*

works are created to be of use in the home, whether as cards for letter writing or as place-mats for a well-set table.

Natti creates her pieces on a circa 1830 hand-powered "acorn" press that her uncle, Eino Natti, had found for the Folly Cove Designers. She continues with this old technology because of the crisp images it produces and the connection it gives her to history. "They all did [it] exactly the same way that I do it, or that Libby did it.... And you still get a wonderful print.... You know, if the electricity goes out, we'll keep printing! If your modem breaks, so what, we'll keep printing. It's just intriguing because of its historic reality. In America, when you say 'freedom of the press,' this is the press!"

5.29
Fish, Portuguese crochet by Alice Morais, 1995, thread, 22 1/4 x 8 1/8 x 1/4. Collection of the artist

5.28 (opposite)
Clipper ship, occupational craft by Dan Hardy, 2007, copper, 24 1/2 x 21 1/2 x 5 1/4. Collection of the artist

5.30

Lane's Cove, Lanesville, on a cold winter's day. Photograph by Maggie Holtzberg

5.31

Cape Ann, *block printing by Isabel Natti, 1976, print on cloth, 13 1/2 x 18 1/2.* Sarah Elizabeth Shop

NOTES

1. From Artist Grant application narrative, December 18, 2000, and from tape-recorded interview conducted by the author, May 26, 2006.

2. As told to the author in telephone conversation, November 8, 2007.

3. Mathew P. Murphy, "Go See Harold . . . He Can Do It: The Building of the *Thomas E. Lannon*," *Wooden Boat* (July/August 1998), 1.

4. Information and quotes from tape-recorded interview conducted by the author, April 28, 2006.

5. Information and quotes from tape-recorded interview conducted by the author, April 23, 2007.

6. Information and quotes from telephone conversation, October 2, 2007.

7. Information from tape-recorded interview conducted by Eleanor Wachs, April 26, 2000, and by the author, August 11, 2002.

8. Quoted by Suzanne Daub in "Blending Art and History," *www.yesterdaysisland.com/spring_01/spring_articles/scrimshaw.html* (accessed August 21, 2002).

9. Information and quote from tape-recorded interview conducted by the author, July 9, 2007.

10. Information from tape-recorded interview conducted by Kathy Condon, July 25, 2002.

11. Portuguese immigrants began arriving in the United States in the early 1900s because of political difficulties at home.

12. Information and quotes from tape-recorded interview conducted by Kate Kruckemeyer, March 21, 2000.

6 **Passing It On** Traditional Arts Apprenticeships

Apprenticeships are a time-honored method by which an individual learns skills, techniques, and artistry under the guidance of a recognized master. The vast majority of artists whose work is shown here learned in just this way. In 2001, the Massachusetts Cultural Council established its Traditional Arts Apprenticeship Program, which supports the passing on of traditional knowledge from master artist to apprentice. Since its founding, the apprenticeship program has supported more than fifty artists in a vast array of traditions, both old and new to Massachusetts. In addition to the skills that are handed down, it is the relationship between master and student that is nurtured. The individuals featured here have all been supported by MCC apprenticeships.

> *Everything has roots. Ain't nothing new babe.*
> —Jimmy Slyde on tap dance, buck dancing, step dancing, and hip-hop

James T. Godbolt, also known as Jimmy Slyde, has a place in the history of tap that is legendary. Called the "Grandfather of Tap" by his acclaimed student, Savion Glover, Slyde is now one of the few remaining members of a quickly vanishing generation of America's master jazz tap artists and teachers.[1] This is a tradition that is still best passed along from dancer to dancer, master to apprentice, feet to feet. A Boston native, Slyde began studying in the 1940s with Stanley Brown and Eddie "School Boy" Ford at the Stanley Brown Dance Center. As a solo artist, Slyde has performed on stage, at clubs, and in dance festivals throughout the United States and Europe. He has appeared in a number of movies and has even worked with jazz greats such as Count Basie, Duke Ellington, and Louis Armstrong. In 1999 Slyde was awarded a National Heritage Fellowship from the National Endowment for the Arts. Jimmy Slyde and his student Edward Mendes III, known as Rocky Mendes, were awarded a Traditional Arts Apprenticeship in 2001.

On a cold evening in January, I drove to the town of Whitman, some thirty-five miles southeast of Boston, with intern Catherine Moore to observe the apprenticeship in action. The Whitman Academy of Performing Arts is housed in an old wooden building with double doors and creaky steps. We entered the building's foyer and spotted a directory on the wall. Press-on white lettering displayed the art forms being taught—ballet, jazz, hip-hop, Irish step dancing, and modern. Several classes were under way on the evening of our visit. As we climbed the wide stairs we heard the distinctive sound of metal tap shoes on wooden floorboards.

A long hallway led to various studio spaces, and we followed the sound of the tap dancing. The lights in the studio were turned off, but there was a faint luminescence from the street lamps outside. In the dim light that filtered in we could just make out two figures dancing in the dark. A wisp of a man stepped toward us and introduced himself as Jimmy Slyde, along with his apprentice Rocky Mendes, some fifty years his junior. Rocky has been studying tap dance since he was nine years old, and he started pursuing it as a passion when he was sixteen. By age twenty-three, Rocky was teaching his own tap dance class at the Whitman Academy (cat. 6.1). It becomes clear during the interview that Rocky is learning not only how to dance, but also about the history of his art form. He can recite lists of dancers from long before his time—their names as well as their importance to the art.

I ask Rocky to describe what it is like working with Dr. Slyde. "It's hard, but it's fun. A typical session includes dance, talking, making sure I get it, yelling at me."

"Is he tough?" I ask.

"Yeah, but I like it. We start off with just basics."

"Which, to a nondancer, would be?"

"Shuffles and slaps. Then we eventually get into riffs. Then we go back to brushes."

"What is a brush?"

"It's one sound. It's just brushing your foot backward, like walking backward, basically. And you pick it up, it's BAP! And then a step, there are two sounds—BAP-Bap! BAP-Bap! That's a brush step."

"What is a slap?"

"A slap is lifting up your leg like you're almost about to jog, but then just to throw it down." Rocky's foot makes the sound of two slaps.

"And a riff?"

"A riff is just throwing it in four sounds, so the whole foot hits at different times."

Slyde reminds us, "Rhythm tap is a dance style that has as much to do with listening as watching. It's much more than pounding the floor." I ask Rocky to reflect on ways his apprenticeship to Jimmy Slyde has been important to him, "Prior to this experience, I was simply ahead of myself. I always wanted to do more difficult steps. I now realize that to advance my skills, I must focus on the basics so that they are always there whenever I call on them. Many people today just simply create in blind ignorance without a foundation. They call it new without thinking, researching, or learning about the past. It's important to learn the history, and who the originators of this art form were, before we can build and truly create today."

While some of the apprenticeship award winners meet only once or twice a week, Jimmy and Rocky often meet every day or every other day. Jimmy's self-titling as a "nudger," instead of a teacher, becomes obvious as he verbally encourages Rocky while he dances. In his teaching, Slyde stresses going back to the basics—time step, shuffle, riff, brush, slap—

6.1

Jimmy Slyde (sitting) and Rocky Mendes.

Photograph by Tom Pich Photography

these are the moves a dancer must master, like mastering the elements of speech in order to have a conversation.

Learning the steps and knowing the history of tap are important parts of this apprenticeship, but so is mastering the performance aspect or the genre. Slyde uses his own experience in show business to explain,

> Dancing is one thing. Studio is one thing. Mirrors are another. But an audience is another part. Then you're getting into the business part of it. You have to have something to say to be in front of an audience. You have to make gestures, as well as speak. When you're in front of an audience you see nothing; you've got bright lights coming at you. But they're out there. "I known you're there! I can hear you breathing." That was the business I was in for fifty years. I played saloons and cabarets and places where they'd say, "Bring on the girls!" *while* you were dancing. You have to have something to reply with—a smile. You don't want to lose the audience. You say, "Yeah! Here they come now. With high heels on." [Slyde does an animated step combination, all the while smiling to an invisible audience.] You have to be adaptable. That doesn't come easy; it took me a long time to learn that. So I'm just trying to pass some of that on to [Rocky].

Jimmy has Rocky demonstrate a few steps for me. "What do you call that?" Slyde asks. "Time step."

"Time step! Uh uh, Uh uh, Uh uh. Gotta get yourself together." Rocky continues with a different step and Jimmy demands, "What do you call those?"

"Slaps!"

"Uh huh. Like, slap?"

"Like, slap! Rocky laughs."

"Uh huh! Uh huh!" Rocky moves on to another step. "What are we doing, so anybody might know?"

"Riff, riff, riff, riff! Slap, slap, slap, slap!"

"Well what else do you do? How 'bout a little walk?" Slyde and Mendes walk in a large circle around the studio in time with one another.

"That's good, good! A little hop-skip now! Uh huh! Uh huh! What about a toe heel? What about a heel? Oooooh! What you got? Walk around? That makes it sound very good. Go see yourself in the mirror and see what you look like. I didn't know you could move! Oh now, I like that!" Slyde and Mendes take cues from each other. They trade off doing similar steps, then pause. "Anything else you'd like to show the young lady while you have her attention?" Rocky hesitates and Jimmy teases him, "Oh you have to think about it, huh?" Rocky laughs. Then Jimmy tells me, "He's a joyful young man and I think he's worth every minute of it."

We call the chisel an iron brush.

—Qianshen Bai, Chinese calligrapher and seal carver

Qianshen Bai practices the ancient art of Chinese seal carving, etching characters onto small blocks of jade, ivory, or other soft precious stones (cat. 6.2). Chinese seal carving is a miniaturist art; the carver attempts to strike a balance of beauty, all within a square inch.[2] Originating in the Qin dynasty (221–210 BC) as a way of authenticating documents, seal carving has evolved into an art form with multiple uses. Seals can be divided into four broad types: private seals for identification; official seals used by government offices for sealing documents; pictorial seals; and phrase seals for expressing poetic lines, proverbs, or moral admonitions. Chinese seals and seal carving are inextricably linked to the arts of Chinese calligraphy and painting and hence occupy a central place in Chinese culture. No calligraphy or painting is deemed complete until an impression with an inked seal stone is pressed onto it.

Bai was recognized for his skills as a calligrapher at a young age in Taiwan (cat. 6.3). While studying political science at Peking University, he won a prestigious national prize in 1982. He was introduced to seal carving by Master Jin Yuanzhang of Shanghai and soon after was taught by another famous scholar-artist, Cao Baolin, at Peking University. Bai arrived in the United States in 1986 to pursue advanced studies. A fellowship at Yale University led him to a PhD in art history in 1996. He joined the Boston University faculty in 1997, where he teaches the arts of Asia, combining art history with studio art.

In addition to being both a skilled calligrapher and a seal carver, Bai is a scholar of the historical and literary aspects of the arts—at a time when the traditional scholar-artist has become rare. The calligraphy on a fan's folded surface renders three poems from the Tang Dynasty (cat. 6.4). To be functional, this folding fan would be mounted on a stick.

Wen-Hao Tien's earliest memory of practicing calligraphy is as a ten-year-old in an after-school program back home in Taiwan. "It was a rainy afternoon in a full classroom with the smell of smoked pine from the ground ink thick in the air. We had to 'copy' the work of the ancient masters. But regardless of how diligently we practiced, our strokes seemed awkward and immature. I remember these afternoons as being simultaneously deep, mysterious, meditative . . . and frustrating. The teacher reminded us, however, that it takes a lifetime to perfect this ancient art form."

Wen-Hao came to the United States from Taiwan in 1987. She learned of Qianshen Bai in 1998, when she began working as a program officer at Harvard University's Fairbank Center for East Asian Research. In 2002, she met and assisted Bai at a community workshop on calligraphy hosted by the Chinese Culture Connection in Malden. In 2005–2006, Tien became Bai's apprentice with support from an MCC apprenticeship grant. I first went to visit them at Bai's Newton home in 2006.

6.2

Qianshen Bai (sitting) and Wen-Hao Tien.
Photograph by Billy Howard Photography

6.3
Qianshen Bai demonstrating calligraphy brushstroke. Photograph by Billy Howard Photography

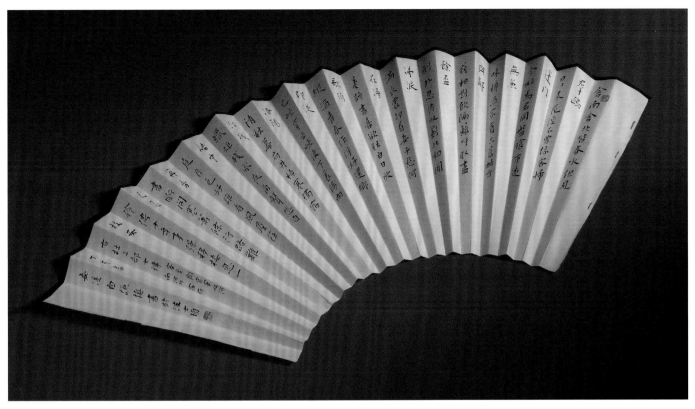

6.4

*Folding fan with calligraphy,
three poems of the Tang
Dynasty, Chinese calligraphy
by Qianshen Bai, 2006, ink
on paper, 10 1/4 x 19 x 12 1/2.
Collection of the artist*

Although she was not new to calligraphy, she was keenly aware of her lack of training: "I practiced calligraphy, but without a master." Bai expresses disapproval, "It's very different. It's like someone playing piano without a teacher." On the day I visited with them toward the end of their apprenticeship, Bai was going to teach Wen-Hao how to take seal impressions and make a rubbing of the side inscription. While I was busy setting up the recording machine, they spoke softly in Chinese. Wen-Hao had brought examples of her calligraphy work, a box of seals, her chisels and brushes, and a book in which she keeps impressions of seals. She also had a book with samples of master seal carvings in different styles. Bai notes, "We constantly refer to the past masters; it's important to know what the past masters have done before you."

During the course of the morning, Bai showed Wen-Hao how to take a rubbing, critiqued her calligraphy, and demonstrated some brushstrokes and the cutting of an inscription on the side of a chop carved by Wen-Hao. Midway through the visit, Bai stopped to make tea for us. Carrying the teapot into the dining room, he held it up, pointing out the Chinese characters inscribed on the front of the teapot. "See, we carve everything."

Wen-Hao reflects on her work with Bai. "My relationship with this art form changed during [my] apprenticeship with Professor Qianshen Bai. He has opened the secret door to the spirit of Chinese scholarly arts and afforded me the privilege of connecting to the past

6.5

Excerpt of poem by Wang Tei, Tang Dynasty, Chinese calligraphy by Wen-Hao Tien, 2007, paper, ink, 17 3/4 x 13 5/8. Collection of the artist

斜陽照墟落窮巷牛羊歸

野老念牧童倚杖候荊扉雉

雊麥苗秀蠶眠桑葉稀田

夫荷鋤至相見語依依即此

羨慕閒逸悵然吟式微

唐王維渭川田家丁亥夏文浩書于波士頓

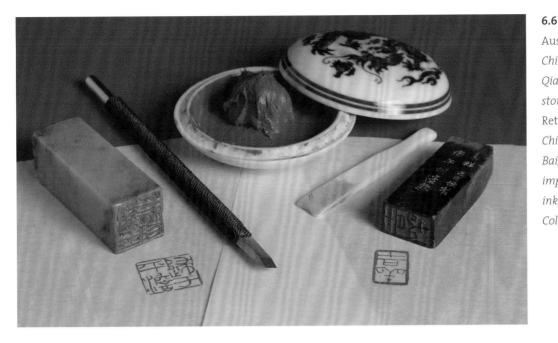

6.6

*Auspicious (left),
Chinese seal by
Qianshen Bai, 1994,
stone, 2 3/8 x 3/4 x 3/4;
Return to Simplicity,
Chinese seal by Qianshen
Bai, 2 1/8 x 1/2 x 7/8; seal
impressions, 2007, paper,
ink, each 7 5/8 x 4 3/4 (sheet).
Collection of the artist*

while discovering my own artistic voice. Owing to the close apprenticeship, the practice of art seal carving and calligraphy remain simultaneously deep, mysterious, meditative . . . and replaced the frustration with satisfaction" (cat. 6.5).

By September 2007 Bai and his wife had moved into a new home. A newly renovated basement provides a great studio space with plenty of room to work. Two walls, floor to ceiling, are tightly shelved with Bai's collection of scholarly books on Chinese art. On the desk are examples of Wen-Hao's calligraphy. Despite their familiarity, the relationship between them is formal. She refers to him as "Professor Bai." As the photographer Billy Howard sets up lighting to shoot a portrait, Bai points to a character Wen-Hao has drawn and comments quietly, "In this case, at the very beginning for a while, [for] two strokes, you may not notice the pace of the breath. But after a while, you are into a very stable situation and breath." He looks over her characters, then dips his brush in ink and uses it to point out things to be corrected. "Too small. . . . A bit crowded." He moves on to another character, "This is good." Wen-Hao smiles (cat. 6.6).

"The art [of calligraphy] really demands someone in a very peaceful state of mind. Second, you try to reach a state in which your mind and your hand are in a very harmonious relationship. And it conveys what's in your mind. Or what is *not* in your mind." Bai uses an analogy that seems surprising at first: "I think it is similar to Michael Jordan, the relationship between him and the ball. [The] ball becomes part of his body. We have to reach that state. His muscle, his breath, his movement—how fast; all became an integrated oneness."

This one-inch seal and impression is the character Du-lo, representing Dokuro Osho, a Zen Buddhist monk (cat. 6.7). The impression is made by pressing the seal into a pot of

Du-lo, *Chinese seal by Wen-Hao Tien*, 2006, stone; seal impression, 2007, paper, ink, 2 3/4 x 3/4 x 3/4. Collection of the artist

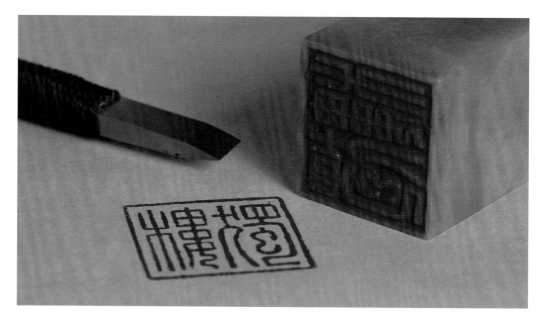

thick red seal paste, made of pulverized cinnabar, mineral oil, and strands of fiber. To achieve an even impression, it is important for the seal to be completely level.

Feridun Özgören learned the traditional art of *ebrû* in the 1980s from Niyazi Sayın (b. 1927) who, in a long master-apprentice chain, is linked to Mustafa Düzgünman (1920–1990), Necmeddin Okyay (1883–1976), and Edhem Efendi (1829–1904), the shaikh of the dervish lodge of the Uzbeks in Istanbul (cat. 6.8). In Özgören's East Boston studio, several Turkish musical instruments he made hang on the walls. Evidence of *ebrû* making defines the space—there are calligraphic stencils, drying *ebrûs*, combs, and other tools, and a wall of jars holding pigments, similar to the jars in iconographer Ksenia Pokrovsky's studio. At the center is a sturdy table, on which sits a large wooden tank filled with a viscous liquid. Carrageenan, a seaweed, has been added to water to thicken it so that it can support pigments floating on the surface (cats. 6.9, 6.10).

In 2000, Özgören was preparing for a major exhibition at the Beit Al Qu'ran, the Museum of Islamic Art in Bahrain. He had a year to finish a minimum of forty pieces and he needed assistance. Güliz Pamukoğlu, a member of the Cambridge Musiki Cemiyeti, a group that practices classical Turkish music and is led by Özgören, was eager to learn more about the art of Turkish marbled paper and seized the opportunity to work with Feridun. The experience gave her a foundation in all aspects of this art. During 2001–2002, Güliz served as Feridun's official apprentice in an MCC-funded apprenticeship. "She is the best of my students. They mostly come and go—I call those 'curious students.' Once they see how much work it is, they quit. By the third week, there's nobody around. It's a somewhat messy process, and if the ox gall is old, it's going to smell bad." Having survived this olfactory ini-

6.8

Güliz Pamukoğlu (standing) and Feridun Özgören.

Photograph by Billy Howard Photography

6.9

God, May His Glory
Be Glorified, ebrû *with
calligraphy, Thuluth script
in Arabic, calligraphy
by Mehmet Tahir Efendil
(?–1845); by Feridun Özgören,
2005, water-based pigments
on paper, 40 x 25 3/4 sheet,
45 x 31 mounted. Collection
of the artist*

6.10
God, May His Glory
Be Glorified, ebrû *with
calligraphy, Thuluth
script, in Arabic,
calligraphy by Mehmed
Tahir Efendi (?–1845); by
Güliz Pamukoğlu, 2005,
water-based pigments on
paper, 40 x 25 3/4 sheet,
45 x 31 mounted. Collection
of the artist*

tiation and no longer a beginner, Güliz was ready to incorporate calligraphy into her work. This entailed learning how to cut calligraphic letters out of paper.

The light *ebrû* is done all over the paper. Then paper letters are cut to be used as stencils and glued with water-soluble glue. It is an iterative process of masking, exposing parts of the paper, then dipping and washing to remove the stencils from the paper. Feridun explains, "There are conventional Turkish patterns like *batal*, which means just sprinkle and leave it as it is. And we have *gitgel*, which means 'come and go'—you go and come back; it is like a herringbone. *Bülbül yuvası* (nightingale's nest) has swirls of color. *Hatip* (corolla) has many varieties, like the heart and the star. Flower motifs include tulip, pansy, daisy, carnation, and rose. There are a large number of combed varieties. Some motifs are created using different kinds of additives such as turpentine."

When I visited with them in 2002, Güliz had recently been to Turkey. She brought back powdered pigments to prepare and use. She was interested in how colors had been used historically in marbled paper, both in the East and the West. "I started looking at which colors are used in traditional Turkish art and how they are combined. Europeans use a lot of related colors. Turkish color combinations are different—each color stands on its own, not necessarily blending with the others. Yet perfect harmony is achieved in the overall composition."

Because both Feridun and Güliz play traditional Turkish music, I wondered aloud about any similarities between making *ebrû* and making music. Feridun responded, "Most *ebrû* makers I know are also musicians. One of the most important aspects of Turkish music is improvisation. You have all the *makams* (musical modes) and you have all the pigments. You have musical instruments and you have *ebrû* tools, and what you do with each of those two sets is an improvisation. You are improvising in every *ebrû*. The improvisations cannot be repeated because they happen only at that specific moment. Therefore, in both music and *ebrû*, the outcomes are unique and can never be duplicated exactly."

Güliz reflects on the MCC grant and realizes that she started looking at the practical aspects of making *ebrû* more methodically. The grant motivated her to research the history of *ebrû*, not just in Turkey but in other countries as well. Feridun adds that Güliz learned a very important lesson; an artist should not try to save money by working with inferior materials.

As artists, we are limited in resources, especially as beginners who have to go through a lot of material. Güliz is very, very careful and almost frugal, saying, "I don't want to waste this beautiful paper." I said, "There is no waste in learning art. It may not come out the way you want it, but you have to use the right material, good material, the best material available to you, and ruin that material if necessary. Otherwise, if you try to use newsprint, it's going to buckle on you and you are going to dislike the whole thing. Get a good-quality paper, lay it down, and if you ruin it, that is fine! But then you see

how the paper absorbs colors and how the paint reacts to the paper." In that sense, the Council's grant was helpful . . . she learned that she should not try to save on paper.

Suhas is a very exceptional player. He is one of those students that comes along only once in a lifetime. —Tara Anand Bangalore, Carnatic musician

Tara Anand Bangalore has a deep knowledge of Carnatic (South Indian classical) music, one of the oldest music systems in the world (cat. 6.11). The appeal of this noble Indian art form lies in its juxtaposition of adhering to strict tradition while at the same time adding fresh perspective with constant improvisation.[3] Equal importance is given to melody, rhythm, and lyrics. The building blocks of Carnatic music are *talas* (rhythmic cycles) and *ragas* (melodic scales). Each *raga* is created from seven base notes, but unlike Western classical music, these notes have different forms; seven notes can result in a total of sixteen pitches. On a fretless instrument such as the violin, this is especially challenging.

Tara began her training at the age of four in India. As is customary, she learned directly from prominent gurus (teachers) in Delhi—Sankara Sarma, Vedavalli Ramaswamy, T. R. Subramaniam, and S. Gopalakrishnan. She also trained under T. Rukini and T. M. Thiagarjan in Chennai. Before moving to Massachusetts, Tara performed across India. Her teaching of both violin and voice is held in the highest regard by the Indian community of Greater Boston. Her students regularly garner awards at the Cleveland Tyagarja Aradhana Festival, the largest Carnatic music festival in the United States.

Suhas Rao, who grew up in the western suburbs of Boston, has been playing the violin since he was six years old and has been Tara's student for the past ten years. Although his musical training began in the Western classical style, his parents introduced Suhas to Carnatic music at age six by taking him to a concert at a local temple performed by Tara. He has been studying with her ever since. In 2006–2007, both received an MCC apprenticeship. In his final year before college, they are taking the opportunity to work on advanced items, such as *Ragam Tanam Pallavi*, which is both rhythmically and melodically challenging. When asked to describe his guru's teaching style, he answers, "She's strict but still fun at the same time. She is very encouraging." Asked what about her playing inspires him, he notes, "Her clarity of tone and creativity."

Tara Anand attributes Suhas' success to a blend of intelligence, artistry, creativity, and enviable work ethics. She reflects on her aspirations for the apprenticeship, "Time permitting, I would like him to help me teach my younger students so he can start learning how to transfer these skills to others. At the end of this year, we hope to be able to organize a concert for Suhas at one of the bigger local organizations that support this art form. The goal would be to make him perform a full-length concert—three to four hours, with accompanists." She seems confident about reaching this goal, "Suhas listens to Carnatic music. You've got to immerse yourself. The options are less here [than in India]. You need to find the music and grow with it."

6.11

Suhas Rao (left) and Tara Anand Bangalore.
Photograph by Billy Howard Photography

J. D. Smith is a master bladesmith, a craft discipline as old as the Iron Age itself. Blade-smithing is the hand-forging of edged implements (knives, swords, chisels, engraving tools) with superior qualities (cat. 6.12).[4] These high-performance characteristics include superior edge holding, strength, optimal design for functionality, and beauty of form. Smith specializes in the fabrication of pattern-welded steel, also known as Damascus steel (cat. 6.13). All the hot work is done at the forge at the Massachusetts College of Art, where Smith is on the faculty. "For pattern welding, the fire needs to be hot—2400 to 2500 degrees." He prefers gas fire to coal fire; it allows for greater control. "Since fire is the main tool you're working with you want it to be as trouble-free as possible."

J. D. began as an apprentice blacksmith at the Saugus Iron Works National Historic Park in Saugus, Massachusetts, under the instruction of Steven Nichols. After mastering traditional smithing skills, J. D. turned his attention to the more specialized area of bladesmithing. Eventually, he joined the American Bladesmith Society as an apprentice and advanced through the journeyman grade to the rank of master bladesmith, a status held by fewer than seventy other individuals worldwide (cat. 6.14).

Paul Cooper works as a full-time machinist in Woburn. He has been interested in knives from an early age (and has the tattoos to prove it.) Since 2004, Paul has been studying under J. D. By the time they began their MCC apprenticeship in 2007, Paul was already well versed in the fundamentals of pattern welding. Paul says that J. D. has helped him refine basic bladesmithing skills and has shared his knowledge of many of the subtle techniques (cat. 6.15). By the conclusion of their work together, Smith has high hopes of his apprentice achieving master status within the appropriate time frame, as set out in the bylaws of the American Bladesmith Society.

Cooper made this dagger in 2006 (cat. 6.16). It is based on a Malaysian dagger, notable for the curves in the blade. The sheath is tooled leather. "The belief is that some of these knives were so powerful that if you stuck one into a person's footstep or shadow, it would become lethal." The handle is made of Tasmanian myrtle and embellished with copper-leaf inlay. When I ask what it is used for, Paul responds, "It's a weapon." He alludes to J. D.'s philosophy of making knives, so I ask J. D. why he makes knives.

"Weapons are a very unique class of human artifact. They can separate a free man from a slave. Slaves could never own or touch a weapon. A weapon presumes you own your life and the right to protect it. For me it is very clear-cut. If you're in a society that permits you to have weapons, you are free. Why do I make knives? It's a statement. I make them because I can. Because I'm free."

Ksenia Pokrovsky lives on a residential street just outside the center of Sharon. It is a decidedly Jewish neighborhood, with six synagogues located within walking distance. But Pokrovsky follows another faith—that of Russian Orthodoxy. The writing of icons is both about deep religious tradition and a true ecumenical sharing of art and belief. Students from all over the world come to study with her. Sister Faith Riccio is a star pupil of Ksenia

6.12

*Sheath and dagger, bladesmithing
by J. D. Smith, c. 1997, Damascus steel,
silver, African blackwood, 16 x 4 3/4 x 3/4
knife; 11 x 1 3/16 x 1 1/4 sheath, by Robert
C. Golden; Folding knife, bladesmithing
by J. D. Smith, c. 2005, mocomegane, steel,
mother-of-pearl, open 12 1/8 x 1 1/2 x 7/15,
closed 6 3/4 x 1 1/2 x 7/16. James J. Treacy
Collection*

6.13

*Detail of dagger showing
pattern-welded steel. James J.
Treacy Collection*

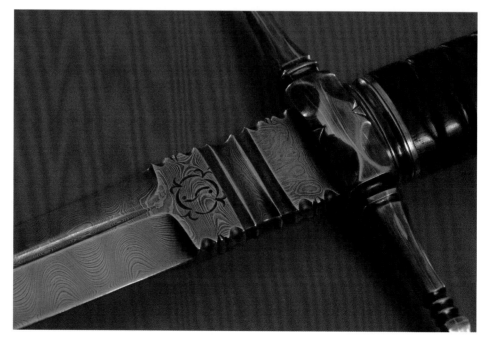

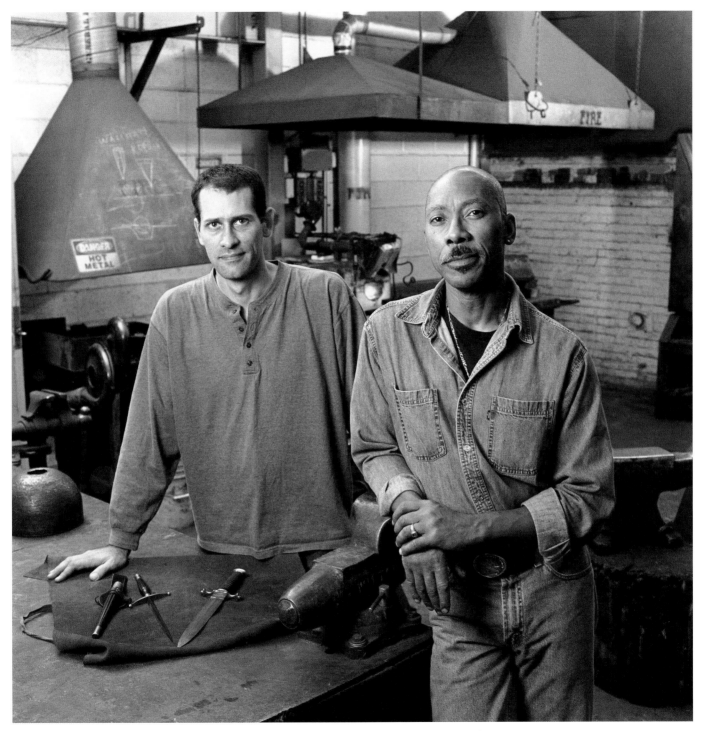

6.14

Paul Cooper (left) and J. D. Smith.

Photograph by Billy Howard Photography

6.15
Paul Cooper hammering.
Photograph by Billy Howard
Photography

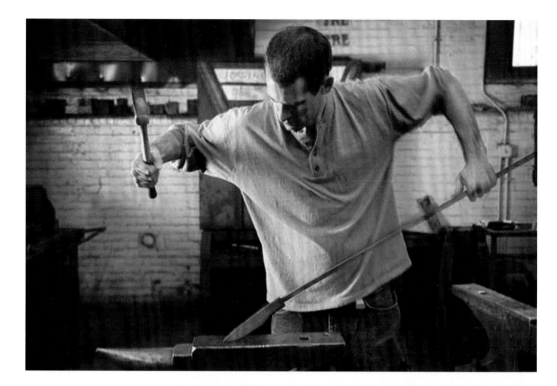

6.16
Damascus kris,
based on Malaysian keris,
bladesmithing by Paul
Cooper, 2006, steel, knife
12 1/4 x 2 3/4 x 7/8, sheath
9 1/2 x 2 1/2 x 1. Collection
of the artist

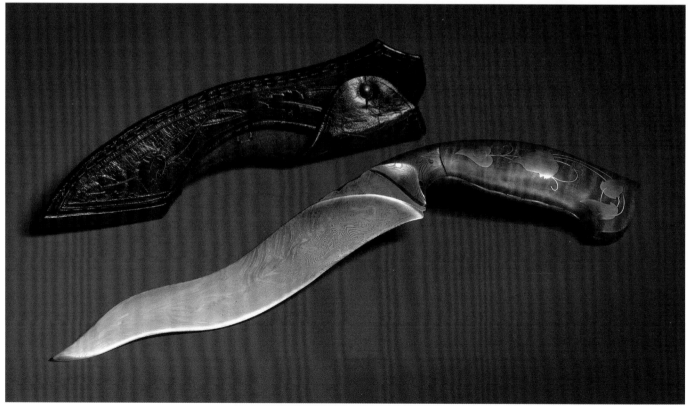

Pokrovsky, "She is a good student; she works very hard" (cat. 6.17). I first visited with Pokrovsky in January 2001. Six years later, I was back.

Ksenia's studio was full of students' work, icons in various stages of completion. Already at work was apprenticing Sister Faith Riccio, who gave me a welcoming hug. Riccio, who lives in an ecumenical community on Cape Cod, explained how she came to work with Pokrovsky. "The community I live in is like a modern-day abbey. It has always had a great concern about the older arts, and my prioress asked if I would learn icons. I really hadn't been an artist. I had done some drawing and I was a computer graphic artist. I said 'Sure.' I started out kind of on my own, a typical American thing to do. So I came up here to see Ksenia. I found her on the Internet. And she said, 'Well, you really don't know what you're doing,' in her just wonderful, diplomatic way. I said, 'No, I don't. And I'll keep doing that if you don't help me.'"

Sister Faith showed me her work, which included a number of icons she had nearly completed. She also pulled out a number of transparencies of icons on which she had traced the faces as a way of practicing (cat. 6.18). She was currently busy with an icon of Jesus washing the disciples' feet—having individually drawn the disciples and now finding just the right position on the gessoed board. During her apprenticeship, Sister Faith spent significant time in the Pokrovsky household, traveling weekly, several days at a time, to work under Ksenia's guidance. Ksenia considers Sister Faith one of her best students (and she has had many), remarking how hard Faith works. "She has the time to devote to this" (cats. 6.19, 6.20).

After about two hours, Ksenia offered us tea or coffee and we walked to the kitchen, a large room at the back of the house. Five or six parakeets had the run of the place. Perched on either side of the room, they occasionally whooshed by, flying at alarmingly low levels. On the table were an assortment of cheeses—Saint André, cheddar, and goat cheese—and saltines. Another student of Ksenia's was also visiting. They all seemed to have a convivial, teasing yet respectful manner with each other.

When Billy Howard and I visited them again in mid-September 2007, the number of parakeets had grown to eleven and Sister Faith was seeking advice on yet another icon she was working on. Ksenia leaned over Sister Faith's shoulder and examined the icon. "It should be more one angle." Sister Faith had removed the face of Mary. She told Ksenia, "I went back to redraw the faces because I was so unhappy with them. You show me where you'd put the eyes." Ksenia picked up a brush and painted Mary's eyes. Sister Faith was pleased, "That's so much better." She then shared this with us, "When you learn icons, you get really good at taking things out. It's so much about stylizing anatomy that is real. I have an anatomy book with me at all times. Even though they're stylized, they're anatomically correct." Ksenia puts this another way, "One of the reasons the old icons are so powerful is that they are based on truth."

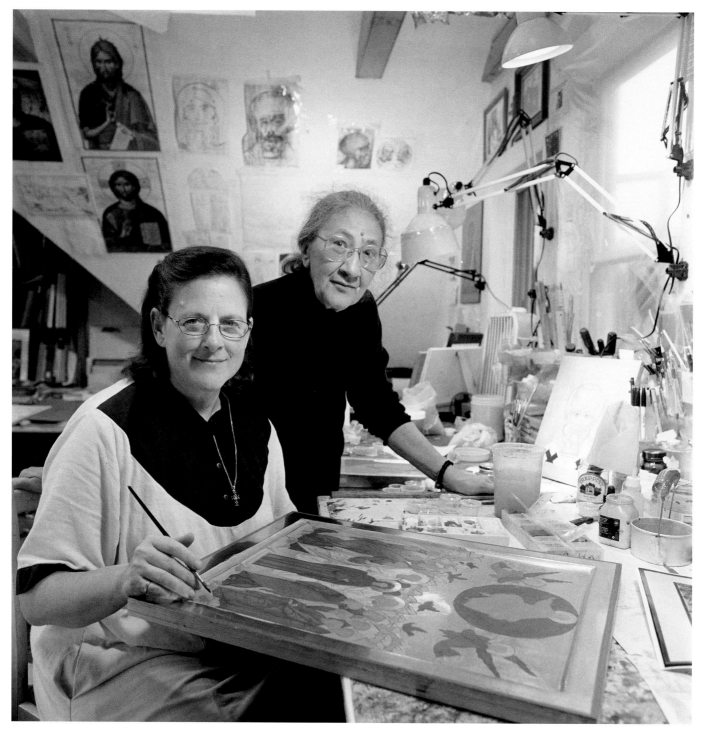

6.17
Sister Faith Riccio (sitting) and Ksenia Pokrovsky.
Photograph by Billy Howard Photography

6.18

Practice drawing by Sister Faith Riccio.
Photograph by Maggie Holtzberg

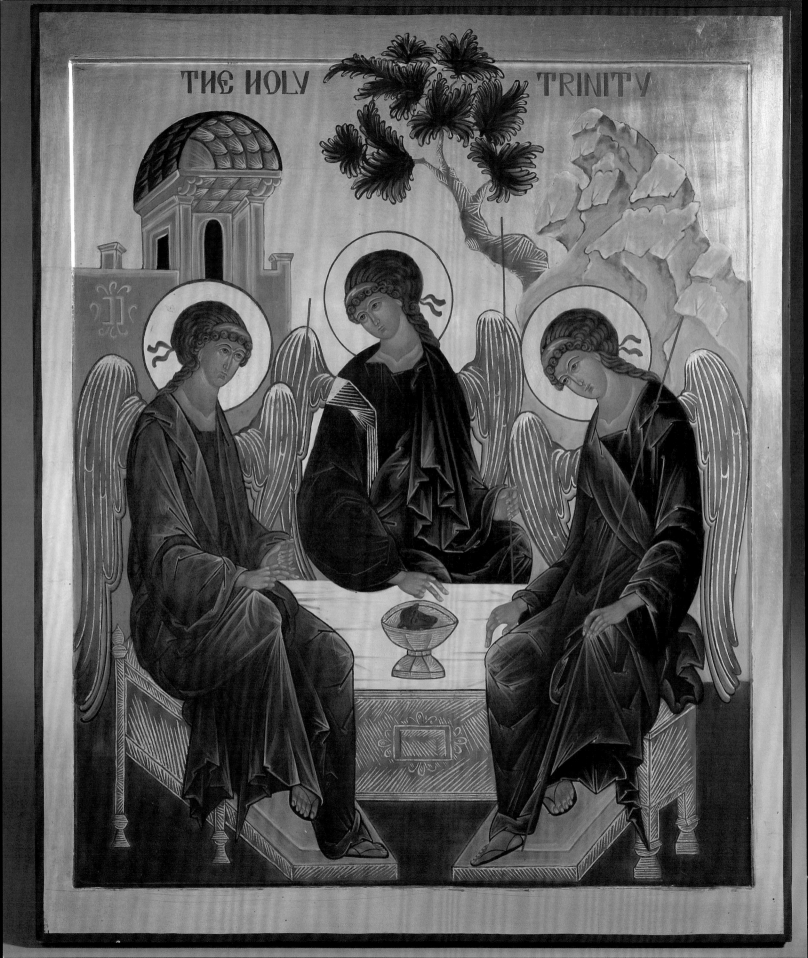

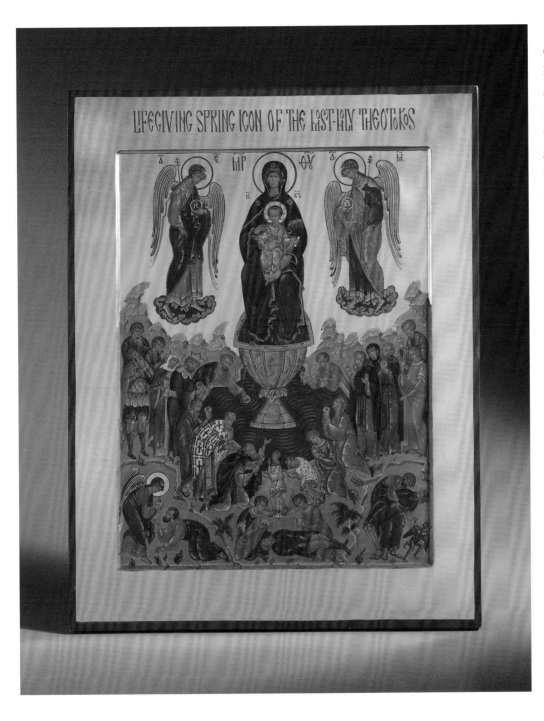

6.20
Lifegiving Spring,
Russian Orthodox icon
by Ksenia Pokrovsky, 2006,
egg tempera, mineral
pigments, gold leaf, wood,
24 1/2 x 19 1/4 x 1 3/8.
Collection of the artist

6.19 (opposite)
The Holy Trinity, *Russian*
Orthodox icon by Sister Faith
Riccio, 2003, wood, gesso,
pigments, gold leaf, 30 1/2 x
25 3/8 x 1 1/4. Collection of
the artist

NOTES

1. Information and quotes from 2003 apprenticeship application narrative and tape-recorded interview conducted by the author, January 27, 2004.

2. Information and quotes from 2005 apprenticeship application narrative and from tape-recorded interviews conducted by the author, April 15, 2006, and September 11, 2007.

3. Information and quotes from 2006 apprenticeship application narrative and personal communication with the author, September 13, 2007.

4. Information and quotes from 2006 apprenticeship application narrative and personal communication with the author, September 14, 2007.

Photographer's Note

To photograph the work of an artist entails a series of challenges not unlike those faced by a translator bringing a literary work to life in another language. One is always keenly aware of the compromises. In a work of translation, the words, idioms, and ideas expressed in one language can only partially be conveyed in another, and the translated work is at best only an evocation, a reflection of the original. Nowhere is the same difficulty more apparent than in photographing a three-dimensional work of art. The photographer has to decide which point of view he will take, which side to shoot. Immediately, this makes all the rest of the piece unavailable to the viewer. Even if the photographer renders all sides, the experience of viewing several flat photographs is different from viewing a piece "in the round." Detail is inevitably diminished, the color palette is altered, and texture becomes unavailable.

I employ a number of techniques to overcome these limitations. To reveal three-dimensionality I like to wrap light, often coming from behind, softly around my subject. I use hard-edge lights to emphasize curves, shapes, and details. Surface texture may not be tangible in a photograph, but if I skim the light properly across a rough surface, viewers can "feel" it with their eyes. Shadow is as essential as light. Keeping some areas in shadow is as important as highlighting others. It is this play of light and shadow that creates emotion, and emotion, for me, makes the photograph.

My goal, then, as a photographer whose task it is to translate the work of an artist into another medium, is to grasp the emotion, the power of the work, to find how it speaks to the viewer, to distill what it is trying to say. Then, through the tools at my command—light, shadow, and composition—I try to create a picture that captures as much of the original as possible in terms of shape, color, and texture, and, more importantly, that evokes in the viewer the same thoughts and emotions as the actual work of art.

I know from the outset that my photographs represent works of art that most viewers will never see or touch. For this reason I feel a real responsibility to the original artist to make my representations as true to the artist's vision as possible. Even though perhaps not all of us are able to read the *Odyssey* in classical Greek, hopefully we may still feel the wind on our faces from across that wine-dark sea.

Jason Dowdle
Blue Sky Film

Page numbers in *italics* refer to illustrations.